COMPILED AND EDITED BY
DREW HAYDEN TAYLOR

· ·

An EXPLORATION and DECONSTRUCTION of the *Aboriginal*
ARTISTIC SPIRIT as *seen* and *practised* through VARIOUS ART
FORMS that *demonstrate* REFLECTIONS on *society* through an
INDIGENOUS *perspective*, including TALENTS *not just limited to*
those considered strictly TRADITIONAL in origin, but *inclusive*
of more CONTEMPORARY forms of *cultural expression*.

· ·

 Douglas & McIntyre

15 16 17 18 19 5 4 3 2 1

DOUGLAS AND MCINTYRE (2013) LTD.
PO Box 219
Madeira Park, BC
Canada VON 2H0
www.douglas-mcintyre.com

Cataloguing in Publication data available from Library and Archives Canada
ISBN 978-1-77162-070-3 (print)
ISBN 978-1-77162-071-0 (ebook)

Editing by Cheryl Cohen
Cover design by Anna Comfort O'Keeffe
Cover illustration by Maxine Noel
Interior design by Shed Simas
Printed and bound in Canada
Distributed in the US by Publishers Group West

Canada Council Conseil des arts
for the Arts du Canada

BRITISH COLUMBIA
ARTS COUNCIL
An agency of the Province of British Columbia

Douglas and McIntyre acknowledges the support of the Canada Council for
the Arts, which last year invested $157 million to bring the arts to Canadians
throughout the country. We also gratefully acknowledge financial support
from the Government of Canada through the Canada Book Fund and from
the Province of British Columbia through the BC Arts Council and the Book
Publishing Tax Credit

Contents

e

Introduction

·······················

ART IS UNIVERSAL. YOU CANNOT BE A PEOPLE OR A culture without art. It shows who we are, and what is important to us. It also shows how we think, and how we express ourselves. The beauty of art is its breadth of expression. When I look at a beautifully baked and decorated cake, I appreciate it just as much for its aesthetic nature as for the taste (almost). A dance performance, a beautifully designed jacket, a painting ... they are all different, but all can represent the traditions of a people. Art can take your breath away, it can make you laugh, it can make you cry, it can make you spend insane amounts of money to possess it. Or it's something your six-year-old can do that finds its way to the refrigerator door.

Welcome to _Me Artsy_. In many ways, I think it's probably easier to define and explore humour and sexuality—and two earlier books of mine struggled to explain these elements of Native culture—than to deconstruct the artistic spark. Yet here we are again, trying to express the concept of talent and inspiration. I guess I am a sucker for punishment.

Me Artsy not only sticks its big toe into the sea of aboriginal creativity in its many different forms, but also tries to understand why we decide to get our toes so wet. Being an artist is a complex and fabulous existence, but it is often fraught with unique perils. We are all artists—deciding what we are going to wear that day or read that night or how we cut our hair are all artistic choices. That being said, we all walk or run, but few have become world-class sprinters or marathoners. Only a handful of us have based our lives around such tenuous and frequently unappreciated professions. I don't think you are technically allowed to call yourself an artist unless you have had somebody say to you, at least half a dozen times, "Wouldn't you rather be a lawyer or an electrician?" Worthy occupations for sure, with their own unique creative perspectives, but being a writer or an actor or a musician, or working in a hundred other occupations that celebrate humanity's need to generate something individually ingenious from nothing or something completely different ... well, I find that a little special. And yes, I know I am hardly objective on the topic.

Within the covers of this book you will find fourteen (thirteen not counting me) fabulous and interesting artists, all sharing their artistic origins with you, and thoughts about what they do and why. I have tried to present as many different and varied creative professions as possible, to highlight the rich nature of our country's aboriginal arts. There are people here who celebrate their culture by practising traditional and time-honoured arts, right beside those who have embraced new mediums to better explore their heritage. We have people from the Far North, and both sides of the country. We have Inuit, Haudenosaunee,

Anishnawbe, Haida, Dogrib and many others. It's a cornucopia of people, cultures and arts. We have a little something for everyone.

So put on your dancing shoes, get out your glasses, dig the wax out of your ears and set the table. You are about to meet some very interesting people.

DREW HAYDEN TAYLOR
Curve Lake First Nation, Ontario
October 2014

𝒞
Story of My Life

· ·

ZACHARIAS KUNUK
producer & director

I WAS BORN IN A SOD HOUSE, MADE FROM THE EARTH around us, near Kapuivik, Baffin Island, on November 27, 1957. At that time the Inuit were still living on the land like their fathers and grandfathers before them. Back then, the Roman Catholics had already built a church on nearby Igloolik Island. That and the Hudson's Bay trading post were the only wooden buildings in the area.

I have many memories of living in the North as a child, like being carried on my mother's back. One time I woke up there and stuck my head out into the bright sunlight. My mother was standing over a hole in the ice with a rifle in her hands. This is where seals come up for air. One suddenly appeared and she fired. I remember the noise of the gun scaring me so much. I also remember having long hair. I was named after my father's mother, Kigutikajuk, and so my parents didn't cut my hair because they treated me as her. They used to comb my hair and it would hurt a lot, and I hated that. Another memory is of being on a dog team one spring. We were trying to cross a river. My

brother and I were in a wooden box on the sled and my father was in front. We started crossing the river, with my mother farther ahead, leading the dogs. She was up to her waist in the river.

Several years later, when we were still living in our sod house, an old man blew his top. There were about fifteen people living in an open room. The man's son tried to sharpen his spearhead and the man didn't like it and, for some reason, lost his mind. Everybody ran out of the house after he started digging at his bed and acting generally crazy. We were about to go to sleep when this happened and my mother and I—in my long johns, without boots—ran out of the sod house in the dead of winter. I remember running outside in my bare feet.

The sod house had only one door. The roof and window were made from animal parts. During my childhood winters, I would use my sealskin kamiks (boots) as my pillow and wear my caribou-skin jumpsuit. When we first woke up, our parents always told us to go outside to take a piss. When I'd come back in, my mother would ask: "Where is the wind coming from?" and "Can you see the clouds or the moon or the sun?" and "Is it blowing snow or a blizzard?" I was always asked these questions. Later I learned that this was our way to meet the day and that all the animals that I would hunt in my lifetime lived out there. And for girls it was the same thing: they had to go out first thing in the morning too, but it had to do more with women's ways.

To get out of the sod house, you went through a door to the ice porch. Our dogs would be sleeping by the door and all around our house. I thought at that time we were the only people on Earth.

Later, at the age of five, I met my first white man—a Catholic priest, and he stuck a needle in my shoulder. Ouch, I remember that.

In 1963, at the age of six, I got baptized as an Anglican. I remember we went to Igloolik, which was a big community. I remember sitting in the church. I was the smallest on the pew, sitting beside my late older brother, older sister and my oldest brother. I looked at the stove and on top of it was a kettle, melting snow to baptize us. Farther up in the church, I saw a man dressed in black, kneeling down, probably praying. All of a sudden he stood up, dressed in his black gown. I thought it was the Devil himself. I was very scared. I started crying and I wanted to pee, so my mother took me outside the church and I had a pee. She shook me and told me to behave.

When I was seven or eight years old, my family wintered alone in Kanglimajuk, again living in a sod house, close to a caribou-hunting area. I remember we had lots of caribou meat, fish and seal hanging on one side of the porch. On the other side of the building were non-food items like skins, outside clothes and other dry goods.

One summer when I was eight, my father took me out on the land to shoot my first caribou. I remember that day: we were hiding on a little hill flat down on our bellies, waiting for the caribou to arrive. I could see a number of caribou coming, so my father told me to keep my head low. I was holding a .22 rifle, single shot. Being so young and small, I could not pull the trigger, so my father tied a small rope to the trigger for me to pull. I had my head low but I could see the caribou antlers so close. By accident I pulled the trigger ... only to hear *click*. It had misfired. The caribou heard the sound and they started to run away. My father

told me to shoot again, at one in particular, and I did, killing it. Then the rest of the caribou continued running and my father managed to kill a second caribou. I was so proud that day. And after butchering the caribou I had killed, my father marked the meat so it wouldn't get mixed in with the other meat, and during the winter I would look proudly at it—my caribou hanging from our porch. But the next thing I knew, all of it was gone, meat and skin. As was our tradition, I was not allowed to keep my first kill and it was given to an old couple. I carried their late son's name.

I was given five names in all—Kigutikajuk, Attagutaluk, Nujaktut, Tagaq and Kuatuq—all from people who had passed away before the year I was born. As I grew older, I started to know who my namesakes were and which families they belonged to. But later in my life, the government came into the picture, and because we didn't have family names and they could not say our given names properly, we were given Inuit numbers. Mine was E5-1613, and when I was baptized I got the name Zacharias from the Bible.

During the summer of 1966, my late brother and I were travelling with my father on a big boat—a Peterhead boat—to the big town of Igloolik, on Igloolik Island. We would go there sometimes to resupply. Not this time. Next thing I knew, my late brother and I were on the shore of Igloolik, crying as the Peterhead returned to our camp with our father. This was the saddest day of my life. We were there to stay for school, to learn the white man's language. We stayed with relatives for two years. As I got to understand the English language in my social studies, I learned about the other world and its people and animals. What I remember the most is learning about Africa and its animals—monkeys, elephants, lions, tigers and giraffes, all

animals that I would never hunt in my lifetime. I did well in math and art, but never really mastered spelling and spoken English.

It was around then that I started to notice movies, but it cost a quarter at that time to get in and that was expensive. I saw my cousin carving soapstone to sell so he could go to a movie, and so I started carving with him. At that time there were not too many white people in Igloolik, mainly teachers. So we would try to sell our carvings and sometimes we were lucky, but most of the time we missed the movie. But when I was at a movie, it was like God had sent me somewhere. I saw these people killing each other and when they pointed the gun and right at me ... very scary. Mostly we watched cowboys and Indians fighting, as our main man John Wayne would lead the cavalry, looking for scouts that didn't come home that night. We would find them dead on the ground, arrows sticking out everywhere, even from the horse. I started to think like John Wayne and say, "What kind of Indians did this?" Sometimes in other movies we started to notice that the bad guy who had been killed in the last movie was alive again.

Then, at the age of sixteen, I quit school in Grade 8. In order to get any higher education, I would have to leave Igloolik and I didn't want that. So instead my father flew me to Arctic Bay, to work in the Panarctic Oils for two years. There I worked as a labourer, and in 1975 I returned to Igloolik.

In my late teen years, I was really into carving and making a living. One day I bought a 35mm still camera and began taking pictures. The problem was that when I finished a roll, I'd take it to the store and have to wait two to three weeks, sometimes a month, to get the pictures

back. In 1981 I started a family and had to pay the rent with my carvings. I was now dealing with an art dealer in Montreal—Eskimo Art Gallery. I used to go down to Montreal to sell to this gallery, and while I was down there in the big city, I was amazed at all the things to see: tall buildings and stuff. I also learned that any breathing person could own a moving-picture camera. Interested in the idea, I told the dealer I wanted a camera like that. So the art dealer took me to a corner camera store called Blacks. There I bought a Sanyo colour video camera, with a tripod and porter pack, and a twenty-six-inch floor TV and VCR so I could watch what I shot. In 1981 there was still no television in my community. This was because back in 1975 our community voted for no TV, and again in 1979, so there was nothing like that in Inuktitut. I remember I used to have recorded cartoons to watch. Kids playing outside would be glued to my window watching TV with me. But in October 1983 our village finally got a TV signal, and we watched our first hockey game on television.

For the first two months that I was trying my new camera out, it kept recording in black and white, even though my camera was supposed to record in colour. Finally, someone who was shooting in Igloolik showed me the colour balance—just a simple switch. From then on, I would record community events and my family.

In 1984 I was still figuring out my camera when Paul Apak came to me and asked if I wanted to work for the Inuit Broadcasting Corporation. He said they were looking for help and I decided to try it. So I worked for IBC for eight years doing camera, sound, lights and editing—which at that time was on ¾-inch tapes. Before long, I became the station manager. I never really had any formal training

in handling a camera. I learned most of it from Paul Apak Angiliq, and also I received two weeks of camera training in Iqaluit.

The trainer for those two weeks was Norman Cohn. What Norman taught us was very different from my IBC days. At IBC we would set up the tripod and just shoot from that one spot, maybe moving a little. But Norman taught us that as cameramen the whole floor was ours. So we took the camera off the tripod and started to move around, which to me was more fun and the results looked more real. One of Norman's tests was shooting in church at a Sunday-morning mass. We had to walk right up to the priest during his sermon delivery, which I have never done before. I had to get shots from all angles and locations. It was scary, but at the editing table it turned out very well.

My Igloolik station was winning lots of production awards. Members of my staff were constantly walking around carrying a ¾-inch camera, porter pack, battery belt and tripod, with tapes stuffed in their pockets. I wanted to reward them with a four-wheeler but my director said we didn't have the budget. Angry and disappointed, I quit. Right afterwards, I co-founded Igloolik Isuma Productions in 1991. Even when I worked for IBC, during my holidays and time off I was doing my own independent projects, even as far back as 1985 when I made my first documentary from an Inuk point of view. In 1988 I tried my first drama—three of them, in fact, called *Qaggiq*, *Nunapa* and *Saputi*. Soon afterwards, in 1994–95, I made a 13½-hour series titled *Nunavut*. In 1999–2000 we shot *Atanarjuat: The Fast Runner*, then *The Journals of Kund Rasmussen*, and after that my company made more documentaries ranging from *Inuit*

Knowledge and Climate Change to Cree reconciliation ... so many of them that I have lost count.

A lot has happened since those early years. Igloolik Isuma Productions declared bankruptcy. I got my Order of Canada and an Aboriginal Achievement Award. In 2001 *Atanarjuat* won the Cannes Caméra d'Or prize. I have been awarded an honorary doctorate from Trent University, Ontario, and I have another one coming. There is so much I did that I won't even talk about because that's who I am. In our culture we don't talk about ourselves or how great we are.

My culture, its four thousand years of history, and other aboriginal cultures have always fascinated me. I am fascinated when I lie down to sleep in an igloo, counting the blocks in the spiral and thinking that whoever figured this out must have been a genius ... and whoever figured out how to build a kayak and to hitch dogs to pull a sled? It just blows my mind. So, being fascinated by my culture and with what has been invented for this climate, as a film-maker making different Inuit culture documentaries I feel that I am doing my job, and this is what I love to do: I love my job.

THE MAKING OF *ATANARJUAT: THE FAST RUNNER*

IN 1988 WHEN we created and shot the dramas *Qaggiq*, then *Nunapa* and finally *Saputi*, we were already trying out ideas and actors. In those days we worked with our ideas, and no script. I just knew what we needed for shots and the actors would improvise their own lines. Normally we just

tried to follow what the actors were doing but for the main shots we would set and position the cameras. After those smaller films we wanted to try to do a real feature film because we knew we could do it.

In 1998–99 we got year-end money from Telefilm to start the process. Then in the middle of the shoot we ran out of money and had to stop. That's when we really found out how this film financing works. Unfortunately, being an aboriginal company we kept running into brick walls. We didn't know we could not do a feature film. The financing money mainly went to English- and French-language films, and there was not enough to do an aboriginal-language one. But 1999 was also the year that Nunavut—our own territory—came into creation, and we wanted to make this film as our contribution to Our Land (Nunavut) as it became a reality.

Thanks go to Norman Cohn, who knew how this complex film-financing system worked. We had to fight our way through the bureaucracy just to get the slice of the pie. Paul Apak started to direct the film but when we ran out of money he became sick. Just before he died, we managed to get the financing in place to finish the film. And when we started again I had to take over the role of director.

Why this story? Why *Atanarjuat*? I heard this story when I was a child. In those day when we lived on the land and in a sod house like our ancestors before us, and travelled around by dog team, at bedtime my mother would start to tell us little ones a story to put us to sleep. Of course we did all fall asleep, and the next night we would beg her to tell again that part of the story we had missed. That's how I learned about this story of a naked man running for his life. Paul Apak did research by interviewing

Elders. He got them to tell the same story and when we noticed any missing parts, we'd create bridges to help the story along.

It was fun when we put this community of Igloolik to work. Nothing like this had ever happened before. We put Elders to work with young assistants. Hunters helped us make props, like a sealskin tent, that hadn't been used in ages. We brought the past back to life. Luckily for us, the Elders still knew how to make these objects. Just watching the women making costumes like they used to—using string to measure each actor to fit their costumes—was amazing to watch. We trained the actors for their roles, and part of that involved much singing. Our office sounded like a church—you can hear traditional ajaja songs being sung from outside and even down the street. It was fun to watch the actors, mainly the women, putting their makeup, wigs and tattoos on at 7 AM, because each day they had to look the same.

On shoot days we would load the actors up in sleds and pull them by snowmobile to the film set, where the hunters had worked hard to make igloos. It was a never-ending job: they had to keep rebuilding them. To get four seasons, we had to shoot over a period of six months. We shot segments in locations where the story actually happened, and then for some shots we would just shoot where we could, like the running of Atanarjuat. That took us two days to shoot. We hand-held the camera most of the time, with no tracks or any special equipment. There was also no catering, because we used animals for props and then we would eat them. Of course we had brought store-bought food for emergencies. Shooting in twenty-four-hour midnight sun meant we hardly used artificial lights—only

in the night scenes inside the igloo and the stone house. Sometimes when we shot in bad weather we'd get very cold, but we needed those shots.

Then a year of editing followed—long hours at the editing table putting it together. The first showing of the film was in Igloolik, since the people living there had helped us make it. We found the biggest building, a school gym, and screened it for everybody. It was the scariest moment of my life, but during the movie I heard the people laugh, so I knew we had done our job. Now it was ready for the rest of the world to see. I had never realized so much travelling is involved when you are promoting your film.

We hit Cannes. I knew this was our first try at serious filmmaking so I was not expecting to win anything. On the day when we knew only the chosen ones would be invited to walk the red carpet, we took the day off from the festival and visited an island. While Norman and I toured the place, we got a call telling us we were invited to the big gala, so we hurried back to our hotel and put on our monkey suits. That evening we were like saints: we walked the red carpet and then entered the theatre for the awards.

Suddenly my name was called. I didn't know what to do. My group pushed me to go up to the podium. I did and since I'm an Inuk I started to speak Inuktitut for a few minutes, then changed into English. I later found out there was no Inuktitut translator and the language was broadcast internationally that way for the first time. In May 2001, Inuktitut was spoken at the Cannes Film Festival, and it happened to be me speaking it.

I sometimes wonder why we had to go out of our own country to get recognized in our own country.

Verbing Art

·······················

MONIQUE MOJICA
actor & playwright

"Art is not just for beauty but to make our knowledge speak.
Art is a defence and an action. Art is a woman."
— knowledge keeper/linguistic specialist *Argar* Ricardo Arias Sipu,
Aligandi, Guna Yala, Central America, September 2008

RITING THIS ESSAY HAS BEEN LIKE TAKING A DEEP-sea dive. The self-reflection it led me through has made the result profoundly (and uncomfortably) personal. Perhaps that is fitting. Being an artist and sustaining a life as an artist is a profoundly personal need—a compulsion even. Being an artist has meant many things on multiple levels throughout my life. As a child, I don't think there was ever any expectation that I would grow up to be anything other than an artist. My mother recently told me that I was *born* an artist and that was how she knew she had to nurture and support what she recognized in me. The only real question was: What kind of artist would I be?

Six decades later, I'm still trying to answer that question—to examine, reflect, fine-tune and challenge the implications of living as an artist, an Indigenous artist—an Indigenous woman artist in a land where there are an irreconcilable 1,200 missing and murdered Indigenous women and girls. That can be counted. The tally keeps rising faster than we can update our Facebook statuses.

To write this essay, I invoke and re-embody the Earth Diver to bring up a muskrat's paw of earth from the bottom of the sea, call Sky Woman to spread it around as her feet shuffle dance and transform it into solid ground upon which the Star Daughters may land. Over and over again ...

LIVING AS AN artist has meant forging a spectrum of identities and moving among them fluidly: Lunatic/Healer, Creator/Destroyer, Transformer/Sacred Clown, Warrior/Magician, Visionary and Fool. And it is also the terrain where all of these facets of the self struggle to converge towards wholeness.

Living as an artist has required me to be fearless in search of cultural recovery and to reclaim those missing pieces with fierceness in order to put unspoken language in my mouth and unpractised rhythms in my feet, to literally put myself back together. To soothe the scars and replenish those empty places that the onslaught of the past five hundred–plus years left in its wake; nothing less than survival depends on the artists' ability to do so. As an Indigenous artist, I feel it is my responsibility to do so. Living as an artist has allowed me some agency with which to channel rage and sorrow and to transform them into something uplifting for my community, and for myself.

As a mature artist, I find that it is becoming more formidable to confront the uncertainties of an artist's precarious income, more exhausting to maintain the outlaw identity of "living in the margins," harder and harder to keep myself interested in dreaming up new projects. And probably also because I have been on this earth for some time now, and have dedicated my outlaw life's work to reconciling the irreconcilable through the vehicle of my artistic

practice—through theatre—I know that being an artist is what makes me tick. Despite the consequences, like it or not (and sometimes I don't), it's what keeps my heart beating.

SCHOLAR, EDUCATOR AND dramaturge Ric Knowles, my collaborator since 2001, refers to my work not as autobiographical but as "auto-biological" because the performances I create live organically *in my body*.

What I understand this to mean, in part, is that because I started my training as a dancer, embodiment has always been the most accessible means of artistic expression for me. I also understand it as part of being on a continuum, part of my family's living legacy as performers that spans four generations. The embodiment of stories from my immediate elder generations, from my ancestors and from ancestral lands is what connects me through time and space to that intangible, temporal, performative medium we call theatre. A medium that is temporary in nature because it exists only in the moment that it is being performed live—then it evaporates, to be held in the memory of the event, until it is repeated.

I believe that Indigenous cultures recognize the need for performance and repetition. Back in the day, just about everything was performative—whether it was planting, making fire, paddling canoes, going through rites of passage or taking part in large gatherings at sacred sites where clans and nations came together to re-enact creation stories, emergence, migrations and our own interconnectedness to land and place in relation to the cosmos. The stories of the people ground us in our identities and relationships and validate both in our worlds. It is because of this interconnectedness that another friend and collaborator, artist/

scholar Kaspar Saxena, has offered that perhaps it is appropriate to call my work "auto-ecological." I feel that both *auto-biological* and *auto-ecological* are true descriptions for different stages of my creative process.

In mainstream North American society, artists are not valued as making *essential* contributions to society—celebrity culture is valued, yes, but (Louis Riel's prophesy[1] notwithstanding) not the raggle-taggle bunch of characters driven to sacrifice so much for the privilege and the freedom to create our art. So I am aware that it is not common to have, as I do, a personal background that led me to think of artists as valuable and important people. Nevertheless, in the Greenwich Village of the 1950s, where I got my first view of the world, artists *were* revered.

Among the varied characters who passed through my parents' East Village apartment were dancers, painters, folksingers, musicians, potters, sandal makers and carpenters. Way before they founded the Spiderwoman Theater collective, my eldest aunt, Elizabeth (Lisa Mayo), was a musical theatre and nightclub singer, while the youngest, Muriel Miguel, was a modern dancer, and my mother, Gloria Miguel, was pursuing classical voice training. My world stood still for art and those who created it. Artists were going to change the world!

I have never lived in a world without art. From age three my mother registered me in every kiddie dance,

..................

1 I am referring to these oft-quoted inspirational words from Louis Riel, Métis spiritual leader of the Resistance movement: "My people will sleep for one hundred years, but when they awake, it will be the artists who give them their spirit back." Riel was hanged in Saskatchewan in 1885 by the government of Canada.

drama and art class in New York City that offered a bursary for a little brown girl. From the Henry Street Settlement House on the Lower East Side to way uptown at the Museum of Modern Art, I was a busy kid.

My parents themselves taught me much about life and death, love and war through their perception of art and the stories within the art that was in and around our everyday lives. In the New York City of my childhood, art was a pervasive presence. From statues of gargoyles and dragons, lions, unicorns, Atlas, Poseidon and Mercury to Lady Liberty herself—it was the statues, monuments and memorial arches of New York that taught me about Eurocentric mythology, history and religion. (Who was that guy in a diaper with the arrows sticking out of him, anyway?)

I still remember the details of how my mother taught me what war is. It was on a visit to the Museum of Modern Art. I must have been about three years old and Picasso's *Guernica* was on exhibit. It was huge (I was small) and its drama and its violence were, at the same time, fascinating and repulsive. Heads, limbs, breasts dismembered from bodies, and faces grimacing in agony. My mother and I sat in front of it as she answered my three-year-old questions of "Why?" and "Why war?" over and over again... It is forever the image that war conjures up in my mind.

It was a necessary lesson and my mother connected it to my life in order to explain my father's trauma from his experience as a hidden child and Holocaust survivor in World War II France. I was born only seven years after my father arrived in New York as a war orphan. Much of what I accepted as "just things Daddy does" were what we would today easily recognize as post-traumatic stress disorder. Even though the trauma that survivors

experienced may have been seldom openly talked about in those early postwar years, what was *never* spoken about was the ongoing genocide of Indigenous people on the very land where we lived.

To this day, the war against Indigenous peoples, our lands, our women and children remains largely unacknowledged, along with the ways in which racial and gender violence are inextricably bound to settler/colonial greed and to those who continue to benefit from it. And what was not represented in the artistic worldview of my childhood was any sense that Indigenous art had a place among the influential greats as "high art" or that there were any Native artists or performers (outside of my family) central to the body of work being created as part of the mindset of post–World War II North American identity.

Living with invisibility has informed my work. It has driven my need to explore the history of that invisibility and to make it visible—"to make our knowledge speak," in the words of knowledge keeper Ricardo Arias Sipu, and to transform it into "a defence and an action."

ON THE OTHER side of the Brooklyn Bridge lived my grandparents and the rest of my extended Indian family. This is where I learned many unspoken lessons in creating art. Aunt Lizzie acted out every story about the heroic "Mousie" that she ever told me, while Uncle George spun tales about the owl that lived in the backyard. Grandpa taught me to do beadwork, starting with daisy chains and graduating to loom work, and on Sunday afternoons the sound of my uncles' breath blowing over the *gammu* (Guna flutes) came from the front parlour as they told stories in a language I could not understand. Here is where

I absorbed my family history from stories heard from under the dining room table.

This is the place of beginnings. It is a place to which I have had to return (over and over again...) in order to define and redefine my artistic practice. And when my own memory was not enough, I have had to remember things I never knew. I have had to travel to ancestral lands, to the origins: to the Tidewater region along the Rappahannock River of Virginia and to Yandup Nargana, in the autonomous Indigenous territory of Guna Yala (which is within the geopolitical borders of Panama), to the earthworks complexes, effigy mounds and the Mississippi River, which hold and archive the history of our migrations and emergence, and which continue to perform for us the stories of who we are. As long as the land exists, the stories, songs and languages are still here.

However, I would not have been able to hear those stories if I had not been simultaneously engaged in a conscious and ongoing process of decolonizing my perceptions, my belief systems and, therefore, my artistic practice. I had to unlearn the fear of *not knowing*. The fear of being called out for not knowing culturally specific information, language, songs, dances and ceremony has been used to silence and to de-authenticate from both outside and inside the Native community. Unfortunately, that fear also stunts our ability to connect, to reclaim cultural identities, to grow and to create.

I would say, then, that one of the most important things I've learned how to do as an artist is to be a receptor—to receive images, feelings, frequencies and information. To hold and process those through my body until the stories can be released within the container of

the rehearsal hall in front of witnesses. *Auto-biological* and *auto-ecological.*

My family history includes the knowledge that I am only one generation away from aboriginal sideshow attractions (a fact that still blows my mind). My Guna grandfather, Antonio Miguel Mojica, was a sailor who docked in Brooklyn, New York, where he met and married my Rappahannock grandmother, Elmira Spencer. Her mother had fled north from Westmoreland County, Virginia, just after the Civil War. It was very dangerous to be an Indian in the South in those times. During the Depression, my grandparents did what many Native people did to put food on the table in the 1930s: they played Indian, created medicine shows and danced for tourists. My mother, her older sister, my grandparents and extended family were on display in the Indian Village right next to the Freak Show at the Golden City Amusement Park in Canarsie, Brooklyn—"at the very end of the Myrtle Avenue streetcar line," as my mother describes it. Golden City was a competitor to Coney Island and although it burned down before the '30s were over, the impact that it, and many other places like it, has had on the livelihoods of present-day Native theatre artists can still be felt. Way too frequently we are still expected—no, *required*—to "play Indian" on mainstream stages.

That is not to say that tradition rules in the performances that Indigenous theatre artists are creating—many things have changed, from *within* our community. When I first moved to Toronto in the early '80s for a stint as the artistic director at Native Earth Performing Arts, most of our theatre was still firmly rooted either in multicultural folkloric recreations of "myths and legends" (what I call history) or in explaining "us to them." Non-Indigenous

Canadians were the target audiences and that strongly influenced what went into those creations. We had to build an Indigenous theatre-going base and that need grew into performances and explorations that explained "us to us." But it also created a new trap: the victim narrative.

So, as I see it, that is the dichotomy of what is bankable on the mainstream stages today: romanitcized folklore or gritty, sensationalized victimhood. More recently, the reconciliation theme has begun to creep in as well (as long as it allows the settler/colonials to continue to feel warm and fuzzy and does not truly indict). What has *not* changed are the power dynamics and our ability to have control over our image, our cultures and our history when we are performing within a mainstream institution. We still hit the racism of the "buckskin ceiling." We are still recovering from "playing Indian" as a performance form. It is probably one of the single most dangerous quagmires that any Indigenous performer has to navigate. It pays very well, and therein lies the rub.

Our choices are either to put ourselves at the mercy of the artistic vision and politics of non-Indigenous directors, playwrights, artistic directors, designers and public relations machines and to stalwartly try to affect change from within those institutions, or to struggle to create or own theatre where our Indigenous artistic visions are in control and we unapologetically hold power over our voices, our stories and our images.

I believe my contribution as an Indigenous theatre artist lies firmly within the work created by doing the latter. In *Princess Pocahontas and the Blue Spots*, in *The Scrubbing Project* (with Michelle St. John and Jani Lauzon of Turtle Gals Performance Ensemble) and in *Chocolate*

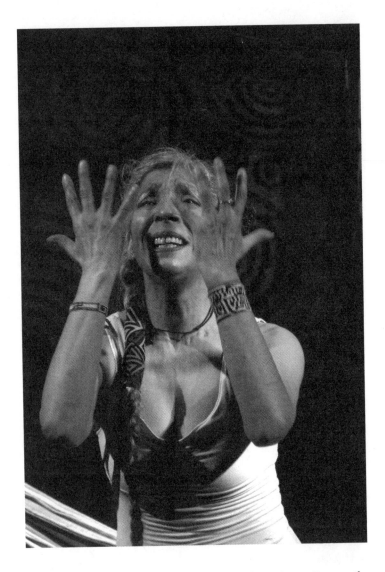

Production shot from the premiere of *Chocolate Woman Dreams the Milky Way* by Monique Mojica: Dule Wagua (Mojica) lands in Yandup Nargana. PHOTO BY RIC KNOWLES

Woman Dreams the Milky Way, where the collaborative team of Chocolate Woman Collective and I deliberately set out to deconstruct the "house of *Balu Wala*" (the house of evil, house of greed, envy, lies, indifference, thieves) so that we can construct a new house for our theatre. Anishnaabe activist Winona LaDuke puts it this way: "We don't want a bigger piece of the pie, we want a different pie."

ONE OF THE most challenging periods of my life to sustain living as an artist was as a single mother. The structures within which theatre is created are neither child- nor parent-friendly. My son, Bear, had been a "backstage baby" from the time he was three months old and even as a toddler knew that he had to report to the stage manager to offer his volunteer services. This was a boy who brought down the house lights, rolled many feet of cable and pulled up a lot of gaffer tape! But as he got older, sitting in on rehearsals got stale (even if he did learn *everybody*'s lines for entertainment) and having a mother who ran monologues aloud on the subway (instead of talking to him) was not a happy thing. And even though the arts funding was a very different scene in the mid-'80s (it actually looked as if it was possible to do this work for a *living*), my absences over the long, unconventional hours coupled with the low pay led my son to declare as a young teenager, "I *never* want to be an artist! I have watched you and my dad struggle as artists. I don't want to do *that!*"

Well, the poor kid never had half a chance. Today, he is known as Bear Witness, the video artist who along with Dan General and Ian Campeau form the DJ collective A Tribe Called Red. When he called me from backstage after their Juno win for Best Breakthrough Group in March 2014,

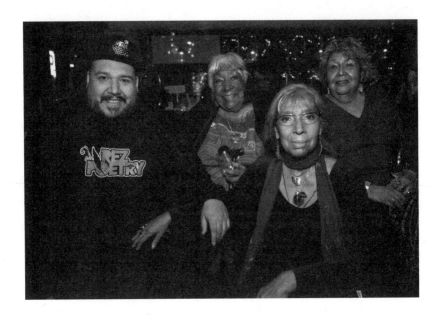

Three generations of artists gather at the reception of Monique Mojica's mother's solo show. Left to right: Bear Thomas (DJ Bear Witness), Gloria Miguel, Monique Mojica and Muriel Miguel. PHOTO BY DAN HENDERSON

he said to me, "I was raised to be right where I am now." And I suppose he was. I am obnoxiously proud of him, of his groundbreaking work and his ability to articulate what he is doing and why. He is the fourth generation of performers in my family, so he too takes his place on the continuum.

RICARDO ARIAS SIPU, the knowledge keeper and linguistic specialist from the island of Aligandi in Guna Yala who is quoted at the start of this essay, is an *Argar:* one who interprets for the community the dense, poetic and metaphorical language of the *Sahilas* (chiefs). In 2008, on my first visit to Guna Yala, I had the privilege of spending

nearly a full day in his company while he talked about art. He talked about the original purpose of the *mola* (Guna women's textile art and clothing) and of the oldest techniques for creating *molas*. He explained that the intent of both a *mola*'s designs and the specific colours of the medicine dyes that were steeped into its fibres was to protect a woman's body, like a shield. Based on this concept, it follows that to *re-activate*—as the *argar* said in a private conversation with LeAnne Howe and Jim Wilson in Ada, Oklahoma in March 2014—the original purpose of Guna art within my artistic practice is to act in defence of women's bodies. The complexities and conceptual sophistication of what he shared has had a radical impact on my grounding as an artist. "Art is a defence and an action." *Molas* are high art. So are the ancient effigy mounds and earthworks that I have been visiting since 2011 with LeAnne Howe, my Choctaw collaborator and co-writer of *Side Show Freaks & Circus Injuns*. To "re-activate and re-animate" (words the *argar* used) the original purposes of Indigenous artistic practices is very, very powerful. It literally means that by doing so, we have the potential to *move the spirit.*

I do not know if in my lifetime if I will see a day when we, as Indigenous artists, can simply create because, as artists, we must. What would we create if we were not perpetually "in reaction to" the colonizer? What would our work look like if we were relieved from responding to the reverberations of the same shock wave that began with first contact? These are critical questions for me.

In the present, we Indigenous performing artists are always in a position not only of educating the "other" (teaching Indian 101) simultaneous to researching, creating and developing new plays, but also doing that at the

same time as we are exploring and devising Indigenous processes of artistic practice and performance! I have no idea what my work would look like without that pressure cooker being its container—but I long to find out. Maybe that longing is what has kept me going back to try again. Over and over...

"Art is a defence." I art in defence of women's bodies. "Art is an action." I art to make our knowledge speak.

I art for that little brown girl asking, "Why war?" Over and over again...

I art to protect our lands, waterways and breath.

I art for all the young Indigenous artists coming up fast behind me who don't know a world without Indigenous artists in it.

I art for my son, Bear Witness, and for A Tribe Called Red.

I art for my niece, Josephine Tarrant, a champion powwow dancer and musical theatre performer.

I art for my Sun Dance daughters, theatre artists Erika Iserhoff and Pj Prudat. I art for my New Zealander daughter, director Dione Joseph. I art for the skilled writers and ferocious bloggers Leanne Simpson and Chelsea Vowel. I art for filmmaker Ariel Smith. I art with the water walkers, prayer paddlers, moccasin vamp beaders and round dancers. And I humbly ask them to receive my handful of earth from the bottom of the sea, as the Earth Diver re-enacted breaks to the surface.

I art for you.
I art for you.
I art for you.
I art for you.
Degii...

e

A Mark in the Land

· ·

MARIANNE NICOLSON
installation artist

*T*HE YELLOW-ORANGE CLIFF RISES ALMOST VERTI-
cally out of the water to dominate the landscape
around it. Looking at it from the vantage of a boat in 1997,
it seemed so easy to think I could paint that cliff. Others
seemed to think so as well. "You should put a painting on
that cliff," they would say to me as we travelled in and out
from Gwa'yi Village in Kingcome Inlet, which lies on the
coast about 500 kilometres north of Vancouver. After hear-
ing so many comments, I thought to myself "Yeah, I could
do that." This is when I learned that sometimes ignorance
is our best ally in an endeavour. Not knowing how hard
this was going to be was the only reason I even attempted
it—along with an overriding belief in the histories of our
people, the Dzawada'enuxw, as I had been taught them.

Once, while I was living with my Uncle Ernie Willie
in Kingcome Inlet, after I had graduated from Emily Carr
University of Art and Design in Vancouver, we were trav-
elling back home in a small open outboard from Alert Bay.
He would stop the boat periodically and point things out

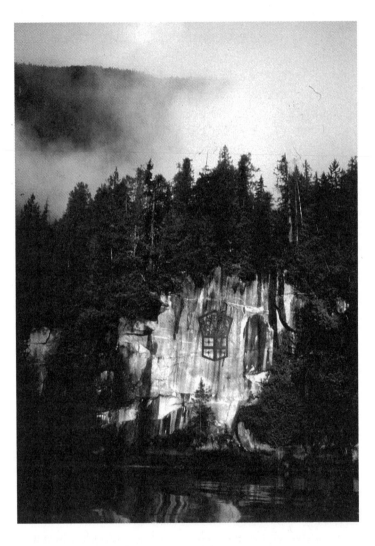

Marianne Nicolson's *Kingcome Inlet Cliff Painting*, a 38-foot-high mural painted on a Kingcome Inlet cliff face in 1998. The mural depicts Kawadilikala, the great wolf, holding his treasure box. PHOTO COURTESY OF JUDITH WILLIAMS

to me. He pointed out the white beaches and told me these were middens, the white colour created from years of clam consumption on the part of our people. Middens were evidence of our deep-rooted presence in the land: ancient village sites. Perhaps others might see only an empty white beach, but after this I could see centuries of occupation and activity. Another time we stopped and he stretched his arms wide. "See from that mountain there?" he asked me. When he had my full attention he arced his other arm across his body and stretched it out far in the opposite direction. "These are all the lands of the Musgamakw Dza-wada'enuxw, the four tribes of the Kingcome People. All this land is ours." With this statement hanging in the air he started the engine and we resumed our journey. It wasn't until later, when I was back attending school at Simon Fra-ser University with my sisters, that my sister Midori told me, "We don't legally own any of that. According to Canada, our reserve is the three square miles that encompass our village and a few small postage stamps here and there in the Broughton Archipelago. According to them, we are actually considered squatters within our own territory!" I couldn't reconcile this information with what my uncle had taught me. Whose truth would I believe? My own peoples' or the government of Canada's? I decided there was some-thing wrong with the government.

Having moved to Kingcome after completing univer-sity, these trips meant so much to me at the time. My uncles and cousins would bring us in and out of Kingcome and always we would pass that yellow-orange cliff. Below it, a little off to the left, exist an old set of pictographs that had been painted in 1921 and added to in 1927. Oral history said that these pictographs had been painted by Molly Wilson,

a sister to Billy Wilson, who was the father of my Auntie Beverly Lagis, who had taken my sister Midori and me in to live with them in the summers as teenagers. In this painting were depicted a series of coppers—our iconic symbol of wealth—a ship and some cows. The dates included in the pictograph were unusual but significant. My great-uncles, Chiefs George and John Scow, brothers to my great-grandfather Chief Peter Scow, had been avid potlatch men in the 1920s. They were responsible for these images. Reg Halliday, brother of Indian Agent William Halliday, had sold the cows to the Scows and they had been used to feed the people. At that time William Halliday was aggressively attempting to end the potlatch and had incarcerated many of the Kwakwaka'wakw for being involved in traditional ceremonies. I personally thought it was really great that it was Reg who sold the cows to be used in a potlatch that his own brother was adamantly opposed to.

Seventy years later, every time I passed those pictographs I felt gratitude and admiration for my great-uncles' tenacity in continuing our traditions despite very real persecution. They hadn't just defied the Indian agent, but proclaimed their defiance in a painting on the rocks, within our lands. These were the things I thought about when I would look at that yellow-orange cliff and people would say, "You should put a painting on there." Okay, I finally thought. "It's time to try." I would fail on my first attempt.

In the summer of 1998, after much preparation, as I sat in Clarence Moon's boat looking up, I realized the moment had come. It was time to get out of the boat. After thinking this endeavour through for months, it was finally time to start climbing. I had hired a professional rock climber to work with me and had prepared a giant

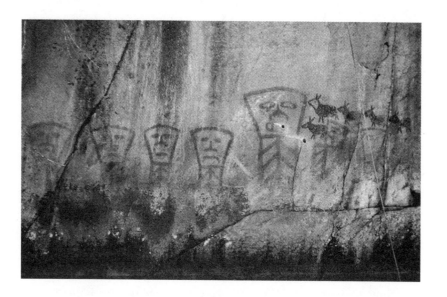

Traditions continued despite persecution: pictographs painted at the mouth of Kingcome Inlet, dated 1921 and 1927. PHOTO COURTESY OF MARIANNE NICOLSON

blue tarp as a stencil for the design. My Uncle Ernie had told me to put a wolf with a treasure box on the cliff. This would represent the origins of our people in the Kingcome Valley. Our original ancestor was the wolf Kawadilikala, who came with his family and his great treasures, the four great dances of the Dzawada'enuxw, to the Kingcome Valley when there was first light in the world. The wolf is designed so that he is turned in the direction of the village. In the design, I had put the box on Kawadilikala's back with the design of the sun referencing the beginning of the world, or the beginning of the day. In our language, Kwak'wala, 'nala is the word for "the day" and also the word for "the world." It is the same. I had placed the image of Kawadilikala, the great wolf, with his treasure box,

within the face of a giant copper or `tłakwa. These shield-shaped objects were the highest form of wealth used up and down the coast. Within the bottom, or body, of the copper I had drawn four stars to represent the four tribes of the Musgamakw Dzawada'enuxw tribal confederacy: the Dzawada'enuxw from Kingcome Inlet, the Haxwa'mis from Wakeman Sound, the Kwikwasut'inuxw from Gilford Island and the Gwawa'enuxw from Watson Island. Four stars for four tribes together united by a shared geneology, biology, history and geography.

In 1936, a year before my mother was born, these four tribes had strategically requested to carve a totem pole in memory of King George V, who had died in January of that year. At the time, the carving of a totem pole was considered illegal. Despite the opposition of Indian Agent Murray S. Todd, who had by then replaced William Halliday, the idea gained favour with the Anglican church, especially in light of the proposal to build a church alongside the pole. The pole was innovative and unusual by traditional standards. Instead of displaying a single family's crests and history, the chiefs of the Musgamakw Dzawada'enuxw decided to display four crests, each representing one of the four tribes. On the top was carved Kwankwaligadzi, the great thunderbird of the Gwawa'enuxw; below this was carved the wolf Kwalili, younger brother of Kawadilikala, which represented the Haxwa'mis; below this was carved Lawagila, the great raven crest of the highest-ranked clan of the Dzawada'enuxw; and finally beneath this was carved `Tsekame, the cedar man and original ancestor of the Kwikwasut'inuxw. This pole still stands in Gwa'yi Village, in Kingcome Inlet, and I see it as a testimonial to

the innovation and tenacity of our old people to find ways of holding onto their way of life despite tremendous pressure to give it up. Today, I think we find strength in it as a symbol for us to be united in the face of contemporary pressures to see First Nations individualize under capitalist ideologies, sell their aboriginal title, and assimilate into the mainstream. If our ancestors held onto their traditions, histories and sense of themselves despite all odds, so should we.

Having mapped everything out conceptually and having prepared ahead of time as best I could technically, I was finally faced with the reality of climbing the cliff. It seemed simple enough. Left foot up, right hand up, right foot up, left hand up; if I could remember this pattern and focus on it then I could begin. Thirty feet up I looked down and was filled with terror—the kind that floods your body and makes you forget what you are supposed to do next. What was I doing? Why did I think I could do this? *What if I fail? What if I fall off this cliff and humiliate my family?*

I was reminded of an incident from childhood when my other sisters and I had promised Midori our treat money if she would jump off the high tower at the Crystal Pool in Victoria. I watched safely from below as she cautiously stood on the edge, hesitated, then took the step forward that would send her hurtling below for what seemed like eternity before her little body hit the water with a triumphant splash. In our minds it was money well spent. Well, it was me now ... standing on the high board. This wasn't quite what I had in mind when at age five I decided I wanted to be an artist. I had no idea at that time that creating art could be so diverse a practice. How did I

get from safely drawing on pieces of paper to this? With these thoughts in mind I decided ... "too late now, no going back." I forced myself to move, left foot up, right hand up, right foot up, left hand up. Below me a flotilla of community members in boats watched expectantly.

There were many problems. We were unable to anchor the tarp down adequately. The summer winds would lift it up along with myself and the rock climber Val Fraser. It was like trying to work on rough seas. We were able to spray-paint a few areas and beneath the tarp I could see the lines looking rough and somewhat crooked on the rock face. Discouraged, I thought that if I wasn't going to do this well, then I shouldn't be doing it at all. After an exhausting day of battling the elements I came down feeling defeated and perplexed. After a few days I had to accept that this system just wasn't going to work. I was going to have to swallow the bitter pill of failure and find solutions to some monumental dilemmas.

Taking the knowledge I had gained from the failed attempt I began to map out new strategies. Having seen the original tarp on the cliff face I now knew it was too small. My cousin Sandy had told me this as we worked to cut out the template lines in the old community hall. He had been watching a group of us on hands and knees cutting the tarp with knives and nonchalantly observed, "It's too small." It wasn't a question but a statement. I remember feeling annoyed at the time. How would he know? But Sandy had been right, so I doubled the size and broke the tarp into four sections that could be managed, rather than one.

I thought about why I had failed. What wasn't quite right beyond the obvious? It occurred to me that my head and my heart were at odds. My head could map this out

certainly, but what of my heart. In Kwak'wala, when we wish to know what someone is thinking we can say "Wixsis noke'yekus?" which can translate as "What is in your mind?" or "What is in your heart?" I thought about this and realized that what needed to be very clear in both my mind and in my heart was that this work was to be for everyone. It wasn't just for me, or even just for my family ... it was for all of us, the Dzawada'enuxw, the Musgamakw, the Kwakwaka'wakw, for all First Nations whose lands and stories had been overridden and unjustly appropriated through colonialism. Remarkably, when I realized this very clearly and felt it in my heart, then everything came easily.

I met a man named, of all things, Rocky, who started to help figure out the technical details of the second attempt. In October of that year we brought a nine-foot-long, single-cable motorized platform, a generator to operate it, the revised tarpaulin templates, and hammer drills to secure them to the cliff. Once more we prepared everything in the old community hall and once more we made our way downriver in Clarence Moon's boat. Using what was left of the old village Sealander as a float, we prepared for the second attempt. Rocky and I climbed the outskirts of the cliff to get to the top and secure the single cable for the nine-foot platform. Looking outwards from the top of the cliff over the inlet I was both exhilarated and terrified. For some reason, I felt the strong presence of my grandfather Charlie Willie, whom I had never had a chance to know since he had died before I was born.

The next few days were a blur of early mornings, all day on the cliff, and exhausted nights. Along with my cousin Malong Dawson we would take the slow unstable ride up the cliff and secure the tarp by anchoring it down

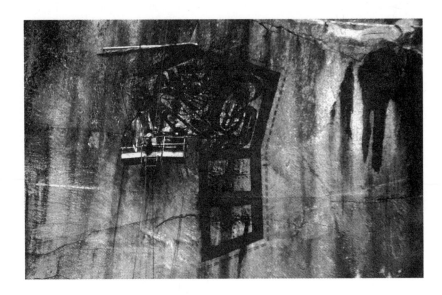

A slow, unstable ride: Marianne Nicolson (right) works on her mural from the nine-foot-wide platform rigged on the cliff face. PHOTO COURTESY OF JUDITH WILLIAMS

through wooden dowling we had attached to its edges. Once the tarp was secured, we would spray-paint over the tarp stencil, roll it up and paint the outlined areas in by hand. I lost my fear of the height after a while and began to enjoy being up there. The weather was a blessing and for the most part held up. For a few days we were forced to stop for rain but otherwise it was prime conditions. This was a blessing considering it was October. Slowly the painting began to cover the cliff. We completed one section at a time, so I held my breath not knowing what the final result would look like until the final tarp was finally lifted. While we were moving the nine-foot platform over for the second part of the painting, the cable got stuck on a

cedar withe. Rocky decided he could break the withe from below by anchoring the platform to the boat and running the motor full tilt. The cedar won and broke the safety bars on the platform. Without any other option we secured the safety bars with sticks and bungee cords and kept going. And then, somehow ... it was done.

Malong offered to drive us out to the middle of the inlet and for the first time I was able to see the painting in its entirety within the landscape. I thought it was beautiful, and what I felt was relief. Relief that somehow this painting had become a real thing and that it was indeed worthy of the history that had inspired it. My wish was that the work exist on its own and not be associated with one particular person. In a way, I wanted people to forget that I had done it so that they could feel ownership of it. I often, myself, think of the boat ride out of Kingcome after finishing that painting.

It was my Uncle Frank Willie who brought me down-river in his outboard to catch the big boat out with all our equipment. He would die a year later in a boating accident upriver along with my Uncle Ernie. I will always be grateful that they lived to see what they had been so instrumental in bringing to life. I remember their gracious patience in teaching an often-ignorant young person the ways of our ancestors and the commitment I felt towards keeping these teachings alive. I think of this generosity now, when younger people ask me questions. It has influenced all of my artworks, both traditional and contemporary. I think of the beauty of human expression and endeavour and of the drive to attain social justice. If I have achieved anything in life, the drive and inspiration have come from those around me. The results are shared accomplishments. If

there is to be true justice and reconciliation for the First Nations within this country called Canada, there is still a tremendous amount of work to be done and we will need help from all over. The power of art, of creativity, cannot be underestimated and this painting is a testament to what can be achieved in reclaiming our place within the lands we inhabit.

My Grandmother's Eyes

MAXINE NOEL
visual artist

M E? ARTSY?

I never knew anything different.

Drawing, design, imagining the life of the world into images, all are just how I think. Even as a young child at Birdtail—a Dakota, Sioux First Nation located on about 28 square kilometres in southern Manitoba—this was just how I saw my way in the world. It was a part of my being, not a choice.

Because of that, I didn't pay more attention to it than to getting up in the morning or washing my face. I didn't think I would someday be an artist, didn't think it a special thing. It was just part of who I was, so when I thought of my future I thought of everything else instead.

At one point I wanted to be a concert pianist. My grandmother enrolled me in piano classes at the residential boarding school, without asking. I enjoyed making music, though not the teaching methods used on young Native kids in that setting. But I have one uncooperative

crooked finger, so the idea of playing professionally never got beyond the maybe stage.

I think it was in high school when I first thought I should be a race-car driver. It was a good dream, but stayed a dream, though to this day I am one of the best freeway drivers I know, always in the fast lane.

While still living in the residential school, we attended the town high school and it was there I joined the secretarial course. It was what girls did at the time, and I found I was quite good at it. I worked for the town lawyer in Birtle, Manitoba, after school and on weekends. Though some who know me might find this surprising, I have a talent for details and organization, something that lawyers themselves seem never to have. And this talent, with the skills I learned in those high school classes, felt like a simple way for me to move from the reserve into the big city. It was a skill I could use to move into the adult world, I guess.

Winnipeg scared me. Toronto scared me even more.

So in 1964 I moved to Toronto.

Concert pianist. Race-car driver. Moving to the scariest city I could think of. I wonder today if this wasn't part of a lesson my grandmother quietly taught me about the importance of having the confidence to choose and face the biggest challenge, rather than the easiest one. I somehow knew, even then, that persistence is hard work, and that making choices will always be scary but that it is also where we strengthen our confidence.

In Toronto, first by sheer persistence itself, and then because I became very good at it, I worked for major Bay Street lawyers, including some of the best and hardest-working criminal lawyers at the time. The work was complex and compelling, especially because in

criminal law I knew that we were dealing with people's lives, and that this work was so important to my people and their challenges in a harsh society with little room for tolerance. Those I worked with encouraged me to consider taking up law myself, encouraged me to go to law school. They saw my passion, they understood that I cared about the values of justice and fairness, but after several years in that setting, I realized that the legal system was still a broken thing, in particular in the way it addresses my people's needs and values. Had I stayed in that setting, I knew it would end up making me bitter and angry, which is not what I knew we needed to make the changes my people, and all of the communities we live in, need.

After more than a decade in Toronto, I moved west, to Edmonton, where I worked with corporate lawyers, developing lifelong friendships that would shape my future, both as an artist and as a Native woman, in ways I never imagined at the time. It would take a couple more detours before that would become clearer.

While living in Edmonton, I watched downhill skiing on television and was fascinated. I had played baseball and hockey when I was younger, and played each quite well. I enjoyed being athletic, the challenge that this offered for my body and my determination. Watching the skiers, I was drawn to this sport as something that I could do to regain the connection to my body that sport provides. I took lessons and after lots of tumbles and stumbles, was awarded a gold pin for excellence by my instructor. I was pushing myself, looking for challenges, but also looking for something else, something still nebulous and unclear. What happened next was an important step towards that emerging clarity.

Because I was so persistent in my ski training, always pushing myself to do better and learn more and more challenging skills, I spent a lot of time flat on my ass waiting to be plucked from the slopes by the ski patrol. There was a selflessness in what these people did, given the risks. They would pick me up, ensure I was safe, and never complain. This attracted me, that these people had a dedication that had practical benefits, benefits they provided to complete strangers. And so, the following year, I decided to join the ski patrol. I took the required first-aid test, and then applied for my first "on the hill" test, which would help the patrol judge my abilities. I had only been skiing for three months at that time but I was good enough in those first tests to be "invited" to test on the most difficult area of patrolling, what in northern Alberta is called mountain patrolling. While testing for the patrol at all was, for me, a significant challenge, the idea of testing for the most demanding aspect of patrolling was too daunting, and I explained to my patrol leader that since I had only been skiing for a few months, I wasn't ready. Instead, I focused on working the lower reaches of the hills, and especially enjoyed climbing chairlift towers to evacuate skiers, learning in the process that I love heights and the challenge of conquering them.

At the end of that year, I thought that I would become a professional ski patroller and even take the ski instructor's test and become an instructor. This work, which combined physical challenges with a commitment to service, had many of the things I knew were still missing in my life. However, events closer to my heart steered me into a different part of my path.

In 1976 my father died. He was much too young, and had survived horrific degradations as a prisoner of war in Hong Kong, degradations that followed him until his death. My father was a fine, loving, scarred and angry man. I loved his kindness and his faults, his gentleness and his despair. I returned home to Birdtail for his funeral, and that time back home brought me back, as well, to the still unclear path my life was to take, a path that was to bring together creativity and the sacredness of my people and of community.

After some time at home, I returned to Ontario. While still working with criminal lawyers, this time in Cochrane in northern Ontario, I was asked to run the Ininew Native Friendship Centre. This was a challenge that came to me because I was an outsider. The board of the friendship centre wanted someone from outside the area to run the centre while they carried out their search for a permanent director. After they approached me, asking if I might consider taking on this temporary position, I discussed it with my boss in the law office. He said he knew that I needed to do something more tangible than serving the needs of his office and his law practice, something that would more directly connect me with my people in a practical way. He also warned me that this kind of position, even if only temporary, would be a "high-burnout" job, but said that he was confident I had much to offer the position and that I would find the challenge rewarding and important to my life as a Native woman.

Native friendship centres were meant to be a safe place where First Nations peoples could find support as they moved into, or just within, what were and still are

harsh urban settings. But even in this brief time there I could see that they quite quickly became crisis intervention centres instead, often without the tools needed to address the complexities of the crises that until then no one knew were as widespread and deadly as they were. Friendship centres continue to provide these interventions today, better equipped than at the beginning, though the crises have not abated.

I accepted the position, though what was to be a temporary appointment turned out to be a year and a half. Even though it was a longer run than I had expected, I enjoyed working with the Cree people in this northern community, coming to respect their resilience and commitment to their culture and to more clearly appreciate the hardships and heartaches they faced. My organizational skills and the strong relationships I developed with the people of the town where the centre operated allowed the centre to thrive. This kind of collaborative challenge, something that was part of what had been missing in my life, planted important seeds in my heart, and was an important step on the road I was on.

The path I had followed until this point had a direction, though at the time I did not see it. It wasn't in the direction of art, but rather what I now see was beginning to take shape in my head and in my heart was a sense that my people, indeed all people, needed healing, not just crisis intervention or more effective and better organized criminal case management.

I was in transition, though as is often true, I did not know it at the time. Part of that transition was spiritual, the result of my years at residential school as well as, more importantly, the teachings my grandmother had softly and

kindly instilled in me. A different part of that transition was creative, about expressing my values in ways I could share.

These two things began to come together when I was spending time at the friendship centre checking up on the Little Beavers program. I met, mostly by chance, the young Tomson Highway, who would over the years come to be one of my finest, and strangest, friends. He was in my office, admiring the paintings on the walls and asked whose they were. I was embarrassed to confess that they were mine.

From my earliest years, I had drawn from my imagination and from the world. Like breathing itself, perhaps, I would cover whatever spare paper I could find with images and visual stories. Heart to spirit to hand, this just came naturally to me. I wasn't an artist. That never once crossed my mind. (While I was fortunate to work for a number of years, beginning in 1977, with artist/teacher Clement Berini, whose belief in me gave me the foundations of my art and continue to influence my work and my learning today, it would only be many years later that his influence and teaching would become clear.) The drawings were just how I would see the world around me—a way of speaking to that world, and slowly over subsequent years, a way of speaking about it. Not that I knew that was what it was, or what I was doing.

So, while keeping lawyers' schedules on track, or struggling to help keep the friendship centre doors open, I had continued to paint. If asked then, I probably would have said I did it for my own pleasure, that it was a hobby. But I know now, these many decades later, that it was more than that. It was like I was having a conversation with myself about who I was, who I am, and where I fit in the

world. More than that, it was a conversation about what I could bring to the world, what tools I had to add to the stories of the worlds around me.

When Tomson admired those early paintings, I fell back on the earlier story, that these were just a hobby, something to fill the bare walls of my office. Transitions are almost always difficult to move through, and there was comfort in not allowing myself to take the persistence of art and creativity in my life too seriously. I was still asking questions, after all.

But Tomson was persistent. He told me I should move back to Toronto and take the time needed to develop my art. Not a suggestion, but a combination perhaps of an order and a warning. I think Tomson saw that the paintings I was doing then were much more than just a hobby to pass the time, and that I needed to pay closer attention to the story that was beginning to emerge out of those conversations on canvas between my spirit and the world around me.

I did move back to Toronto, but not into the world of art. Not yet.

In Toronto I met Plains Cree artist Don McLeay, who had lived with Northwest Coast Native artists and was an accomplished carver, as well as a painter with his own unique style. He was a good friend and mentor who passed away a few years ago, at the age of ninety.

On my return to Toronto, Don told me about a job with the Ontario Native Council on Justice, addressing the needs of First Nations inmates in and out of Ontario prisons and jails.

My role, after being specifically approved for the position by the Native Sons group at the Guelph Correctional Centre (formerly known as the Ontario

Reformatory—Guelph), was doing research and interviewing First Nations inmates and former inmates throughout Ontario. This was harsh work, a side of the criminal law I had not seen from behind my desk in lawyers' offices, even though I knew it was out there. My role was to interview First Nations inmates and ex-inmates, in detention centres and prisons, in district jails and at community resources centres, and even at a logging camp back out in the bush. First Nations peoples have long been over-represented in Canada's prison populations. The project I was working with was part of what is still an ongoing process of addressing the destructive relationship between First Nations communities and the criminal justice system.

Two things overwhelmed me doing this work. The first was the most unexpected: almost every person I interviewed was kind and gentle, even gallant. They were almost always respectful and generous. I had expected to be afraid, entering prisons and speaking one on one with people whose crimes might have been violent. Instead, these men and women were welcoming and open-hearted.

The other thing that nearly overwhelmed me was the depth of the brutality they had experienced, and the brutality of many of the things they had done. That so many still retained their dignity and even compassion in these circumstances awakened something in me, something that would later come to form a core part of my life as an artist.

It was also Don who was insistent in encouraging me to consider committing to being an artist. In 1979 he wanted to introduce me to David Shand of the now-defunct Thompson Gallery in Toronto, telling me to do three new paintings to show David. I was still working with the Ontario Native Council on Justice at the time, and Don let

me use his studio to complete the paintings. I did the work, with no real sense of what all of this might mean. I did not have the idea, then, that I was an artist in that specific way that I thought of artists. The painting and work I did were still like an interior monologue, still me talking to myself about who I was and how I could speak in the world.

Don took me to meet David Shand, and I showed him the paintings I had done. This was September of 1979. When David saw those paintings, his response was to offer me what would be the largest challenge I had faced as an adult.

How soon, he asked, could I put together enough work for a show?

I didn't know this, at least not in any detail at the time, but David Shand, as director of the Thompson Gallery, was an early and vigorous supporter of First Nations artists. He was also a ferocious and effective advocate and promoter for the artists he worked with, not only challenging the art world to take notice of new young talent, but also challenging these artists to explore and expand their own abilities and goals. In the time I would work with David, he pushed me to pursue work in as many different media as I could imagine, from silk screening and stone lithographs to many different types of painting, so that I continued to challenge my technical practice while refining the language of my work to deepen and broaden the stories it tells.

That was all a bit later, though. That first moment in the gallery with David and Don I remember clearly what my immediate reaction was, that I was filled with doubt and confusion. I'm sure I was polite, but I know I thought this guy was nuts, perhaps even both of them. Why, I know I asked myself, would anyone want to hear what my

Maxine Noel at the Thompson Gallery on the opening night of her first show. Left to right: Maxine Thomson, co-owner of the gallery; David Shand, gallery director; Clement Berini, an artist and teacher who worked with Noel early in her career; an unidentified gallery patron; and Noel. PHOTO COURTESY OF MAXINE NOEL

paintings had to say? Even I wasn't sure what that was, so what, I wondered, would I do if anyone asked me what my work was "about." I knew what art should do, telling stories and creating spaces for listening and learning. But I had no idea what the story was in my work. I wasn't ready for this, in any way.

David was tireless in those months, securing mentions of my work in magazines in Canada and the United States, as well as both television and radio interviews. He even organized an interview in *The Globe and Mail*, which I learned later was unheard of for a young and unknown

artist. With David's dedicated efforts and Don's studio to prepare my work, that first show opened in March 1980. My grandmother's reminder, to choose the most demanding challenge, with determination and commitment, was still quietly guiding my life and my decisions. That quiet lesson, to grow into my challenges fully, was shaping new choices.

But I also remember standing in the gallery on the night of the opening and thinking, "My god, what have I done now?"

The show itself was a moderate success, many people coming to see this unknown young woman's work. Many of my pieces sold, which only added to my confusion. A different confusion, however, would have the most lasting effect on me and on the decision I would now make to commit to art as the work I needed to do.

One of the pieces in that first show was almost sold twice. One of the gallery staff had sold a piece, but this had not been clearly noted in the show. Another staff member was discussing the purchase of the piece with a different collector when the error was noted. The woman who could not buy the piece was sitting in the middle of the gallery crying. I was terrified.

It was a turning point. The world of my painting, which had been a private world for so many years, was now a public one. Where before I had been softly talking with myself, now I was speaking out loud, and to others. I was moving into a new world of storytelling, and with that, into a new world of responsibility. When you see a person crying in front of one of your paintings, you can see that the messages of your work are powerful in their effect on the world. You realize you have a responsibility to tell those stories, to convey those messages clearly and well,

with care and with both passion and compassion. Art at its deepest and most honest, which are things I strive for in my work, is for me about the struggle to communicate emotion to emotion, a struggle that demands of me as an artist a commitment to ideals and values that are more than just the beauty of line and form and colour. For me, it is about affection, the thing we need most and struggle hardest to share. The younger me, face stained with wild blueberry, or secretly sipping tea with my grandmother, knew this even if she could never have put it into words. We grow out of and away from our childish wisdom and perhaps that is inevitable. But that wisdom never leaves us because it is the clearest kind of knowing, the clearest connection with our ancestors and with the world today, a connection that forms the foundation on which we make the world we need, and preserve the world we inherited.

From that night in March 1980, and still today, painting is how I speak, like the poet with a pen and paper, the actor or the dancer with the stage and the lights. It is how I hold onto, cherish and pass along the knowledge of my people, and of my own experiences and understandings of the world and how to live in it. I speak with line and colour, and my work, in galleries or people's homes, becomes part of their story by sharing messages of mine—messages of joy and of the sometimes painful processes of healing.

It would take me many years, and much work, to learn the lessons of healing that my grandmother taught me in her reserve kitchen when I was a child. Not only personal healing, but the healing of communities through the telling of our stories. My work as an artist, as the core of my life, is about learning that lesson, but not only through the inward work of being creative. In the years since that

woman cried at my first show, I have looked for challenges that combine healing and community.

In 1985 my dear, dear Mohawk friend John Kim Bell created the Canadian Native Arts Foundation, later renamed the National Aboriginal Achievement Foundation, and he asked me to join the board as one of its founding members. Beginning with a focus on the arts in our communities, over time the foundation expanded the scope of its support to acknowledge the achievements and the struggles of our many First Nations communities in a widening range of fields of accomplishment. We honoured Elders for their lifetime of achievement and encouraged and supported First Nations youth as they set out on their own challenging roads to learning their stories and developing the skills to tell new ones.

During those years with the foundation, I had continued to look for new challenges in my work as an artist, and especially, challenges that brought together creativity and community in ways that are both practically and spiritually healing. One I am especially proud of is my involvement with a twinning project between Canadian cities and institutions and towns, cities and institutions throughout Africa, which the Canadian Institute of Forestry initiated as a non-denominational project in 1988. Native artists in Canada designed posters and other items to promote and share information on the African locations and their peoples to raise awareness of ecological, economic and educational needs. I worked on the twinning between Thunder Bay, Ontario, and the Bunkpurugu–Yuyoo district in northern Ghana, a project that would result in the formation of the Naakuukni Forum, an organization with Ghanaian and non-Ghanaian members

on every continent who continue to work for the people of the district. This project supported both local resilience and global collaboration, creating communities that could span continents and encouraging and sustaining the development of new local skills to help meet local needs and challenges.

Because of my commitment to encouraging First Nations and other youth—the new generations of artists and scholars and doctors and engineers and lawyers—I stepped down from my work with the foundation after almost twenty years. "It's time," I told John Kim, "for our new young leaders to lead." But there was another reason: the still-resonating voice of my grandmother, whose brutal death first broke my heart and then repaired it with the legacy of her tenderness and quiet wisdom.

My grandmother.

Her face and her spirit are the face and spirit of my art and my purpose. As my practice has developed, the central image in my work has been the face of a single woman, even in works where many women appear. That woman is my grandmother. Her face, her spirit, and the gentle lessons of her patient voice are the core of my art, and of my life. I had reached a point in the continuing development of my own storytelling role where I needed to return to that work and to renew my commitment to the art I still needed to make. An artist must make art, in the same way a dancer must dance, if their craft is going to continue to grow and their obligations to their work continue to mature.

This does not mean I retreated from the world into my art, into a personal and solitary practice. Though today I live much more quietly in a small Ontario town, my vision of the role of a Native artist in the world has not changed.

All Native artists tell stories, paint messages—have you ever noticed that? Their art is always more than a beautifully executed object to hang on a wall. It is always doubly beautiful and so doubly powerful.

We are messengers, I believe, the portal between many worlds. Michael Robinson asked me years ago if I thought it possible to translate these different worlds into a single piece of art, in a painting or an etching or drawing. I told him then, and still know this today, that yes it can be done because that is what our art is, a way of being fully in all of our worlds. Michael took up this challenge in many of his works, which contain explicit and beautifully imagined portals—portals between the worlds of spirits and human, between humans and their animal kin, or portals between times—while I have imagined this bridge between worlds with my grandmother's eyes.

People imagine these portals, these bridges that allow worlds to connect and communicate, often as a hope or wish, though they seem to rarely speak of them. We, as Native artists, allow others to see those portals and bridges in the world, to speak of them and about them. We don't open these portals, and we certainly don't create them. But we do tell the world that they are there, and that we can see them and pass through them, if we dare.

My life is quieter now, but my voice and my stories continue the work I have committed to—daring to accept the challenges and the responsibilities I see at the core of my art. And yet, I still hesitate when people ask me what I do. I say I am an artist, though even now that word catches in my throat. This isn't lack of confidence or false humility. I am proud of the work I do, but I am not filled up with pride.

Remember the beginning of my story. Drawing the world, from as early as I can remember as a child, was and still is like waking up, like washing my face. When people ask what I do, saying *artist* sometimes feels like I am saying "I'm a face washer." I suppose I could say that I breathe colour into the world to tell stories about who I am, about where we are, about where we have come from and where we are going, that art is the way I breathe.

Yes, art has allowed me to find myself, to find my nature and my spirit. But saying that sounds like art is just some kind of personal therapy. While it can be that, and has been for me as I am sure it has for most artists I know, whatever their field of work, it goes further than that, in ways I am still learning about and exploring. At its simplest, my art is the way I offer healing to the worlds around me, worlds sitting so precariously on the cusp of even more destruction and even more brutality. These worlds are dangerous and beautiful places, sacred to us all, and so their health and their healing are responsibilities we all must take up, each of us finding the work we need to do, and then doing it well and fully. It is both the least we can do and the most important duty we have to each other, to those who came before, and to those still to come. It is not the easiest challenge, just the most necessary.

Me artsy? No, not really.

I am just breathing the healing air my grandmother shared with me. In my painting, I am sharing that air and that healing with the world I am in, and with the world I want to share with tomorrow's children.

Inspiration

· ·

KIM PICARD
fashion designer

*H*OW DID I GET MY INSPIRATION AS A NATIVE FASHION
designer? I have never asked myself that question
until now, so I will try to look back to my childhood to
remember how it all began.

I don't think I chose to be a designer—it just came
naturally. I started sewing from a very young age. My
grandmother was a good seamstress, and I spent a lot
of time watching her sew with her imposing old Singer
sewing machine. She was making garments, crafts, quilts,
moccasins ... I was only four years old and I still remem-
ber. She often looked after me because my mother worked
quite a bit. I was fascinated watching her, and it was she
who taught me to sew by hand.

When I was about nine years old, I asked my mother
for permission to use her old sewing machine, a gift from
my father that had been lying in her wardrobe for several
years. She had never used it. I was disappointed when she
refused, saying she was afraid I'd hurt myself with the nee-
dle. But while she was out, I used the machine in secret and

made denim overalls and a cap for my teddy bear. When she saw my work, she was surprised and asked me where I had found the clothes. I told her that I'd made them. Needless to say, since that day I have never stopped sewing.

I also did a lot of drawings and participated in art contests, which I often won, and I would draw clothes on paper that I stuck on paper dolls that I had drawn and cut. My mother loved fashion: she loved to dress herself and me according to the latest trends, following fashion closely as she did. She recorded the Grammy Awards, Oscars and other galas that were shown on TV. Since cable service did not exist in our area at the time, we watched the recorded tapes repeatedly to admire the performances of the artists and their clothing. I remember seeing Tina Turner in a sparkly red dress that was amazing! I can say my favourite celebrities back in the '80s included Madonna, Cindi Lauper, Kylie Minogue and Culture Club. I loved to watch their outfits and that really inspired me to become a designer. Still, at the same time, my mother would buy me dresses in second-hand stores to play with. My friends and I amused ourselves by modifying some of them and holding pretend fashion shows at home.

In high school I earned pocket money and experience through my sewing—by repairing clothes and making curtains, for instance. In Grade 10, when I had to decide about my future, I was still not convinced about a career in the field of fashion: I was scared. So I decided to enrol in the closest college to my community, that of Baie-Comeau, and study fine arts. As part of this curriculum, I took a course in theatre. A friend and I were then required to make costumes for a play. I particularly remember a velvet dress I created for Juliet, as in *Romeo and Juliet*. I loved the

experience! I also had the chance to participate in the creation of costumes for the grand opening show of the 1994 Pessamit Inter-Band Games and the creation of the mascot with experienced professionals, including Paul-Émile Dominique and his wife, Madeleine, an amazing artist and a talented seamstress. They were my first professional mentors. This is where I really caught the bug, and I decided to move to Montreal in the fall of 1994. The rest is history. I think all these elements together naturally led me into the field of fashion.

I first studied fashion design for three years (1994–97) at LaSalle College in Montreal. I made my first foray into the fashion industry in the summer of 1996, when I worked for the aboriginal designer D'Arcy Moses at the Natural Furs company in the heart of the city of Montreal. I loved my experience! When I finished my studies in fashion, I decided to dedicate a year to learning about marketing at McGill University. While studying there, I also worked for the designer Hélène de Granpré, who specialized in creating haute couture wedding dresses and evening gowns. Then I worked for Native Innovation Design, a Mohawk company. It was my first experience in creating Native ready-to-wear.

After that, I worked in many areas and places in the fashion industry, but soon felt the need to take a five-year break from the fashion world, primarily to work with several different Native organizations, specifically with youth. I always found it important to encourage young people to pursue their dreams. This made me realize that I'd put my own childhood dream to the side. That is when I decided to start my own business. It was 2010.

So what inspires me now in my work?

Fashion designer Kim Picard was one of the seven aboriginal designers chosen to represent Canada at the "Aboriginal Fashion Showcase" during the Vancouver Olympic games. PHOTO COURTESY OF KIM PICARD

Most and foremost, my culture is what inspires me! I feel that I honour my ancestors when I make aboriginal designs, especially when I create Innu (Montagnais) designs. I grew up in the Innu way; I still speak my language and I am proud of it. I defined myself as Innu—this is who I am, even though I have Mohawk and Algonquin ancestry from my father (which I'm also proud of).

I'm also very inspired by my dreams. I am someone who dreams a lot, and sometimes I develop designs based on the animals and symbols I've seen in my dreams. I always try to study the symbols and their meanings, which are important to me. I also have studied traditional Innu clothes in books, museums and on the internet. Of all Innu garments—including gloves, hats, pants and moccasins—it is the caribou-hide coats that are particularly detailed. They have the most meticulous and ingenious work. Some 150 Innu traditional caribou-hide coats still exist in the world today. They are beautiful and very expensive, and thus are becoming true collectibles. In the past, hunters passed on their ideas (mostly from their dreams) to the women, which inspired the creation of their coats. This was believed to bring luck and success in the hunt. Ochre, ink, fish eggs and other substances were used for colour. The patterns themselves were well thought out and carefully crafted. By studying the patterns, colours and techniques used to make these clothes, I gained knowledge that would one day help me to realize one of my dreams: to revive the clothes of my ancestors by giving them a contemporary form.

However, not to be limited, I create diverse clothing and work with all kinds of materials, not only aboriginal

designs. I like to play with materials such as plastic, jute, aluminum and more, and work on unique and original creations. Fabrics also inspire me: sometimes, when I see a beautiful fabric, I can see a dress instantly. Conversely, sometimes I design a garment before seeing the fabric. Inspiration can come from many places, including from people, especially in big urban centres. I like to watch people walking on the streets: their style, their personality and the colours they wear are constantly generating ideas in my mind.

Also, I'm inspired by other designers and their work. I particularly like the designers Roberto Cavalli, Dolce & Gabbana, Valentino, Narciso Rodriguez, Isabel Marant, Elie Saab, Denis Gagnon, Prabal Gurung and Zuhair Murad. My favourite designers, Gianni Versace and Alexander McQueen, now both deceased, also inspired me a lot. I used to spend a lot of money on fashion magazines, but these days just go to the internet to check on the fashion news directly and see the designers' latest collections and new trends.

Some people inspire me in a more personal way. My late Kukum (grandmother) is an important source of inspiration for me. As I said, I could watch her sew for hours when I was little. I remember at the age of four I played with the lid of her sewing machine on her bed and I pretended it was a boat. She is the first one to teach me how to put thread on a needle and sew. These are my best memories! Finally, there was my late friend Véronique Cyr, a wonderful young Innu fashion designer. She was very talented and we shared projects, dreams and a similar vision. Unfortunately, death has taken her too soon, but

her spirit remains with us. She is forever in my heart and sometimes when I create I think of her and the passion she had for fashion.

On my preferences for certain materials, accessories, details, colours and techniques: first, I don't do a lot of beading—it is not my specialty. I do appliqués and embroideries on the sewing machine. As well, I prefer to work with the machine rather than by hand. I create all kinds of designs, especially the double-curved lines inspired by traditional Innu motifs. According to some people, they represent the leaf of Labrador tea. I also create a lot of designs representing animals and floral embroidery. Regarding the colours, I do not have a specific preference. I love all colours: colours are life! However, we all (painters and artists in particular) have predilections, depending, I think, on the time of our lives and the things we experience at the present. For instance, right now I'm in love with midnight blue. Last year it was emerald green and the year before it was turquoise. It also depends on the upcoming trends. For example, every season there are predominant colours, so fabrics are sold in these colours. Sometimes I follow the trend but still keep my style.

In general I believe my style of clothing is welcome everywhere. On the non-aboriginal side there is some ignorance about the meaning of the symbols that I use on my clothes. Aboriginal people generally know these meanings (the properties of animals, their spiritual meanings, etc.) but not always. There is still some teaching to do at this level because we lost much of our traditional knowledge as a result of colonization. For example, some symbols can represent clans or communities. Once non-Natives learn the meaning of the symbols on my clothes, they understand

the approach and the fact that the designs contain a strong and significant message.

Moreover, other inspirations have come to me by participating in healing ceremonies. Once I attended a ceremony after I had not slept for more than forty-eight hours because I absolutely had to finish a garment for a client the next day and as a result of the stress, had endured a sleepless night. I went to the countryside for the healing ceremony, which took place in a tepee, not knowing that this ceremony would last thirteen hours and that we would have to sit, stay awake and pray in front of the sacred fire.

At times I would almost fall asleep and then fell into a trance. I was semi-conscious, I had visions. I saw, among other things, an eagle flying high—he was beautiful and when he approached, he gradually transformed, became dotted and white to be deposited on a paper pattern, just like the ones I draw when I make my appliqués. I clearly remembered the image and then used it in one of my clothing designs. It was pretty special and I saw it as a message from my ancestors: they gave me inspiration and strength to continue to create—create to heal and give strength to those seeing my clothing and especially to those wearing my clothing.

Another time, I attended a sacred ceremony with the Inga people of the Amazon. It was both a great experience and a challenging one because it was extremely awakening: it raised consciousness in my being and made me realize many things in my past and actual life. It wasn't easy but it has allowed me since to understand many things about my life and to make changes necessary for my well-being. This ceremony inspired me a lot and changed my life to a certain point. Ideas and visions came to me during and after.

I didn't sketch all the ideas that came from this, but they remain anchored in my memory.

I think our subconscious and the invisible world (in other words, the angels who protect us) can and do communicate with us when we take part in ceremonies, but also when we ask and pray in our everyday life. It doesn't work every time because we need to live a healthy lifestyle, meditate and purify our soul to be more open to these messages. We must open our hearts and thus awaken our creative power. With time, I realize that when I experience a lot of stress and I feel worried, it is more difficult for me to raise my soul and put myself in a creative mode.

What helps me a lot are the meditation and yoga I've been practising for the past six years. I have had breaks in my practice because I don't always have the time due to my work and responsibilities. However, I take the time when I feel that my body and soul need to connect strongly. Also, contact with nature restores and purifies us and is essential to our creativity, and to the purification of our soul and spirit. That is how the inspiration comes back again and then I feel an indescribable well-being.

With all the challenges that have come along in the field of fashion, sometimes I have felt like quitting and doing something else. I have tried other jobs since starting my career, because being an artist is not always easy due to the perceptions of our society and the context in which we live today. This business has become a reflection of a superficial universe—very technical, commercial, and overconsumption has taken up a lot of space. In general, people prefer to buy cheaper and as a result, their clothes don't last as long. And how about fashion and trends? They change very quickly!

In the days of our ancestors, each piece was unique and carefully created on the spur of the moment, in an artistic way, even spiritual. It could take several weeks or even months to create a unique piece that would be worn with honour and pride. For example, the Innu people had to hunt caribou and there was a whole ritual. Our ancestors thanked the spirit of the animal and used every part of the body, whether for food, tools or clothing. There was no waste. The transformation process of the caribou skin could take up to two months. The caribou hide had to be pulled, tanned and then smoked. Thereafter, the garment had to be created and sewn by hand. That could take a few more weeks. The finished garment took on a sacred importance and was worn with pride and honour.

My objective is always to join the two worlds—the modern world and that of my ancestors—which is not always an easy task. That's why I decided to continue in my profession: I came to believe that with time, I could join both worlds and find a balance.

I will now tell you about four of my most notable inspirations.

ZANIEST INSPIRATION

IN MY THIRD year of fashion-design studies in college, I decided to participate in the Nygård International design contest, which was being held in Winnipeg with the theme "Recycling." For many days I could not find either the material or an idea for my dress design. I didn't want to take what was easiest or the first things we think of when we think of recycling, like plastic or other common materials.

The unique coffee bean–themed dress that Kim Picard designed for the Nygård International design contest won fourth place. PHOTO BY JENNIFER FONTAINE

One day, while I was having coffee with a friend at a café near our college, I suddenly took note of the transparent wall. There were two vertical rows of transparent glass and in between were coffee beans of different colours, beautifully laid out in wavy lines. On the floor was a large jute bag, with plenty of coffee beans inside. That's when I had the idea for my dress! I was going to create a dress made of jute, with appliqués of clear plastic with coffee beans inserted into it. This funny idea became one of my most successful and beautiful pieces. It came in fourth in the competition.

DEEPEST INSPIRATION

I HAD A special order from a young chief of a remote community who was experiencing struggles. This man had recently won election and came from a long line of former chiefs in his family, including his great-grandfather. He wanted to place an order and he knew that I specialized in appliqués/embroideries. He challenged me to design a portrait of his great-grandfather and then to embroider it on a Native traditional shirt commonly called a ribbon shirt. Challenge accepted! I was a little nervous because I was afraid of failing. Embroidery with a sewing machine is not like drawing—it's much more complex.

As I drew the portrait on the appliqué paper, I watched his picture on my computer screen to inspire me. I really felt like the portrait was talking and communicating with me. It was a great connection and a special experience. I finished the design of the portrait and it looked good, but something told me to start all over again. I listened to the little voice inside me and started all over on blank paper. Then I cut the

appliqué and embroidered the design on the garment with my sewing machine. Once completed, it became a portrait that spoke much and was meaningful. If you looked at it properly and with the eyes of the heart, you could even see animals, symbols and the map of a part of the territory. It was incredible! Is this a coincidence? No one knows.

MOST MAGICAL INSPIRATION

I'LL TELL YOU a little about my latest inspiration and vision as a designer and also as a human being. To start, I'll give you a little context. In recent years I've faced a lot of obstacles in my life, including the illness of my son and myself. We passed close to death but in the end came out winners and since have made many positive changes in our lives, especially in the three years before I sat down to write this essay. On the night of January 1, 2013, exactly, I had the best dream of my life—a dream of hope, universal love, peace ... I didn't talk about it to anyone for six months. I always asked myself why I dreamed what I dreamed, and I believed life would answer me one day and that I would come to understand it. I mentioned my dream to no one at first because it was such an intimate, outstanding and majestic dream. I do not even have words to describe it properly because I do not want to trivialize it, but in short, I will do my best to share it.

I dreamed about a house in the countryside. I was hearing noises outside, people talking and in awe. Everyone was out of their houses because something strange was happening. Curious, I went out to investigate and there were planets in front of us, which we could touch. It was

as if galaxies had come down to Earth and all the planets and stars had become accessible. Then something big was moving towards me and the more it approached, the more I was able to distinguish it. It was a big blue bird. When I saw him up close I was speechless: he was huge, imposing in all his glory! He spread his wings and flew up gracefully and slowly, as if he were in the water. I could hear the graceful flapping of his wings. He then took me and somehow trained me to fly. So there I was, flying alongside him. He was so sweet, with lots of love. He looked at me from the corner of his eye, with a look so soft and full of trust, love and compassion ... like an angel.

I had never dreamed of anything so majestic, mystical, magical! It was so real I could almost touch him. The way he looked at me gave me confidence—as if nothing was impossible. (I'd never had much confidence.) When I woke up I had tears in my eyes. I had just lived a beautiful, mystical experience that I will never forget.

I put this dream in the bottom of a drawer, thinking that it must surely mean something and that I would retrieve it when the right time came, and see its true meaning. I didn't even know what this bird was until one day while doing research I found out that I had dreamed about the big blue phoenix and according to legend, the phoenix is a bird that rose from its ashes: it symbolizes immortality and life after death (dying to live again). I believe that to dream about him is like a cycle is completed and there is transformation and spiritual rebirth, not just in my own life but in the whole world. I had found one of the great meanings from the dream, something special that could help me with what I do: it became the theme for my next collection of clothes. So I came up with these key

words as inspiration for my collection: *freedom, grace, mystical, magical, fantasy, midnight blue, fairy tale, universality, multiculturalism, phoenix, light, mystery, elegance, purity, smoothness, romantic, angelic, resurrection, transformation, innovation, peace, universal love.* For the fabrics, textures and accessories, some words came to mind: *polished, shiny, fluid, iridescent, veiled, metallic, brilliant, blue feathers.* The colours I had chosen were midnight blue, yellow, ivory, red, lime green, shades of grey and black.

When I worked on that collection for a fashion show, it was a huge success. In an article in the fashion blog magazine *Sur Mesure Magazine*, a journalist came up with the story about the phoenix and the meaning of it. I was amazed and thought: okay, I was able to transmit my inspiration!

MOST SPIRITUAL INSPIRATION

THERE IS A creation dear to my heart that I would love to achieve one day. In the past I thought I didn't have the strength to complete this project because it was too profound and dear to me, but now I know that someday I will be able to. Although I had not yet realized it by the time this book was going to press, I'm going to tell you about it—it's a dress project—because I think it's one of my most amazing inspirations.

This project is more personal than what I am used to, and the idea came to me one evening. I had a vision. I will try to keep this short and tell you how it started. From 2005 to 2010 I worked for Quebec Native Women Inc. (QNW), which defends the interests of aboriginal women from Quebec

and aboriginal women who live in urban areas, and as you probably can imagine, being involved in organizations such as QNW or the national Native Women's Association of Canada (NWAC, of which QNW is a member), you see and experience many harsh things because you have direct contact with the people, especially women facing injustice in general. Back in 2008, I heard a lot about the program Sisters in Spirit (SIS), which worked on the issue of the 500 aboriginal women missing and/or murdered back then (listed as 1,200 women by 2014) and which is an initiative of NWAC. I saw a few presentations about this cause and every time I felt useless, frustrated and sad. In September 2008, I was at a non-violence training workshop on Prince Edward Island that included a moving presentation of SIS by ex-NWAC president Beverly Jacobs. I hadn't known that she had lost a family member herself—that her cousin is one of the missing and/or murdered women. So I was very touched by that. Then, at the end, she mentioned the two teenage girls missing from Kitigan Zibi. I became very emotional because one of them is my cousin, Shannon Alexander, who had only been reported missing two weeks beforehand. Back then, Beverly said there were 509 women missing or murdered in Canada. That was the official number, but she said there are probably more women than the authorities knew about. She was right! Considering our small aboriginal population, that number is alarming and disturbing. For most of the unsolved cases, like my cousin Shannon and her friend Maisy Odjick, someone knows something somewhere. That is why the idea of creating a dress about this subject came to me—because I thought it would bring a little bit more awareness to the general public and the media so they could be more sensitized to the cause.

How exactly did that project appear to me?

Still in PEI, I was walking down the street towards the Atlantic Ocean and while I was walking I was thinking about all those missing women and about different ways to bring more awareness to the general population (because the subject never made the front pages in the media) and then I saw two beautiful feathers on the ground and I grabbed them. That is one thing I like to do when I visit new places. (In recent years, people have tended to give me feathers to insert into my creations.) I was thinking about Shannon and Maisy and associated them with the two feathers. I walked on, arrived near a huge field and there were several feathers on the ground. I thought about all the lost women on the fields. My heart broke and then I had a vision of a dress with 509 feathers, each feather representing one of the women.

How was I going to do this?

I was going to ask the people of Canada to send me one feather for each woman missing, and with the 509 feathers I would be receiving I would make a beautiful dress that would become a travelling exhibit for museums in various strategic places across the country. I would place the dress on a mannequin in a glass cube along with pictures of the missing women and a description of the SIS program. At the end of the tour, I would put the dress up for auction. All the money raised would go to a cause associated with missing and murdered women.

Why a feather?

Because birds are the ones who fly highest from the earth and closest to the Creator. Some of the birds are also messengers, like the crow. I am also convinced that some of the spirits of the women who have been murdered

violently have been imprisoned somewhere because of the women's sudden and violent disappearance. To me it's symbolical to say that they will fly, that they will find their freedom, with the feather as the symbol. These feathers will give them wings to reach the Creator because the project will make more people aware of what has happened. I will make that dress using all the 1,200 feathers honouring and representing each woman.

Each feather will have a history, a story or a testimonial to share from the person, or family, or group of people who gave the feather. I would like to take a photograph of each feather and share stories in a beautiful book with a photo of the dress at the end. So this is a little synopsis of my project, but there are so many more ideas that came with it. A last note: when she was missing, Shannon was wearing a silver necklace with a feather on it. I like to believe in signs ... they make a difference.

TO FINISH, ONCE in an interview for *Les Cahiers du CIÉRA* (a publication of the Université Laval) I was asked what personal or professional achievements I was particularly proud of and why. I think it is important to talk about these, as they are also inspirations and reminders for what we work hard for and the goals we want to achieve in life.

On a personal level, what I'm proudest of is my teenage son, of course. I tried to raise him as best I could, to transmit our culture and teach him to be respectful of others. I hope one day he will look up to his mother in order to achieve his own dreams. It will then be a great accomplishment for me. I will always be there to help support and encourage him to reach his goals.

On a professional level, it's not the prizes I've won or the big fashion shows I've participated in that matter the most. I think to be able to touch people with my clothes is my biggest accomplishment. Some experience strong emotions when they see or wear my creations. For example, a client who had cancer and is now cured has told me that the cape I made for her gave her the courage and the will to live when she wore it during her treatment, especially because of the symbols on it. There was a turquoise tribal turtle designed on the cape. The turtle signifies good health, long life, perseverance and protection in Native culture and the colour turquoise is the colour of healing. I also like to help people have a better opinion of themselves. For example, I have organized and participated in many fashion shows in aboriginal communities. The youth involved experienced an enhancement of self-esteem and pride in their aboriginal identity, and at the same time they made their parents proud of them. To me, the greatest achievement is to be able to create garments that have that power.

During the interview for *Les Cahiers du CIÉRA*, I was also asked what aboriginal success means to me. In my opinion, success is to follow our dreams while remaining close to our roots. To me, it is not synonymous with prestige or money that can be won, but the recognition of your people. I would not have attempted to launch an international career without first managing to get into the aboriginal community, without receiving some form of approval. It is important to me that Elders feel that I am advancing on the right path, that my work meets and respects our culture. This is in my opinion the best form of recognition.

My Blues Journey

MURRAY PORTER
bluesman

BEING AN ARTIST ... HMMM ... WHAT DOES IT MEAN ... an aboriginal artist ... hmmm ... well, it means everything to me. Born and raised on the Six Nations of the Grand River Territory (a.k.a. da bush), I was lucky to have role models to guide me on my journey. From poet E. Pauline Johnson (the original aboriginal rock star) to actor Harry Smith (a.k.a. Jay Silverheels, or Tonto in *The Lone Ranger*), with a side dish of musician Robbie Robertson, actor Graham Greene, and actor/musician Gary Farmer ... it seemed to me I had no choice in the matter. I had to be something!

I had a love of music as long as I can remember. From George Jones and Merle Haggard to Nat King Cole and Ray Charles, I can hear the grooves that came from those grooves (in 33⅓-rpm records) even now. My mother, Glenda, had tons of LPs and allowed me to hear what was happening outside of our rez. I took a few guitar lessons, learned some basic chords, and quickly realized that guitar was not going to be my forte. Then one day my parents

bought a piano so my sister could take lessons. Vicky would learn the songs while I listened close by, and when she finished I would sit down and play the songs that she struggled so mightily to learn. She became discouraged by this, and I became encouraged! I would take my guitar and play the chords, then find the notes on the piano. I began to see a pattern in these notes and started to play the same chords on the keys. So ... naturally I joined a band. Since I couldn't read music, the guitar players would say "Play it like this," so basically I was taught piano by a bunch of guitar players. I wouldn't change a thing if I could. I developed my own style of playing and thanks to those guys (Sid Hill, Donnie Powless, Faron Johns, Oren Doxtator ... etc., etc.), I learned how to play in a band.

There was a band on the Big Six (Six Nations) called Sam Martin and the Country Braves. They made a record, which my mom still has, and it freaked me out. I thought, "Indians can make records?" Then I saw Redbone on *The Midnight Special.* I thought, "Indians can play rock 'n' roll?" Then I really started to listen and found out about Buffy Sainte-Marie, Jesse Ed Davis, Floyd Red Crow Westerman, and so many others. Then I thought, "I can do this too!"

One night, after I'd been sent to bed, with my transistor radio (the aboriginal iPod) tuned in to a program from Chicago, I heard B.B. King sing "The Thrill is Gone," and I thought, "Now, that's what I'm talking about!" And my bluez journey began. I bought all the blues records I could find—B.B. King, Muddy Waters, John Lee Hooker... My rez is situated forty-five minutes from Toronto, ninety minutes from Buffalo, NY, and 2½ hours from Detroit, MI. With Motown being so near, soul music had a huge influence on me as well. My parents were big country music fans, so my

earliest recollections of music were the Hanks (Snow and Williams), The Possum and Merle.

Those lonesome notes still ring in my ears.

Six Nations has long been a hotbed of talent, especially the blues. Robbie Robertson, Derek Miller, Pappy Johns Band, The Healers (formerly known as the Breeze), as well as Gary Farmer, Graham Greene, Santee Smith and so many visual artists and writers.

The journey of the blues to Six Nations is a sketchy one. Many believe, as I do, that the early formation of the blues started when slaves were brought to America from Africa and escaped from their oppressors into the woods and swamps of the South. Not knowing the flora and fauna of their new surroundings, many ended up in Native camps where the locals taught them to survive and there was plenty of cross-cultural exchange. Since slave owners had taken away their drums, they were taught to make drums. They shared songs with each other and I believe that is when the birth of the blues began. Many of the early blues stars had Native blood, including Big Joe Williams, Charley Patton, Little Walter and Muddy Waters.

The next part of the journey involved the Underground Railroad, which was actually a series of Indian trails that took the runaway slaves into Canada to freedom. The Tuscarora Nation of the Carolinas were instrumental in helping hundreds of slaves cross the Niagara River near Niagara Falls. The Tuscaroras were then adopted into Haudenosaunee Confederacy in 1722, becoming the sixth nation. I believe this is how the blues found its way to Six Nations and to me. I realize that this was many years before W.C. Handy wrote what some believe was the first blues song, "St. Louis Blues." But the "call and response"

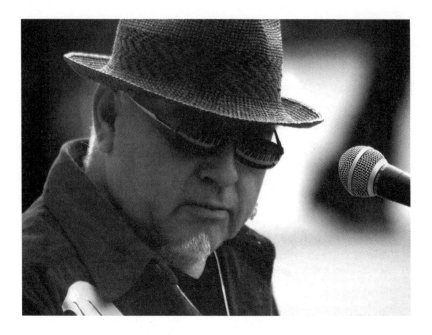

With his instantly recognizable brand of blues piano, Murray Porter shares the stories of aboriginal Canadians with audiences around the world. His music also touches on universal blues themes of love lost and found. PHOTO BY ELAINE BOMBERRY

style of singing that slaves used while working the fields is uncannily similar to the Stomp Dance songs still sung by our people today. Also the steady *thump, thump, thump* of our traditional drum is very similar to the shuffle beat used in a great many blues songs.

As a teenager, like so many others, I was drawn to rock 'n' roll. Zeppelin, the Stones, The Band and so many others. After listening to these great recordings I noticed a lot of the songs in early rock were actually old blues songs. Willie Dixon was a prolific songwriter whose songs were recorded by blues and rock artists alike. He had a

knack for putting the right words in the right place, and I thought, "If I can do that, people might like my songs." So I put a lot of effort into my lyrics and some songs were very personal. I started to write more politically charged songs that were about my aboriginal experience and that of our people—"500 Years," "Heart of the Eagle" and "Colours" were early examples. I also grew up, like most of our people, with humour, laughter and joy in our house, no matter how hard the times may have been. It's one of the greatest qualities of our First Nations and it seemed only natural for me to use humour in my songs.

In 1992 I played one of the first big gigs in Washington, DC, for the Smithsonian Institution's Festival of American Folklife. It was the five-hundred-year anniversary of Columbus's so-called discovery of the New World. I wrote a song called "1492, Who Found Who" that explained our side of the story. He was lost, and yet he discovered us? That started me using humour in my more political songs as sort of a way to get my point across without standing on a soapbox. A spoonful of sugar helps the medicine go down! I wrote another song about the "Indian" Status Card that First Nations need to prove that we're Native; it's called "White Man's Card" and basically it asks, "Prove to me who you are." I was a bit worried at first about adverse reactions to my tunes, but my fears were unfounded because people of all colours could understand what I was trying to say. I just wanted them to see our point of view.

In 1993 I signed with First Nations Music/EMI and recorded my first album, titled *1492—Who Found Who*. The next year, the Aboriginal Juno Award was introduced and my record company decided to put me in the blues/gospel category and submitted, but I was not nominated. I often

wonder: If they had submitted to the aboriginal category, would I have won? No time to dwell ... I started to play some big shows across Canada, the USA and Europe, sharing my Native culture, blues style, with the world.

One of my best memories of that time was a month-long tour of Australia, where I used some aborigine musicians and really bonded with them as a fellow Indigenous person. We weren't that much different in our beliefs. The legends and stories were different, but the message was the same. Mother Earth and all her creatures need to be respected and revered. We don't own the land—we are the caretakers of this place for the future generations.

During this time, I also did some tours for our Canadian troops—here in Canada and around the world as they worked as peacekeepers for the United Nations—with a show tour based out of Montreal. We had comedians, musicians and dancing girls! It was a great experience for a little Mohawk from the rez. One particular tour took us from Montreal to Goose Bay, Labrador (on the East Coast), to Alert (the most Northern manned outpost in the world) to Haida Gwaii (as far west as you can go in Canada) to Port au Prince, Haiti ... in three weeks! I sure learned a lot about staging, coordination and packing—imagine packing for a trip to all those places at once.

On a subsequent trip we had stops in Germany, Israel and Egypt. I got to climb the pyramids, ride a camel, visit Bethlehem, place a prayer in the Wailing Wall, barter in the market in Cairo and float on the Dead Sea. During the first thirty years of my life, I had been on one plane. Since then, I've been on small-prop planes, seaplanes, helicopters, boats, ferries, cruise ships and jumbo jets. None of this would have happened had I not chosen a life of art. At first

I just wanted to play music so I could get off the rez and play for more people. After seeing the reactions of the audiences I played for, I was determined to be one of the best in Indian Country, Canada and the world.

In the meantime I was raising four sons and music just wasn't paying the bills, so I had to get a real job (carpenter) to make that happen. My career was sort of put on the back burner for a few years while I worked during the day, went to hockey games and tournaments, and played music on the weekends. Sometimes I had to get up at 6 AM, work all day, come home, eat supper, sleep for two hours, go do the gig, get home at 2:30 AM, then get up at 6:00 and do it all over again! Repeat, repeat, repeat ... This is what an artist will sacrifice for the sake of their art. I know many others who have done the same.

In 2002 I had written a bunch of songs and wanted to record them. So I joined a band with some former bandmates from my formative years called the Pappy Johns Band. These guys had just broken up with their guitar players and the timing was perfect. These were the guys who taught me the chords and structure of the blues and how to play together with passion and soul. My cousin Faron Johns, one of the best singers I have ever heard; Oren Doxtator on drums; Donnie Powless on bass; and Joseph Mahfoud on guitar. We were only the second Canadian band ever to be invited to play at the Chicago Blues Festival, and the first Native band.

Things didn't work out with Joe, so we looked for a new guitar player. We hired another former bandmate of mine, Josh Miller, also from Six Nations. Josh was from the bands 3 Wheel Drive and The Soul Kings, who were usually my backup band from earlier in my career. It was the

perfect fit. We recorded an album in 2003 called *Full Circle* (so named because of our coming back together after our separate musical journeys). We were invited to play at such venues as the prestigious Montreal International Jazz Festival, the First Peoples Festival (the grand opening of Smithsonian's Museum of the American Indian in Washington, DC), Blues sur Seine (outside Paris, France) and many others. We were nominated for a Juno Award in 2005 in Winnipeg, but fell short. We had a great run and I still play with those guys when I get back to Ontario. We are all brothers of the blues.

In 2006 my youngest son, Murray Jr., turned twenty-one and I needed a change. I had played practically every club and festival in Ontario, and gigs were drying up. I thought about where to go ... Chicago, New Orleans, New York? I realized that I still had a big Canadian fan base and no health coverage in the USA! So then I thought ... Montreal, Winnipeg, Calgary? Finally Vancouver came to mind. My partner and manager, Elaine Bomberry, and I had lots of friends there and we decided this was the place to be. So after a few weeks doing the couch tour in New York City, we came to British Columbia. The couch tour continued in Vancouver for a few weeks until we found a place of our own. We left Ontario with two suitcases, a laptop and a guitar. I didn't really know anyone in the blues music scene and they didn't know me.

My first stop was hitting the blues jams in town. I went to the legendary Yale blues bar for their Saturday-afternoon jams and after about three weeks the house band said, "How'd you like to do a gig with us next week?" To this day, I still play gigs with Robbie Montgomery and his legendary Vancouver band Incognito, who have been gigging for more

than thirty years. These first connections led me once again to become a full-time musician, which had always been my goal. To be able to do the thing you love the most, and get paid to do it, is everyone's dream. I put together a band and began doing gigs all over B.C., once again tapping into my extensive First Nations fan base.

What I didn't realize was my music was being kept alive in B.C. by a community radio station called CFNR-FM in Terrace, which had a network of more than fifty stations all across north and central B.C. Everywhere I went, I would play and people knew the lyrics! I was totally welcomed by the blues and Native communities. I couldn't have been happier. I had moved to the Capilano rez (Squamish Nation) in North Vancouver, which has a high-rise apartment building located on reserve land.

Once people found out I was here, the gigs started to come. One of the most amazing shows I got to play took place just a short while after I arrived in Vancouver. I got a phone call from the Tulalip reservation in Washington state—they have a casino and put on outdoor concerts in the summer. They asked if I would like to open as a solo act for ... Etta James *and* B.B. King! They said, "We can't pay you much money, so..." I said yes before the person on the other end of the line could finish talking! To play a show with the legendary man who had inspired me to play the blues so many years ago was a dream come true. It was his eighty-second birthday that day and the last show of the tour. We had birthday cake on his bus and he was one the nicest gentlemen I have ever met. The topper was meeting Etta James. We had separate trailers on the grounds and after I did my show and Etta did hers, B.B. was playing. I happened to walk by and saw her sitting in the trailer. I

thought that if I didn't try to say hello I would be kicking myself in the butt for years to come. So I walked to the door, knocked, and Etta said, "Who is it?" I said, "My name's Murray Porter. I'm a Mohawk and opened the show tonight." She said, "You're Native? Get over here!" She held out her hand and I thought she was gonna shake my hand. Instead, she pulled me down on her lap and gave me a big red lipstick kiss on the cheek and said, "Us brown people gotta stick together!" I left that lipstick on my face for the rest of the night until it wore off on the pillow. I will never forget that night as long as I live.

Soon I had enough songs for an album, but no record company. It's not easy in these days of illegal downloading and tough economic conditions to score a recording contract, especially when you are an over-fifty Native blues artist. My guitar player, Rick Boulter, is also a recording engineer. He and his partner—my bass player Helene Duguay—were living on the rez too. I could see their house from my balcony. We started to record in a spare bedroom in their house. The result was my latest album to date, *Songs Lived and Life Played.* Helping me, along with Helene and Rick, I had Chris "The Wrist" Nordquist on drums, with guests Dave "Hurricane" Hoerl (harmonica), Chris Allen (harmonica) and Renae Morriseau (background vocals).

We submitted to the 2012 Juno Awards and were nominated. Not bad for a little Mohawk from the rez! The awards that year were held in Ottawa, and Elaine and I attended. This was my second trip to the Junos and I sort of knew what to expect. It didn't make it any easier waiting to see who was going to win. I was up against a hard-rock band, a country singer, a house music duo and a traditional singer. How do you judge that? Anyway, the

night came, the nominees were announced, *and the winner is ... Murray Porter*! So many years of couches, back seats, hotels, motels, bad food, terrible nightclubs, airports, bus terminals ... you get the idea. All those things were forgotten in that moment.

My culture, my music, my family, my friends and my fans got me this far, I've played the Smithsonian (Washington and New York), the Kennedy Center, the Lincoln Center, the Native Nations Inaugural Ball (President Obama) and so many others. My particular blues journey is far from over. I plan to keep playing as long as my fingers and voice will let me. My goal is to be known as one of the best blues players in this country and to win a Juno Award in the blues category. As this book goes to press, I have been a full-time musician (no day job) for over eight years and am loving it. I'm sure glad I found that B.B. King song on my little radio, because it has taken me places I would never have gone and introduced me to people I would have never met. When B.B. King turned eighty-nine in 2014 and was still playing, I realized I still had thirty-five years left.

Someone recently asked me why the blues have become so popular among our people. The blues is about storytelling. Many of our nations didn't have a written language. Our stories were told orally and passed down from one generation to the next. Blues musicians, to this day, play songs that were written generations ago. Stories that still ring true today. Tales of love lost, love found and love denied don't change all that much over the years. Though traditionally the blues is seen as an African American form of expression, our two cultures have many similarities. Racism, oppression, slavery (a little-known fact: our people were enslaved as well) and poverty. As the late, great

comedic icon Charlie Hill once said, "Native people are the only people in the whole world who listen to blues music, and it makes them happy!"

Non-blues fans have the misconception that the blues is about agony and suffering, and that it's a sad form of music. On the contrary, the blues is about forgetting your troubles and sorrows, even if it's for just one glorious Saturday night. I remember hanging around outside the Ohswéken Community Hall trying to catch a glimpse, through the open side door, of the band that was playing at the time. The Indian Brotherhood (with an all-Native horn section!), John Martin and the Trailmen and so many others. I was blessed to have musical role models in my life at such a young age—not everyone did.

Having been a bluesman for more than thirty-five years, I have seen many changes in the music scene. At first we weren't taken seriously, because "Indians play folk, country and heya, heya music." When we became close friends with Canada's premier blues band, the Downchild Blues Band, people began to see that we had something to offer in this wonderful genre. Elaine Bomberry began a series of concerts in Toronto showcasing Native blues. She called it Rez Bluez. With help from the Toronto Blues Society's Derek Andrews, these shows were a huge success.

On the strength of this, an idea formed to make Rez Bluez into a television variety series of blues and comedy. The Aboriginal Peoples Television Network bought in to the idea and we produced two seasons of thirteen one-hour episodes. We had to choose which bands to use because there were so many! We selected the best of Native blues musicians and comedians from all over Turtle

Island (North America). The show went on to win a 2008 Aboriginal Peoples Choice Music Award (APCMA) for the best television program promoting aboriginal music.

In 2009 both Elaine Bomberry and Pura Fé Crescioni worked with Guy "The American" Fay though her record label, DixieFrog from France, to produce *Indian Reservation Blues and More*, a three-CD compilation box set with enhanced video on each disc, plus a beautiful booklet with liner notes. This kind of product had never been put together for Native blues music before. The fact that the largest blues record label in Europe was interested in our blues, and included more than thirty Native musicians from all over Turtle Island was phenomenal. It is on sale only in Europe.

The APCMA's, Native American Music Awards, Indian Summer Music Awards and the former Canadian Aboriginal Music Awards all have best blues album categories. The Maple Blues Awards acknowledged Elaine Bomberry's contribution behind the scenes with the 2003 Blues Booster Award. She was the first woman and the first aboriginal person to win this award. Over the years, I have also been nominated for a Maple Blues Award. Within Canada's Juno Awards, several of the recipients have been blues musicians, including Digging Roots; Derek Miller, with two Junos; George Leach, the 2014 winner; and myself in 2012.

Today there many, many excellent artists working hard on their careers. Indigenous (featuring Mato Nanji), who opened up more than seventy-five dates for B.B. King, is just one example of the talent we possess. There is not enough space on the page for me to list all the great musicians working today. That tells you a little bit about the state of the blues in Indian Country.

I just hope that in some small way I have blazed a trail for others to follow. I do this for love, not for money. As the great Donnie (Downchild) Walsh once told me, "You wanna know how to make a million dollars playing the blues, son? You start out with two million and work your way down."

The journey continues!

For Sisters

KARYN RECOLLET
cultural theorist

The movement—
Shawl sways in orbs and light
Breakthroughs—ruptures ... breath
She moves with her sisters because she loves them
pulsations of life-blood transposed into syncopated beats
looping old stories on the new, new on the old ... traversing
urban and back again to join the electric powwow
we dance—the past is in our future—star walkers
celebrating our connections
traces she leaves—
glyphed Indigitized space
she is continuity—
her love for hip hop shapes her feet as wings
(Recollet, 2014)

RESEARCHING FOR MY DOCTORAL DISSERTATION between the years 2007 and 2010, I had the pleasure of interviewing Indigenous hip-hop artists from across Indigenous North America, also known as Turtle Island. These conversations prompted me to consider the relationships that exist between Indigenous knowledge systems, Indigenous media and feminisms on the one hand and popular cultural critique on the other. I witnessed the generative and transformational space of hip-hop culture and

how it could contribute to new ways of naming and reshaping our world(s). Indigenous North American/Turtle Island artists Ostweleve (a.k.a. Ron Dean Harris), Eekwol, Kinnie Starr, Numinous (a.k.a. Carrielynn Xwementelot Victor), Theresa Apt Exact Warbus, Quese IMC and Daybi-No Doubt have each spread Indigenous knowledge to create ways of moving us forward beyond present realities and spatial realms towards a future Indigenous condition, or *futurity* in Indigenous literary circles. This writing is indebted to these artists as they mobilize this transformational vision to create social change. Through a combination of digital sound creation, carefully crafted lyricism, rich visual material and other forms of expression, Indigenous artists such as the aforementioned individuals and the electronic music group A Tribe Called Red are complementing our contemporary urban lives with a rich archive that is documenting our journeys into the future.

Indigenous artists are in effect coming up with a futurity as they critique the ways in which Indigenous people have been shaped within the popular imagination. I am interested in how Indigenous artists use cultural raw materials to produce a new Indigeneity that reflects the lives of Indigenous peoples in the now. A Tribe Called Red (ATCR), for example, uses stereotypical illustrations of the cowboy's Indian as its cultural raw materials, highlighting them using digital techniques that can then be manipulated to produce alternative storylines. They do this through layering, mimicry, repetition and remixing, as they create the visual/aural montages that they use to create the transformational space of the electric powwow.

Hip-hop cultural forms of expression provide a way for Indigenous artists to challenge static representations

of Indigeneity. In the process, artists using these forms of expression produce storytelling projects involving complex urban Indigenous identities. This creates "embodied sovereignty" within urban Indigenous spaces through acts such as the electric powwow. I came to understand the concept of embodied sovereignty through conversations with hip-hop artists such as Ostweleve, Quese IMC, Numinous Theresa Apt Exact Warbus: the language "the colonial weight is heavy" was often used to describe colonialism. Embodied sovereignty can be a way of acknowledging that we feel the impact of colonialism within our bodies. We work with—and through—that rupture as part of our process of claiming Indigenous territories in urban spaces.

Indigenous cultural producers are using the tools of hip-hop culture to create different ways of moving on urban landscape, as reflected in the creation of sound and visual production. There are many examples of these practices, in which migrations and movements across urban spaces are echoed in aural/visual montages, murals and powwow cultural expressions. What follows is a closer look at a couple of instances where artists have created alternative readings of Indigeneity that will have an impact on our future condition through Indigenous hip-hop movement.

ATCR uses repetition and mimicry through sampling to reverse a history of Indigenous absence, to continuously create healthy representations of Indigeneity and to anticipate and claim space in a hopeful future. The group's sampling practices intervene in static misrepresentations of the cowboy's Indian, to put the freedom of Indigenous motion in the foreground. Indigenous motion is aroused within *Sisters feat. Northern Voices*—the video version of the song "Sisters" (from the album *Nation II Nation*) that

was produced by Landon Ramirez and The Field. The first frames of this video illuminate an important jumping-off point of transcendence as three sisters embark on a journey towards the electric powwow. I would suggest that the space that this journey produces is a space of radical decolonial love, with radical decolonial love acting as an expression in relationship to the rupturous spaces of our inner and outer consciousness.

THE JUMPING-OFF POINT

A TRIBE CALLED Red's video for the song "Sisters" features actors Sarain Carson-Fox, Kawennáhere Devery Jacobs and Aria Evans dancing the urban concrete pathway to the initial syncopated loop of Northern Voices female powwow singers singing in their Atikamekw language. Kawennáhere wears Louie Gong Gatherer "Manitobah Mukluks," which shoot neon graphics at the point of contact with the pavement. The effect ignites the movement as if to elevate the dancer and illuminate a transition to another world.

A point of contact with the urban topography underneath, this jumping-off gesture reproduces a fancy shawl dance step in contemporary powwow culture. Mimicking the butterfly motion, fancy shawl dancers fuse intricate footwork and sweeping arm movements to transform colourful, patterned fancy shawls into wings. The dancers find balance in repetition and moving in various directions. The dance known as the crow hop changes the space, as bodies are propelled into motion, reproducing migratory patterns of contemporary Indigenous peoples in urban spaces. Indigenous artists such as B-girl Lunacee (a.k.a. Angela Gladue,

Cree) fuse hip-hop b-girling with fancy shawl dance forms to migrate into different realms. These moments of interweaving Indigenous hip-hop culture with powwow culture via the electric powwow (or other manifestations of contemporary Indigenous movement) provide a glimpse of what it is like to see anti-colonial bodies in motion in urban spaces. This point of departure offers us a visual/aurally inspired moment of reflection on how we activate the remix in our own lives, and so fuse and fashion various experiences to create our urban identities, which are as beautiful and fluid as the Manitoba mukluks themselves. This jumping-off point produces a moment that allows us to reflect upon the ways that we use capitalism and commodities to express our own complex Indigeneities. This fusion is played out through forms of dance in the *Sisters* video. Throughout the video, forms of urbanized street dance and powwow steps are used in a performance of Indigeneity as a way to be on the urban land space as Indigenous people.

ATCR's video and repertoire in general illuminate that hip-hop and powwow culture are fused in the contemporary expressions of the movement. Often those Indigenous artists engaging in hip-hop culture are grass dancers or hand drummers, and engage in Indigenous practices that are then brought into the visual and aural expressive forms. Producing the central directions for Indigenous hip-hop culture, Indigeneity is about adaptation, design and migration brought to life in the form of Indigenous motion. The three sisters in the video spatially map our journeys through our past, present, future and a fourth element that puts our past in our future. The practice of migrating into different realms, or " jumping scale," is rooted in Indigenous creation stories that are alluded to in this video. Haudenosaunee traditional

knowledge speaks of the sacred relationship between Corn, Beans and Squash (in the video, the three sisters) that allows Corn to provide a natural pole to elevate Beans to another scale. In the same way, the spiritual being Sky Woman falls to the Earth and the Earthdiver in Neheyawin knowledge systems dives to draw up a new consciousness. It is as though a reading of ATCR allows a new futurity in which we revision the point of contact to affirm a complex Indigeneity in the now, and choose this over reading contact as a point of conquest of our historical memories.

Indigenous hip hop creates a space that can be seen as geographies of resistance, within which Indigenous artists express complex histories, identities and experiences. ATCR onstage and on video creates a kind of digital petroglyph that challenges colonial representations of Indigenous reality. The ATCR remix of video/audio compilations amplifies the stereotypical representations of Indigenous identities, and in the process critiques them. In an article about Dustin Craig's 2008 film *4wheelwarpony,* Joanna Hearne described Indigenous media as "media that works to de-colonize on-screen representational systems, catalyze cultural revitalization, activate political consciousness, and revise powerful historical narratives" ("This Is Our Playground," p. 49 of *Western American Literature,* vol. 49, issue 1, 2014).

In producing visual/sonicscapes of possibilities, ATCR manipulates and loops visual phrases and symbols stemming from popular culture, which imagine the frontier of digital neon to emphasize the layers of stereotypical representations of the cowboy's Indian and so point out the problematic relationship between the Western gaze and romanticized Indigenous identities. NDNs *from all directions* illuminates angular, linear dances featuring what

appear to be settler colonial feminine bodies, in Hollywood-esque Indian bikini buckskin. These Hollywood-ized images reproduce racist portrayals that have played a part in racialized gender violence.

As society continues to reproduce the colonial frontier (which validates the exploitation of Indigenous territories and bodies), the popular imagination has created narratives based on an oversimplified version of Indigeneity. Given this landscape, ATCR points out the ruptures that exist in Indigenous stereotypes. In doing so, they also reveal that repetition has been used to normalize stereotypes.

ATCR uses digitized neon graphics to challenge the state-sanctioned disappeances of Indigenous peoples. In the *Sisters*, the digitized flash accompanying the moment of departure as the mukluk steps from the concrete generates a moment of transcendence where Indigenous women do not have to follow the norms of a patriarchal environment that diminishes women's right to motion. Throughout the video the rich, vibrant colours in the form of lightning flashes and suspended orbs are visual reminders of a continuity of ancestral Indigenous motion that affirms the motion as rooted in the now. In the form of Indigenous peoples' participation in hip-hop cultural aesthetics, the now is created through the neon graphics. Neon is the new petroglyphing ink being used to archive the movement of Indigeneity. We can observe its use through the creative work of Indigenous visual artists and muralists Corey Bulpitt, Bunky Echo-Hawk, Fiya Bruxa and Apache Skateboarders Douglas Miles and Thomas Breeze Marcus, and Fiya Bruxa; and the fancy shawl regalia created by artists such as Deanne Hupfield (Anishinaabe). Through the use of the neon glyphs, contemporary Indigenous artists are mapping out moments of

transcendence—leaving us, as participants and witnesses to the movement, to decide what this might mean for us.

THE JOURNEY

WHAT COMPELS ME in the *Sisters* video is how migration and Indigenous motion is embodied within the looped Atikamekw phrases, the resonance of the ATCR beats and the danced migrations of the three sisters. In this revisionist storytelling project, the video ignites a shift wherein spaces considered unsafe—as in the forested areas beside highways, and small-town gas bars—are seemingly transformed into sites wherein Indigenous girls and women can feel free to dance and move, as opposed to just spatial geographies where women and girls' bodies are recovered, or seen last by passersby before going "missing." In one scene, the stereotypical Indian car is repurposed as an intergalactic vehicle, putting the "now" of Indigenous femininity in relationship to the cosmos as a space of remembrance, ancestry and futurity. This Indigenous feminist Indian car fades out colonial narratives that sanction violence. In this moment, we are in the driver's seat, and hence in control of the direction of the car. As the Indigenous women's arms stretch, the music loops, fades and rises. We actually see the Pioneer CDJ 1000 MK2 turntables and Serato remixing software, illustrating a counter-history that affirms our active continual presence on this land. I appreciate my deejay brother Kelly Ermine for providing me with this vocabulary.

In the video, ATCR's remixing strategies accompanied by the dance creates a spatial graphic, offering a way of thinking about gender justice for Indigenous peoples.

The migratory process of getting to the electric powwow, for instance the gas-bar detour (in which the women place flashy retro plastic glasses over their eyes while dancing in the aisles), reshape detour spaces into community spaces. Often Indigenous women experience such sites as potential zones of racism and gender and sexual violence.

The *Sisters* video challenges Indigenous disappearance as the three women take turns dancing against the backdrop of a light board illuminating lightning spewing from an Indigenous "plains-style" warrior riding bareback on a horse. This all-too-familiar image represents a colonial caricature that erases contemporary Indigenous presence. This trope is challenged through the process of foregrounding Indigenous women who embody a "new" Indigenous femininity using popular house fused with fancy shawl powwow-dub step dance. These movements contribute to an urban Indigenous dance aesthetic that reshapes Indigenous women's relationship to movement through taking ownership and breaking free of colonial representations of Indigeneity.

The three sisters' movements resemble a toned-down version of a hip-hop-inspired popping and locking dance in which certain muscles hold tension, followed through by a muscle release. This dance vocabulary illuminates moments of feeling the heaviness of the colonial weight (in the words of artists such as Ostwelve) within the body, and the necessary release. These movements also illuminate fluidity within the rupture—and represent a moment of working through the rupture. Perhaps this dance vocabulary echoes our present relationship with Indigeneity—a working with and through the rupture to attain a relationship to urban life as a form of Indigenous embodied sovereignty. Perhaps

we are the connective tissues between rupturous encounters, experiences and memories. And perhaps our doing Indigeneity in the now ... is just life. Travel and migration are just part of that experience as we make our way to downtown Toronto via the GO train and the subway, for instance. In this sense, the space between the suburbs and the electric powwow is being shaped aurally through a slowing down and distillation. New Indigeneities are being articulated in the process of travelling between spaces. The digitally produced fade-out in *Sisters* represents the pulling back of colonial narratives, which have had the cumulative effect of over-determining Indigenous histories and gender identities. The reformulation or remixing of new Indigenous identities involves a recognition of our own body sovereignty as Indigenous women claim a rightful presence in motion on Indigenous lands. What is beautiful about this is that the beats per minute remain the same—therefore the connection of land to body holds. This is the space of Indigenous feminism, which is concerned with the relationship between body and territoriality: gender justice is not just connected to environmental justice, but *is* environmental justice.

At this time, it seems appropriate to say that our history is in the future, given the dominance of colonial narratives and the way that the Western gaze produces an imagined past where Indigenous motion is both unrecognized and contained. This constructed "past" compels us towards the remix as a form of pulling together images and experiences from our visual and sonic archive to create a future. Indigenous artists create alternative geographical and imaginative spaces through which to embed a collective consciousness onto urban environments—requiring us to reconsider and think about how we inhabit urban spaces

as Indigenous territories. Urban artists such as A Tribe Called Red are creating geographies of resistance through reconfiguring urban space. In another example, Maria Hupfield in her video installation *Survival and Other Acts of Defiance* (2012) uses film to project images of herself in the act of jumping while wearing powwow-style jingle boots that she created. This video is projected on a wall in front of an X mark to invite visitors to participate in her movement. Enacting a strong rootedness to concrete, urbanity and place, Hupfield's practice maps urban space, exploring "the ways in which our relationships to the natural world, urban spaces and one another are shaped through the systems of measurement we use to divide, chart, and build the world in which we live," in the words of authors K. Ritter and T. Willard, in *Beat Nation* (2012, p. 44). Hupfield jumps scale through exploring the body's ability to transcend colonial scales (as in the X mark). Jumping scale in the context of gender justice is a response to the ways that colonialism has divided and destroyed Indigenous territories through the creation of railway ties or pipelines that, among other things, affect Indigenous spatial geographies; it also ensures that our ancestors in Star World have Indigenous landscape maps with which to orient themselves to us. As a practice of propelling the body upwards to Star World, the jumping-off point practised by fancy shawl dancers, the three sisters and Maria Hupfield becomes an exercise of Indigenous embodied sovereignty, and a way forward to connect with our past. As exemplified in Hupfield's percussive jingle boots and the *Sisters* neon flash on Manitabah Mukluks, Indigenous artists are using cultural raw materials to illustrate how Indigenous women engage in the practice of literally jumping scale towards a futurity that is all about possibilities.

Rooted in an Indigenous territorial land base, Indigenous women can also jump scale to occupy a space between land and cosmos wherein the past is *in* our future. According to Nehiyaw (Cree) and Anishinaabe (Ojibway) origin stories, Indigenous women share a long-lasting legacy of jumping scale, rooted within the trajectories of Sky Woman falling to the Earth. Through remixing, sampling and designing, fierce artists such as ATCR, Maria Hupfield, and Angela Gladue are producing acts that can generate an Indigenous future. These visionaries illustrate that jumping scale has shaped the now of Indigenous social movements. Their radical love transcends gender and racialized oppression to create new, complex, loving and beautiful Indigeneities.

THE ELECTRIC POWWOW

A TRIBE CALLED Red offers a vision of the future and creates the space for complex bodies in motion as they enact post-Indian—NDN—existence in the urban now. The electric powwow creates a transnational space where dancers are encouraged to critique how racialized identities are produced and normalized. In fact, we are being called to this "performance" to mimic the hyped-up masculinities (as in cowboy-and-Indian-chief culture) in order to intervene and challenge these representations through embodying our own complex Indigeneities made real "in the now"—on the dance floor. Furthermore, the electric powwow can be interpreted as an Indigenous hub space as Indigenous peoples congregate in an "underground" remixing of Indigeneity, affirming tribal and embodied sovereignties on the dance floor.

The electric powwow is calling us to participate in a sonic/visual critiquing of "authentic" Indians of the popular screen. For example, in *EYES* (2009), Bear Witness dubs a series of cinematic performances of Indigenous women through hypersexual settler bodies posing as tropes of Indigenous femininity. The erasure and fragmentation of Indigenous bodies is concerning us in a time when many of our Sisters are experiencing racialized gender violence. What defines the movement in terms of communicating a complex Indigeneity that intervenes in this erasure is the jumping-off point created through the remixing and looping, which inspires us to work with and through the rupturous encounters—but also to envision and embody new possibilities in loving relationship with Indigenous women's freedom to move.

THE SPACE OF RADICAL DECOLONIAL LOVE

SO WHAT DO I mean when I say radical decolonial love? Radical decolonial love requires a shift in conceiving of love from a holding space of permanence. If love were truly decolonial, it would be a love that took into account all our relationships—the varied manifestations of love coming from a place of acceptance towards all of our differences. Radical decolonial love is one that critiques the conditions of coloniality in the very action of lovemaking—it would embrace an understanding of lovemaking (including and beyond acts of sex) as a strategy in all of our relationships—as through living Audre Lorde's sense of an erotic life. (Lorde's *Sister Outsider* 1984/2007 should be on everyone's reading list.)

Radical decolonial love can be perceived as an ethical way of life, whereby we acknowledge each other's differences and gifts and let those manifest into creating new world(s) of possibilities. Radical decolonial love requires a shift in focus away from heteronormative, settler colonial practices of ownership and control over Indigenous lands and bodies, into a space that produces the vocabulary and language to speak of its impact on our relationships with other sentient beings. Radical decolonial love is theory in practice. In the making, radical decolonial love is self-reflexive and poses opportunities for us to reflect upon how we (as Indigenous peoples) are impacted by the influences of settler colonialism. A Tribe Called Red, alongside other provocative Indigenous artists, illuminates these points of departure through the practice of digital petroglyphing and the production of the beats we move to. These practices create a spatial map for how to navigate Indigeneity that is urban and in the now. This in turn creates the counter-narratives challenging tropes of Indigenous disappearance and erasure. Artists challenge the actions of colonial mapping that have proven to be destructive strategies tied to environmental and gender injustices towards Indigenous territories and bodies.

Tahltan artist Peter Morin posited the question "Where do you carry your sacredness when you have been exiled?" Such statements propel radical decolonial love into the future so that it becomes a space in which Indigenous peoples actively commune with territory through a practice of embodied sovereignty that carries the potential to bring us closer to the stars—closer to home. I look forward to the dance!

A Dancing Path

SANTEE SMITH
choreographer, dancer & producer

*Kónhnhe ... I am alive. Kèn:tho í:ke's ... I am here.
There is a presence greater than me and I am a part of it.
The seed centre of creativity that rests in my pelvis at the
axis of my being is timeless.*

SONKWAIATISON NIA:WEN, THANK YOU FOR THIS body, thank you for this breath of life, thank you for this gift, thank you for this journey. Ancestors, guardians, guide and protect me as I travel through this dream. Nia:wen for all I have been given and I ask, ta kha hon nien ... make my path.

But I acknowledge that I am more than this body, this mind, these fleeting images and matrix of emotions. Mere human perceptions are so imperfect. And so, I invite myself to dance in the place between worlds, move amid the real and unknown, the seen and unseen.

Always a ritual: a dance, my soul performance initiates with prayer, affirmation and acknowledgment. Beauty, love, empathy, power, light, bliss ... come into my life! Let me be lifted, transported, transformed, a conscious vibration in the living spiritual universe.

At this time ... let me experience a good mind, heart, body and spirit. Let me be the form in which creative force flourishes and activates. Through my transformation, let

me open the threshold for others to channel their personal revolution. When I move, let it move others; when I breathe through my spine, let others breathe through their spine. Let my awakening spark others' awakening. Through my healing, may others heal.

And so I start before the process begins ... spiralling inward and expanding outward, sometimes with the help of sage, sweetgrass or tobacco or sometimes not. I ask that mundane reality fall away, so I can become vulnerable, naked, revealed, receptive, fragile, fierce, sublime, a radiant beast. Let me be earth, water, wind, fire, plants, animals, cosmos and a warrior woman. Let the universe in my womb radiate. I ask that the energy of this land inhabit me, cover me, support me, sustain me as I stomp, pulse, spin, jump, fall into earth. Fully embodied and sentient, feet digging into the earth and arms embracing the sky, in this moment, I am alive.

Something within and without moves through me. I can't fully grasp the boundaries and terrain as I shift, manoeuvring through the dream landscape. Fleeting moments in blindness and in sight, pushing space, longing for the entranced medicine dance, to be overtaken by spirit. It may be a story to voice or a symbol to embody that is the topic of my search or the sound energy of the music that guides, revealing portals for exploration.

Let me reach a place where I can be released of ego self and experience my essential spirit self. Let me move within these brief moments of loss of ego and connect to the greater presence where the alchemy transpires. This is where the dreams unfold, where movement communicates in a language more effective than words. I am a soul dancer, a sky dancer ... a dreamer dancing forth dreams.

Transport me to a place beyond thoughts because these limited thoughts are not where I will come to know. It's only in the dance of unseen energy where my spirit can be free in darkness and in light. There is no right or wrong in the dance of becoming, breathing into a pure state of presence: being.

Sonkwaiatison, may I be profoundly empathetic to shifts in vibrational energy in order to connect to the mystery of creation: to commune with that which we cannot fully know ... the Great Mystery.

Kónhnhe ... I am alive. Kèn:tho í:ke's ... I am here. Ta kha hon nien ... make my path.

TEKARONHIÁHKHWA SANTEE SMITH iónkia'ts, konkwehón:we, Kenien'kehá:ka. Wakeniáhton tánon Ohawé:ken nitewaké:nòn. Ka'nisténhsera í:ken tánon tekeninniáhkhwa. Tekhenonhwerá:tons Tsi nahò:ten ká:ien ne ohwentsia'kéhshin tánon karonhia'kéhson.

My name is Tekaronhiáhkhwa Santee Smith and I'm an Onkwehon:we woman of the Mohawk Nation, Turtle clan from Six Nations of the Grand River. I am a mother and artist and thankful for all of creation and the strength of my ancestors. A lifelong learner, curious explorer, passionate artist, sensitive, playful spirit, introvert, I'm a lover of our ancient teachings and knowledge. As often experienced by artists, work and life are inseparable: my life is my work and my work is my life, both perpetually in a state of transformation. As an artist I hold performance in a sacred space, as all life is sacred. Throughout my creative process I maintain a fundamental Onkwehon:we understanding of performance, body and the role of an artist.

Music and dance are celebrations of life; the body is a vessel to house our spirit during this earthly existence and the artist's role is storyteller, mythmaker and interpreter of symbol and medicine people. From this perspective my work speaks about identity and humanity in relationship to the universe.

My origins extend from a long ancestral line of artists and innovators, individuals who generated their livelihood from their creativity: family who survived as artists and craftspeople. My paternal grandmother, Elda M. Smith, is recognized for reviving the lost art of pottery making on Six Nations. My maternal great-grandmother, Mary Sky, was a Kenien'kehá:ka Clan mother, midwife, traditional cornhusk craftsperson, and her daughter—my todah (grandmother) Rita Vyse—continued on with the cornhusk, leather and beadwork. These powerful life-sustainers and female ancestors inspire me to continue to express my feminine spirit to uphold the Onkwehon:we matri-focal, matrilineal way of life. The majority of my inspiration and perseverance as an artist emanates from my DNA, my family lineage and our soul's impetus to conceive and harvest.

Both of my parents, Leigh and Steve Smith, were Native-rights activists turned visual artists—pottery makers, and as a consequence most of my early influences were Onkwehon:we Indian-rights activists, such as Wallace "Mad Bear" Anderson (Tuscarora), Mel Squire Hill (Mohawk), Tom Porter (Mohawk) and Mike Mitchell (Mohawk). My family continues to take inspiration from world and spiritual leaders like his Holiness the Dalai Lama, Martin Luther King Jr., Thich Nhat Hanh and Mahatma Gandhi. My parents did a great job in educating

me about our unwritten history, our philosophy and way of life prior to contact and the devastating effects of colonization on our people and the natural world. We studied the works of visual artists like Anishinaabe shaman artist Norval Morrisseau, a.k.a. Copper Thunderbird; Navajo painter R.C. Gorman, Ojibway painter Benjamin Chee Chee, and Chiricahua Apache sculptor and painter Allan Houser; and influential women artists like Daphne Odjig and Frida Kahlo. The significant collective thread that radiates into my work from these renowned artists is the use of symbolic metaphor, transformation and artistic attempts to tap into the spiritual and creative presence that exists in the living universe, to try to make tangible the intangible.

More and more I acknowledge my work as cultural activism, an affirmation of Indigenous contemporary existence, culture and way of life. It has become evident that my art is also about personal renewal, healing and understanding. What does it mean to be a contemporary Kenien'kehá:ka woman? How can my language be present in my work/life after generations of it being systematically stripped away? How can I connect to my own sense of indigeneity and humanity in relation to Western-based society in which I live? I am a re-searcher, seeking out ways to unearth the buried shards of knowledge, the fractured bones of our pre-colonial her-story. It is through my artistic work that I am able to express and explore the complexities of my own earthly reality and humanity, an understanding of where I find myself in the continuum of Konkwehón:we and to be inspired by stories, philosophical concepts, people, spirit and vision.

I also find it fascinating that the overwhelming majority of my Indigenous artistic pioneers lived through

such personal and generational trauma, self-inflicted and imposed adversity, yet through their pain they remained steadfast in their vision, creating groundbreaking and exceptional works of art. They are visionary leaders. Vision and dreams play a meaningful role in my artmaking. My art is the language of dreams and through my creations I am realizing the art of dreaming. Visioning unfolds when my thinking mind slips sideways, in day and nighttime dreaming and in the active dream state of improvisation. Norval Morrisseau explained it well in an interview with the *Vancouver Sun* (on December 9, 1989): "I am a traveler. When I go to bed I feel that my body is gone. I feel that I go into a dream world... There is a place like that somewhere... We all come from there. We are all one in spirit anyway." The dream realm is a well source. In the process of creating a movement language, like a sculptor I carve space, mixing elements into a form to create a three-dimensional moving visual image ... a living dream. Visions tend to germinate or reoccur. A vision or flash of an image or symbol may not make it into an art form until years later. But somewhere in my consciousness the vision is stored until it is time to be manifested.

Kónhnhe ... I am alive. Kèn:tho í:ke's ... I am here.
There is a presence greater than me and I am a part of it.
The seed centre of creativity that rests in my pelvis at the
axis of my being is timeless.

LIKE TEYOTSI'TSYANE:KAREN SKY Woman, I am stardust falling into the blackness of the unknown. I let go and fall, ears fill with a rush of air, then the flapping of wings. I am caught up, suspended and gently placed on the hard shell of a turtle's back. Underneath my fingernails and falling from

my hair and dress are the seeds of life. I shuffle my feet in an earth-wise dance to germinate the seeds, breathing, singing, rocking my hips and dreaming this life into existence.

I am a star dancer, re-creating myself with each breath and with each moon cycle.

WE LIVE IN a living and spiritual universe where the potentiality to create is limitless. This belief comes directly from my Onkwehon:we heritage. The Haudenosaunee believe in a spiritual universe. Part of the Haudenosaunee Address to the United Nations in 1977 articulates the idea of a spiritual world: "Ours is a Way of Life. We believe that all living things are spiritual beings. Spirits can be expressed as energy forms manifested in matter. A blade of grass is an energy form manifested in matter—grass matter. The spirit of the grass is that unseen force which produces the species grass, and it is manifest to us in the form of real grass."

DURING THE CREATIVE process for my first major self-produced work, *Kaha:wi* (2004), I delved into research and spoke with Onkwehon:we cultural leaders, including the late Seneca historian John Mohawk. As he described it, "Our people call themselves Onkwehon:we ... *real people*, meaning real physically. Simply, Onkwehon:we *real* refers to being human—that is a distinction from spirit people (Sky Beings). There is a concept of duality between this dimension and that dimension. We live in a world where things are real but the universe has other dimensions. The unseen are beyond our comprehension yet we need to communicate with the unseen, some people call that spirit." He explained that the Haudenosaunee are conscious of self and of the otherness in the universe. The human spirit

Santee Smith in a scene from the cinematic restaging of her debut production *Kaha:wi*. PHOTO BY JAMES KLOPKO

possesses an umbilical connection to the spirit world. This awareness of spirit and need to commune with the unseen is one of the major themes that permeate my work.

What is the status of our humanity and our relationship with the universe today? How well are we faring as custodians of the earth, the plants, the medicines, the four-legged ones and the elements? What of the water and fish, how are they faring in our humanity? As activist leader and artist John Trudell candidly states, "I am just a human being trying to make it in a world that is very rapidly losing its understanding of being human."

Continually looking for spiritual connections, I am also inspired by other contemporary Indigenous artists' expression and understandings. My friend and renowned author Richard Wagamese sums up a similar understanding of the creative spiritual universe:

I am trillions of atoms and molecules. I am the space between them. I am the whirl and spin and motion of them. I am that glorious energy. That's the reality of me. What I see when I look in the mirror is a reflection of that whole. But most times, I only ever see the surface and hang my own sense of self-worth on that. But the beauty of me, the beauty of us as human beings, is that wild mass of energy working together to form the body, the face, the person I judge harshly when what really matters is the universe that I am. I am whirlwinds, comets, nebulae and pulsars. I am stardust. My beauty resides in the magic of all that coming together to form me, all of it guided by the hand of a benevolent, loving Creator. We are made beautiful—especially in the parts we do not see. (Facebook post, 2014)

SINCE MY WORK is my life and my ceremony, giving thanks has become a fundamental aspect of my individual and artistic practice. Whether directly inside of a work in song or spoken word, thanksgiving is the leaping-off point. Acknowledging that there are spirit beings and a spiritual presence everywhere and in everything, the Onkwehon:we people honoured these forces and our place within the web of creation through ceremony, song, dance and the spoken word. The wording of the Ohenten Kariwatekwen (Thanksgiving Address) translates to "The Words Before All Else" and these words are recited before all major gatherings in the Haudenosaunee community. It is significant since it outlines the ethical, moral, cosmological and spiritual relationships within the Onkwehon:we

worldview. During the address the speaker will gather the thoughts of the people and direct prayers and acknowledgment to the natural world such as to the People, Mother Earth, Plants, The Three Sisters (Corn, Beans and Squash), Waters, Animals, Trees, Birds, The Four Winds, The Thunders, Eldest Brother Sun, Grandmother Moon, The Stars, The Four Beings and Sonkwaiatison (Great Spirit). The thanksgiving tradition obliges humans to situate themselves in a humble position in relation to the natural world. The spiritual concepts within the Ohenten Kariwatekwen inspire my work and outlook on the world ... humans are only one aspect within a vast creation. The other major concept within the Ohenten Kariwatekwen is the repeated phrase "Ehtho niiohtonha 'k ne onkwa'nikon:ra" (Now Our Minds Are One). The term and concept of *one-mindedness* is a paramount utterance and goal. "Ehtho niiohtonha 'k ne onkwa'nikon:ra" also places in the forefront of our thoughts and actions the tenets of interconnectedness, interdependence and social and spiritual cohesion.

Onkwehon:we philosophy is represented in the design work at my family studio, Talking Earth Pottery. Grandma Bun (Elda M. Smith), my father's mother, lived her creativity by experimenting in many forms. She founded Mohawk Pottery with my grandfather Oliver M. Smith in the early 1960s and shared her research and passion of re-creating traditional pottery with many people from Six Nations, including my mother and father. She also invested in learning modern pottery-making techniques from various craftspeople in the broader community. She was a pioneering artist in her own right and like Norval Morrisseau took inspiration from traditional form and stories and through experimentation created her

own contemporary Kenien'kehá:ka expression. She was absorbed in representing Onkwehon:we symbols, such as wampum belts, animal clans and stories before it was popular or widely accepted in the Six Nations community. She was a charismatic, generous and celebrated artist; her fame was heightened by the fact that her brother was Jay Silverheels, "Tonto" from Hollywood's *Lone Ranger* series. She was featured in numerous publications and articles, including *Chatelaine* magazine. At Expo 67 in Montreal, she presented a stunning wampum belt vase to the Queen. Her pottery and work of Talking Earth Pottery are housed in both the Royal Ontario Museum and the Gardiner Museum (which specializes in ceramic art) in Toronto, the Canadian Museum of History (formerly the Canadian Museum of Civilization) in Gatineau, Quebec, and the National Gallery of Canada in Ottawa, among others.

She fearlessly pushed the limits of visual storytelling and embodied voice within her work. In her book *Crafting Identity: The Development of Professional Fine Craft in Canada,* Sandra Alfoldy writes: "While descriptions of Elda Smith portrayed her as the stereotypical Hollywood Indian, her determination and commercial success with experimental Native ceramics demonstrated that she was operating outside of the traditional discourse surrounding acceptable and authentic Native crafts." My grandmother moved in the land of uncharted territory, not falling into the trap of replicating the colonial and imposed "authentication" on Native art; rather, she focused on discovery, uncovering true self-expression and meaningful connection to our stories. With her I share a similar resistance to falling into stereotypical and preconceived expectations of what Indigenous art and art practice should be. There is a

great sense of pride and humbleness in the acknowledgement that I come from a long line of innovators, knowing that our work aspires to represent, explore and revitalize Onkwehon:we identity, place and spirit, manifested within a contemporary context.

But ... I only remember her through stories. I often wonder what compelled her to study ancient Onkwehon:we pottery shards in museums, to dig and work her own clay, to form her first piece? What dream was she fulfilling? What broken fragment of the post-colonial experience was she trying to understand, piece together? Sadly, Grandma Bun developed debilitating rheumatoid arthritis, with extreme inflammation of the joints, which deformed her hands and feet, caused her to struggle through severe pain and forced her to abandon her pottery making. I only know her through stories ... she would tie bells around her swollen ankles and shake her feet in a rhythm, and I would dance for her, together lost in the dream play of grandmother and grandchild, in the reflection of each other. She was my first audience. In her pain I was her joy, her medicine dancer ... I was her medicine. Science is now just catching up with much of Indigenous knowledge, including that memories of our ancestors, our grandmothers are stored within our DNA. She is an encoded part of me.

Kónhnhe ... I am alive. Kèn:tho í:ke›s ... I am here.
There is a presence greater than me and I am a part of it.
The seed centre of creativity that rests in my pelvis at the
axis of my being is timeless.

MY GRANDMOTHER WAS a clay woman, my mother is a clay woman, I am a clay woman, my daughter is a clay woman.

Feet extend down into mud, into subterranean roots, deep into Mother Earth's womb, anchoring me to buried knowledge, bones, layers of ancestral DNA, to the shadow of under, beneath, hidden.

I am a clay woman collecting shards, reading broken designs etched by a hand wiser than mine. Hands grasping at dust while earth tones flash across fields of vision.

I throw breath, spit and blood into the earth, sculpt the form and texture of life, put to fire and flame the terrestrial dreams of earth consciousness.

Un-burial, unearthing the elemental. In my ochre engravings, I journey the pathway of peaks and valleys, of negative and positive space, of life/death/rebirth.

Great Mystery, ta kha hon nien … make my path.

MY ART IS concerned with questioning, challenging myself and listening for the return. Who am I? What is the blood, essence of my dance? What is essential to me and how is this reflected in my art? How free am I to think, move and perform? How do I move in this world, out and into physical space? How does land come into and through my body? What memories are stored in my tissues, blood, marrow and organs? What are the ways of knowing that reside in my body? How is and how can story be embodied and released out? How can I best access instinctual knowledge, scratching away the layers of imposed colonial thought? How can I awaken and affirm the sacred spaces within my female spirit—reconnecting, restoring the intrinsic and powerful psyche? Through this journey I hope to recognize and dance my spirit self. Always pushing for discovery, opening to new pathways and moving

into the mysteries of life. As in life, being open and vulnerable, exposing pain, delving into the darkness of the soul and unlocking the gateways to love and light takes courage. How fearless can I be?

NeoIndigenA, my first full-length solo performance, premiered in Toronto at the Enwave Theatre at the Harbourfront Centre in May 2014 and was a pivotal step in my evolution as a dance artist. The seventy-minute ritual performance is a momentous physical, emotional and mental challenge and a spiritual journey wherein I propose that what is essential energy and intention from old knowing translates to *I am here in this space: now*. Where is land in my body? What language do my bones speak? What is flesh and blood, breath connection to earth and to soulful sky? Although a solo, *NeoIndigenA* is the result of working with a dream team of collaborators. I was fortunate enough to work on mentorship with renowned senior solo artists Margie Gillis, Zab Maboungou and Charles Koroneho; dramaturge Alejandro Ronceria; rehearsal director Louis Laberge-Côté; lighting designer Arun Srinivasan; composers, musicians and singers Tanya Tagaq, Jesse Zubot, Michael Red, Adrian Harjo, Cris Derksen, Nelson Tagoona; costume designer Elaine Redding and set construction Tim Hill. From conception to stage, support for the creation and production also came from individual funders, Kaha:wi Dance Theatre administration, production crew, production associates and presenters.

The *NeoIndigenA* ritual starts before audiences are ushered into the performance space. I position myself amid the seating area and as an audience filters in I am immersed in continuously activating the space with gestures of invocation and surrender to the journey. I focus my

Headshot of Santee Smith in her costume for *NeoIndigenA*, an extremely challenging seventy-minute solo performance that premiered in May 2014. PHOTO BY DAVID HOU

whole being on energy, harnessing it internally and sensing it with antennae palms and fingertips. With heightened awareness to breath, I listen with my pores, open my fontanelle to become a conduit for transformation. I humble myself to this journey because it's not going to be easy—it's not supposed to be easy. I pray that I reach the milestones, transcend altogether and live each moment as if it's the last. Unleashed viscerally, I am human, animal, plant experiencing many deaths and resurrections. I plunge into a sensual and sublime fall ... I let myself break.

Kónhnhe ... I am alive. Kèn:tho í:ke's ... I am here.
There is a presence greater than me and I am a part of it.
The seed centre of creativity that rests in my pelvis at the
axis of my being is timeless.

LIKE KATSI'TSYANI:YONTE, SKYWOMAN'S daughter, I lie shattered by the duality that thrives within me. Within my womb I gestate opposite forces: the twin birth of joy and sorrow, light and dark, the push and pull of amniotic forces. I am the hunter, I am the hunted.

Whispering over bones and antlers, animating the
inanimate remains.
My call reverberates through the space, strong, guttural,
animal.
Spine undulating, I am flesh and bone.
I make myself bare, exposed, wild
Fall into the dark recesses of mind and underworld.
I have desired too hard and fallen
Tripped over my thoughts, stumbled from poor steps taken

But in the struggle and the mud are the freedom and the
flower
Through the obstacles, realization
I am the creator, I am she
I am the cosmos, the universe is in me and everywhere I see
Lying in pieces, in flux the moment is still what matters
This broken moment is beautiful too
Fractured, I let myself break.
Broken bones and promises, fumbling in chaos
Disintegrating body; decomposing thoughts, opening space
for an inner re-evolution
Only through death and birth.
I let this and that part die
I become new again, beginning anew.

I BEGAN CREATING dance when I was two years old. When-
ever I heard music, I would respond viscerally, losing myself
to the real world, falling, floating and spinning into a dream
realm. But I didn't realize until later that I was a creator,
my preferred language being movement. As a creator and
performer I am still trying to get back to that uncensored,
unapologetic freedom of expression I lived and breathed as
a child lost in a world of imagination and dreams.

　　After recovering from two broken legs, committing
to six years of formal dance training at Canada's National
Ballet School, then abandoning classical ballet and com-
pleting physical education and psychology degrees from
McMaster University and theatre training, I returned to
dance as a creator, a choreographer. It took me a while to
rediscover that new dance performance was my passion
and that one of my gifts was to be a performing artist.

I began my professional choreographic career in 1996, when I was commissioned to create two short dance works inspired by Onkwehon:we cultural stories of Sky Woman and the Three Sisters (Corn, Beans and Squash) for *The Gift*, a National Film Board documentary directed by Six Nations artist Gary Farmer. As soon as I was back in the studio envisioning how to portray these narratives through movement, I knew that this was my life's work. For the first time, I was able to explore my love of movement and performance while representing narratives that came from my heritage and let my body speak metaphorical teachings that held personal meaning. As a result of this discovery, there was a tremendous pull to keep finding opportunities to create contemporary performance that highlighted the power, beauty and richness of Indigenous stories and existence both traditional and contemporary. Listening to my dreams, I continued to carve a career in dance and fervently pursued my choreographic voice. Provoked by the death of my todah, Rita Vyse, and the birth of my daughter, Semiah Kaha:wi Smith, I committed to creating my first major dance production, a family creation story. It took about six years to move from the initial spark of an idea to a final production and in 2004 I self-produced *Kaha:wi* at the Harbourfront Centre in Toronto. During the trial-and-error process of creating and producing *Kaha:wi* I learned about creation and production: commissioning and recording with more than thirty Indigenous musicians and songwriters, working with more than fifteen different dance artists and exploring the beginnings of my choreographic investigation of contemporary Onkwehon:we performance and how to direct and manage from grant writing to promotion. It was an all-encompassing

experience during which I also completed a master's in dance at York University. As a result of this work and my desire to pursue and define a career in contemporary dance and performance, I founded Kaha:wi Dance Theatre (KDT) in 2005.

A choreographer is a creator who expresses through the poetry of motion in relation to time, space, energy and form. Movement speaks to me most but I would consider myself an interdisciplinary artist, with music, design and written and spoken word playing equal parts. The overall vision of an artwork takes precedence. The creative process is always provocative, rewarding, enlightening, collaborative and intensive. Extensive research and cultural exchange play a significant part in the process, including interviews with knowledge keepers; studies of historical and cultural sources; language translation; creative dialogue or gatherings; image searches; and brainstorming with others. I love the creative journey from start to finish but performance is still a driving force. During performance the work is released into the world, made palpable in communication and energy exchange with witnesses, and in relationship with time and place. The act of being in the state of performance is exhilarating, transformative, empowering and perception shifting. The whole process from creation to production to dissemination, like life, possesses internal rhythm: rise and fall, two steps forward one step back, side shuffles, slow motion and double time, unison and repetition and so on. It is a dance in and on stages.

Throughout the process, I consistently ask: What am I doing? Why am I doing this? This is really hard work. Is this work bad? What if it's an epic failure? But despite

the self-doubts and struggles as an artist, the driving determination to reach a full manifestation of the vision supersedes giving up. Each work is like a birth: conception, gestation, birth and maturation, all the time nurturing and guiding the life. Choreographic works grow and shift with the influence of new experiences and influences, taking on a life of their own. The work reaches out to audiences in different ways depending on an individual's experiences, perceptions and references.

Kaha:wi is an Onkwehon:we (Iroquois) Kenien'ke-há:ka (Mohawk Nation) word meaning "to carry." As well, Kaha:wi is a traditional family name from my maternal ancestral line that had been passed on over generations in the Kenien'kehá:ka, o'tarahson'a (Turtle clan). Kaha:wi was the name of my grandmother, Rita, and in a naming context means "she carries." At the time of her death, the name Kaha:wi was passed on through a Haudenosaune naming ceremony to my daughter, Semiah Kaha:wi Smith. Onkwehon:we people recycle family names following maternal blood lines to honour the continuous cycle of life and women, who are inextricably linked to the womb of creation. Also, when our societies were intact, naming supported the clan system which was governed exclusively by the Clanmothers. These ancient family names have been passed on since the beginning of time. Kaha:wi Dance Theatre houses this intention and I hope that through my work I can carry forward cultural and familial identity while acknowledging the continuum of ancestral history and extend it to the future.

Since 2005, Kaha:wi Dance Theatre has grown into a major force in the Canadian dance landscape and

internationally. KDT has produced *Here on Earth, The Threshing Floor, A Constellation of Bones, A Story Before Time, A Soldier's Tale, The Creator's Game, Susuriwka—Willow Bridge, Medicine Bear, TransMigration, The Honouring* and *NeoIndigenA*. The company and I have performed in numerous venues—from major theatres and festivals to community gatherings—throughout Canada, the United States and in Mexico, Japan, France, Trinidad and Tobago, and Australia. During this time, KDT has been blessed with the opportunity to collaborate with amazing artists, share our stories and engage in meaningful cultural exchange with Indigenous peoples around the world. Many people join forces and energy to make the work happen. Although the artistic and performative expression is the ultimate focus of the company, some of the most rewarding experiences come from the work we do within communities, training dancers and in particular youth. Everything we do is an exchange, learning from each other.

Through KDT and our commitment to sharing arts and culture, I am thrilled to spearhead an annual March Break Performance Camp for youth, Master Class series, community workshops and Powwow Boot Camp series. I also curate and teach at KDT's Summer Intensive program, one-of-a-kind Indigenous dance/performance training combining Western-based dance techniques, traditional and contemporary Indigenous dance styles and alternative physical training designed for emerging and professional performance artists. I hope that through our work we can ignite passion for live arts and through the rigours of physical training, individuals may come to know that their body, voice and imagination matters—that they may come to

understand their innate creativity as it applies to perform-
ing and their life. There is value in celebrating and loving
our bodies and the spirit housed within. Our ancestors
beautified and honoured themselves, including the body.
There was no shame associated with the body, no deni-
gration of the gift that we were given by the Creator. The
overarching goal that I hope to impart to youth is to honour
their presence through body awareness, to acknowledge
that they occupy and inhabit sacred space and recognize
the power, energy and creativity they inherently possess.

It's significant to acknowledge that with the value
placed on our body, our being has shifted over time. Having
been born into what was once a strong egalitarian Onk-
wehon:we society with many of our practices matri-focal,
I find the status of women in our communities of great
importance and interest. The power of women within
Onkwehon:we society theoretically persists. In his book
Iroquois Culture & Commentary (2000), Mohawk activist
Doug George-Kanentiio articulates that,

> In our society, women are the center of all things.
> Nature, we believe, has given women the ability to
> create; therefore it is only natural that women be
> in positions of power to protect this function. In the
> Iroquois world, a female baby was a blessing from
> the Creator because such a child meant the cycle of
> our generations would continue on. From earliest
> childhood, the girl baby was encouraged to take a
> leading role in her family and group, never to hesi-
> tate to express her feelings, and never to qualify her
> creative impulses in order to please a man.

However, in today's male dominant settler-colonial society and as indoctrinated within our First Nation communities, women endure on unequal footing to men. When Europeans first came into contact with the Onkwehon:we Nations they were shocked and appalled at the power, the social and political status upheld by women. One of the most devastating assaults of colonization is the intentional breaking of the spirit and sovereignty of women and eradicating women's position in relation to the natural world. The history of violence against Indigenous women and the subsequent internalized disempowerment of women has been perpetrated in our society since contact, as evident in the status of missing and murdered Indigenous women in Canada. The value on Indigenous women's bodies is a direct reflection on the value that society places on Mother Earth. She continues to be regarded as a commodity to be silenced, sold, abused, cut down, burned, polluted, forcefully and violently mutated and murdered.

While researching and working on *The Honouring* performance, which paid homage to the Onkwehon:we families and warriors who sacrificed their lives in the War of 1812, I studied our Condolence ceremonies and the Requickening Address. Condolence ceremonies are set in place to deal with the devastating effects of grief, to clear the minds of the mourners so that they can cope with their loss and continue to lead healthy lives. As we know, living in grief can cause physical and mental sickness. The Requickening Address sets into motion a functional death and renewal process. The Rekindling the Fire scene in *The Honouring* symbolizes three important declarations within the address in dealing with grief:

Wipe clear our tears, so that we may see the beauty of this world.

Clear the passage in our throats, that we may speak our thoughts.

Wipe clean our ears so that we may hear the comforting sounds of this world.

This Onkwehon:we coping strategy for loss and grief is one of the critical initiation points for my newest work as this book goes to press—*Re-Quickening*, which examines international Indigenous women's issues and rejuvenating the seeds of feminine power. During the research and creative process for *Re-Quickening*, collaborators and I explore how to restore, reclaim, reconnect and re-create Indigenous stories, practices and ceremonies that affirm the sacred spaces within the female spirit, reawakening the intrinsic and powerful feminine psyche. How can we restore the essential feminine? For the initial steps in examining and questioning the issues surrounding loss of feminine power and finding strategies for renewal, I brought together an incredible team of Indigenous women leaders for a women's gathering of knowledge: Frances Rings (descendant of the Kokatha Tribe, Australia, and resident choreographer of Bangarra Dance Theatre); Monique Mojica (Guna and Rappahannock Nations, actor, playwright, scholar); Christi Belcourt (Métis visual artist, activist); Leanne Betasamosake Simpson (writer, scholar, storyteller, activist of Michi Saagiig Nishnaabeg ancestry from Alderville First Nation) and Elva Jamieson (Haudenosaunee teacher and speaker).

We spoke of mass condolences for Indigenous peoples still experiencing generational suffering from

residential schools, loss of culture, loss of women's place, and loss of land and sacred spaces and connection to the natural world; we talked about the fragments of knowledge remaining and what to do with them; and we explored such areas as traditional and contemporary narratives weeding out the evidence of acculturation. How far do we have to go to recover the essential feminine and her connection to earth, water and air? Can a performance serve as trauma recovery, a mass condolence for lost women and children, for grieving families? How can a dance, a song, a monologue become a new ceremony?

Kónhnhe ... I am alive. Kèn:tho í:ke's ... I am here.
There is a presence greater than me and I am a part of it.
The seed centre of creativity that rests in my pelvis at the
axis of my being is timeless.
Is there a trace of her?
Is there a faint vibration resonating from where she walked
along the river?
Is there an echo of her laughter lingering in the trees,
encoded in the rings of the trunk?
Where her footsteps tread, are her imprints still here?
Is one of her wispy hairs still wrapped dancing on a pine
needle?
Are her dreams and prayers still drifting up and up from
tobacco offerings?
Is there a trace of her here?
Does the land remember her songs?
Are the residue of her tears still holding time and space?
Blood dripping onto the earth
Blood into the earth
Blood, Birth

Blood, Water
Water, Life
Water breaks
Earth bleeds
Is there a trace of her?

THE CANADIAN DANCE Assembly invited me to write the 2014 International Dance Day Message and it was a great honour to share my perspective. The message sums up how significant dance is for me, how deeply it impacts my life and how I feel dance resonates in the human spirit. It's a call to action, a call to dance:

Let dance into your life. Call dance into your life. Breathe dance into your life. Let dance be the connection between your spirit and the living universe. Let dance be the voice of your soulful resistance, your statement of I am here, in this space, now. Let dance resonate from your ancestral memories, from your DNA extending like tendrils to future generations. Call your body forth to move, to speak a language without words. Dance your dreams and poetry. Find that place deep inside your inner landscape that longs for expression. Close your eyes and remember the heartbeat rhythm, the first music you heard in your consciousness. Be the witness to a singular body animated in time and space or to the awesomeness of a multitude moving in unity. Let dance represent your metaphor, art, ritual, ceremony and ecstatic transformation. Energize, revitalize and renew yourself through dance. Renew your bond to the rhythms of the earth. Heal yourself, be yourself

and together we can dance our humanity. Transform your life ... let dance into your life. Join the celebration and ceremony of life; join the dance.

But, less and less I like to use the word *dance* only to describe what I do. Creation and performance have certainly become a personal ritual, a temporal event that I go through, which is a ceremonial process. It's about healing, searching for connection and revitalizing myself as a human in the end.

You are alive, I am alive
You exist, I exist
You are here for me, I am here for you

Let's Get Artsy—Yes, Let's!

ROSE STELLA
actor, singer & artistic director

*W*RITER LEANNE SIMPSON SAID IN THE BOOK *LIGHTING the Eighth Fire* (ARP Books, 2008) that "Nishnaabeg Knowledge holders know that the first step to make something happen is often a dream or a vision."

James Buller, a Cree from the Sweetgrass band of Saskatchewan, was a great dreamer and visionary. He believed that performing and visual Native artists could empower the self-image of Native individuals as well as entire communities: "If Native people had a venue for artistic training, in 20 years we would begin to see ourselves in popular media—in culturally specific print, on stage, on screen, in galleries—as writers, actors, performers" (Association for Native Development in the Performing and Visual Arts online archives, accessed at www.andpva.com in April 2014). The result would be a positive self-image for young people and future generations.

He founded the ANDPVA and the Native Theatre School (NTS) in 1974, believing that with "a viable Aboriginal theatre school in place, Aboriginal actors, playwrights

and directors would have a forum for exploration and exchange, and that the results of this exchange would have a measurable impact on the Aboriginal Theatre community" (ANDPVA archives). And indeed it did have an impact. From the starting point of a 1974 summer program on a farm in northern Ontario, ANDPVA springboarded performers like Graham Greene, Gary Farmer and Billy Merasty into a life of working in the performing arts. Significantly, the seeds were sown for many new Indigenous programs and companies that have arisen since: Native Earth Performing Arts was born as a company in 1982, Spirit Song Native Theatre School in the 1980s, Full Circle Theatre Company in 1992, the Native Theatre School became the Centre for Indigenous Theatre (CIT) in the early 1990s, and CIT became a full-time program under the tutelage of Carol Greyeyes in 1998. I was a participant at NTS in 1991 alongside artists such as Elder Edna Manitowabi, Sandra Laronde, Luanne Harper and Jerry Longboat.

In the spring of 2003, I accepted the responsibility of being the artistic director and principal of the Centre for Indigenous Theatre.

"My people will sleep for one hundred years, but when they awake, it will be the artists who give them their spirit back" is a very famous and possibly over-quoted prediction that Louis Riel made back in 1885. The quote sprang from a dream ... and it shines a light on why the arts are so important to the prevailing resurgence of Indigenous confidence, health, knowledge, identity and culture. However, I have learned that it is not only the artists who "give [the people] their spirit back." It is in the discoveries made when becoming an artist that the artist's spirit is ignited and the energy behind their art becomes a kind of spark

plug for all of us to grasp onto for a boost to our sense of identity. Too ethereal? … maybe … but that discovery, whatever it is, is a portal to self-identity, and having a clear concept of *identity* is paramount to building a relationship with one's art and community.

Identity is more than where you are from, your colour or a status card. Self-identity is about a calm self-confidence, a pride and belief in who you are and who your ancestors are. Unfortunately, Indigenous peoples' sense of identity has been crippled since contact, starting with Columbus—as Thomas King writes in *The Truth about Stories*, Columbus described the peoples he encountered in highly idealized terms and spoke of them as obedient people who would make good servants and could be easily converted to Christianity (p. 70). As King describes, for much of the sixteenth and seventeenth centuries, explorers' accounts depicted Native people as gentle, attractive, good-looking and frequently naked (p. 71). Well, as descriptions go, not so bad; but the way explorers treated the people they met was not so civil and gentle, although kidnapping and selling the so-called other into slavery, was considered quite civilized by their barbaric standards. But then, Native people didn't fare well as slaves, as they often died before they could be sold (King p. 71). Also, it turned out that Native people were a far more valuable resource to the explorers as guides, so we became partners with them—sort of.

As exploration led to settlement, reports showed concern about the Indigenous peoples' vulnerability to the influence of the devil (King p. 71). And by the time the Puritans nested in North America, the newcomers were waging their old religious and social wars against a new

Along with being the artistic director of the Centre for Indigenous Theatre and writer of the play *White Buffalo Calf Woman*, Rose Stella also performs as a singer, dancer and actor. PHOTO BY ROBERT M. SAX

enemy (the Indian), and they began to describe the Indians as savage, unclean, and untrustworthy people who were not worthy of being treated as equals (King p. 75). As King describes, this type of propaganda was gradually transformed into widely accepted beliefs about Indigenous peoples (p. 75). Such a view of Native peoples set the course of the rationalized attempt to exterminate Native people all over North America.

But then, sometime near the end of the nineteenth century, Indians—specifically male Indians—were suddenly viewed as noble and romantic savages. Native men were so idolized that white women wanted to be with them and white men wanted to be them—hence the birth of the likes of Grey Owl, the assumed pen name of Brit Archibald Belaney.

Canada then led the way to the more humane notion of "assimilation instead of extermination"—and children were stolen from their homes to begin this kind bureaucratic process.

The discussion of what happened to Native people's identity after the onset of the residential school era is lengthy and ongoing. The point I am driving at is: our sense of identity—globally, nationally, communally, personally—was broken and robbed. But in order to make art that is identity-based, we first need to know what being "Indigenous" is. Often, when many of our students first come to our program, they are not necessarily seeking to be actors; many are seeking a way to repair their spirit and find a sense of identity that is authentic and not something that is thrust upon them. The question "What is Indigenous theatre?" is asked time and time again ... but before our students can answer that question, they need to know

what it means to be Indigenous. What does it mean to say "I am an Indigenous person"?

Working with identity issues is complex and needs to be approached with understanding. It is important to always keep in mind that many of our young people come from homes of residential-school survivors; or they are children of children who were stolen from families and adopted out to non-Native families. It should not be surprising that their sense of identity is skewed or even crushed. So how do we train actors who come from an environment of abuse and violence ... or homes where being Native was evil and going to church and bleaching their skin was their only redemption? Their identity is tied to that abuse, and our training starts with trying to untie the attachment to all that.

But CIT is not a healing organization. We are a theatre school that carefully constructs its curriculum to best serve the training needs and abilities of our students. We have an understanding of where our students come from and we make sure to provide the students with teachers of traditional knowledge and time with traditional healers.

I was particularly influenced by the teachings, the grace and poetry of Anishnaabe Elder Art Soloman. He was a great inspiration and a voice of hope for many of our people. He was particularly helpful to me when I first started working with youth at the Native Canadian Centre of Toronto in 1991. I continued to seek his help up right up until the time he passed in 1997. His voice and work carried respect, strength, faith, hope and love for his people. Art Solomon also believed that Native people had a way of learning:

The traditional way of education was by example, experience, and storytelling. The first principle involved was total respect and acceptance of the one to be taught, and that learning was a continuous process from birth to death. It was total continuity without interruption. Its nature was like a fountain that gives many colours and flavours of water and that whoever chose could drink as much or as little as they wanted to whenever they wished. The teaching strictly adhered to the sacredness of life whether of humans, animals or plants. (Reflections on the Outdoors Naturally blog, www.reflectionsoutdoors. wordpress.com, accessed in April 2014)

So, what is Indigenous theatre? It is a question that brings Native theatre artists together at conferences time and time again, to find a comprehensive answer. For me, the answer is less complicated. It is about telling stories— past present and future—from our point of view in our own unique way. Stories that will attempt to deconstruct identities that have marginalized us. Stories that reflect who we were, who we are and who we hope to be.

Thomas King has written that stories are everything we are and has quoted Anishnaabe writer Gerald Vizenor as saying that the only way to understand the world is to tell a story (*The Truth About Stories*, p. 2, 32).

Playwrights are storytellers. In *The Rez Sisters* and *Dry Lips Oughta Move to Kapuskasing*, Tomson Highway embellished his stories with humour, truthful horrors, the Cree language and magical characters like Weesageechak and Nanabush to make his own truth play on the stage.

Daniel David Moses brings poetry and history into play with coyote antics and loving irony.

Marie Clements is a filmmaker, playwright, poet and historian who weaves intricate soundscapes and video with her stories, in ways that are remarkable, heartbreaking and stunning. Drew Hayden Taylor's characters are Native individuals we could meet anywhere in Canada; their situations are mundane, but the stories are unique to Native people. His plays are heartwarming, funny, dramatically sad and humanely reflective of Indigenous people across Canada.

To quote from a 2005 online academic document by Dale J. Young, titled "Bridging the Gap: Drew Hayden Taylor, Native Canadian Playwright in His Times," "Taylor opens the door to genuine recognition; elements which stereotypes and polarized cultural separation would normally never allow. In short, Taylor's work attempts to build upon foundations laid earlier by Native theatrical efforts" (p. 218, accessed at OhioLINK—https://etd.ohio link.edu—in April 2014).

I have only touched upon four Indigenous playwrights, but these four significant writers have paved the way since the 1980s for many Native playwrights here in Canada. Now the canon of Indigenous playwrights has grown exponentially across Canada, the United States, Mexico, Central and South America, Greenland, Denmark, Australia and New Zealand.

Indigenous plays need Indigenous actors ... trained and committed actors. Artists who are as committed as the playwrights ... so that is where we come in.

The Centre for Indigenous Theatre—Vision: CIT embraces the spirit, energy and inspiration derived from

the culture, values and traditions of Indigenous people. From these roots we seek to elaborate a contemporary Indigenous performance culture through training and professional development opportunities for emerging and established Indigenous theatre artists.

The Centre for Indigenous Theatre—Mandate: CIT exists to provide theatrical training informed by traditional artistic expression, teaching and values, while creating an environment that encourages cultural exchange of practices and techniques between Indigenous nations and communities.

Simply put, CIT is a three-year professional theatre training program that is uniquely focused on Indigenous perspectives and performance methodology.

So how do we do what we do?

Our theatre training contains the basics: voice, movement and acting. But then we go back to that identity thing again, and so we start by getting everyone singing. Singing round-dance songs, powwow songs, songs from where the students were born and songs from other Indigenous regions. We get them singing and it is remarkable how they open themselves up to these songs. In October 2004 we were invited to visit Six Nations to do a presentation. It was really early in the school year, and some of the students had only just begun the training. The mother of a prominent Native actor was in the audience, and she was amazed: in her experience, Native people are very shy. "How do you open up a group of youths in such a way to perform so courageously?" she asked. I had never been asked that question before, but I was certain the answer was because we start with Indigenous singing and powwow dancing: singing songs that give voice to an identity that

the students were getting reacquainted with, and dancing songs that helped them to embody that voice in way that is new and momentous for many of them. Recently the new electric powwow music by A Tribe Called Red has given a wave to hip-hop/powwow culture that the youth have really latched onto and relate to. I will venture to say that it has its own spirituality...

I AM GOING to step back in time and talk a bit about my own training and professional experience.

When I was studying and training at a Toronto arts university, I met a clown teacher whose name is Dean Gilmour. At the time he was facilitating clown workshops for the theatre department. He was such an interesting person and so different from the other instructors teaching there that I was inspired to study clown with him and his wife, Michele Smith. It was the early '80s, and they were giving workshops on College Street across from the Mars Diner. I was hooked. In my experience, clown training is an art form that accesses the base of our humanity. It is a remarkable art form that involves stripping away the layers of accumulated persona to find a neutral place from which to work. The process was difficult at first, because I was not accustomed to being so still and not doing anything for lengths of time on stage. I didn't get it for a long time. The work wasn't just about a style of performing; there was a philosophy to the work that I hadn't encountered before. This philosophy came from their own teacher: the French master clown Philippe Gaulier.

Gaulier was quoted in the *Telegraph* in 2001 as saying that what he teaches is a "wonderful spirit" rather than a style, and that performers need to navigate a way to

become "beautiful and surprising" ("From the Sublime to the Ridicule," by Dominic Cavendish, March 12, 2001).

Clown training became, for me, a form of soul work that touched on my spirituality in a very subtle way, and quite by accident it also informed the methodology and approach that I took to performing. Because the clown is alive and well as a part of the human condition, it was not difficult to find the "clown spirit" everywhere in the theatre I was engaging in. (Over the years, I was fortunate to study with Philippe several times when he came to Toronto.)

After university, I ran away to Sri Lanka for an adventure. When I returned to Toronto six months later, I met Gregory Heyn. Greg was the founder and artistic director of Insight Theatre Company, a semi-professional group of mostly blind actors whose mandate was "to educate the public to the misconceptions of blindness" while providing a creative arena for the development of the talents of the blind in the performing arts. He was coincidently part Italian and part Dutch Sri Lankan (Burgher) on his father's side, so we had many interesting conversations about my time in Sri Lanka. Another coincidence: Gregory Heyn was also one of the initial instructors at the Native Theatre School. It was the spring of 1985, and NTS had been closed since founder James Buller had passed away in 1982. But Greg often encouraged me to introduce myself to the artists who worked at the Association for Native Development in the Performing and Visual Arts and Native Earth Performing Arts. I was committed, though, to another European adventure and my first stop was London, England.

I was not supposed to be in London longer than ten days. But after a week in London I was cast in a touring "British panto" called *Cinderthriller*—I was cast as

Cinderella, who sang jazzy blues and preferred to marry her best friend Buttons (who was black) instead of the prince. It was an especially huge hit in Brixton, as we were touring it only two months after the famous 1985 Brixton riot. I was touring panto-musicals to inner-city public schools and singing and clowning my way to playing April in an off-off West End production of Sondheim's *Company.* London was awesome. Directors and producers loved me—I could sing, I was funny and I was considered exotic (lol). Life was fabulous! But life being what it is, after almost two years in London, I had to return to Toronto, and on my return I discovered that contemporary Indigenous theatre had been making sensational headlines!

I was finally introduced to the Toronto Native theatre community via being cast as Eileen in *The Ecstasy of Rita Joe.* Our production was at Hart House, and was running at the same time as *Theatre Passe Muraille's* production of Tomson Highway's *Dry Lips Oughta Move to Kapuskasing.* It was at that time that I met Tina Bomberry, Gloria Eshkibok, Monique Mojica, Michelle St. John, Jani Lauzon, Ron "Loon Hawk" Cook, Gary Farmer, Kennetch Charlette, Raoul Trujillo, Billy Merasty, and the late René Highway—a man who was kind and generous beyond belief. It was an exciting and inspiring time.

It was also when I met Marrie Mumford (Métis/ Chippewa–Cree), who at the time was a theatre director, teacher and political, social and educational advocate for Native artists. Working at ANDPVA, she was restoring and reopening the Native Theatre School for the summer of 1991, and she wanted to hire me to work as the assistant to the artistic director, Floyd Favel. I jumped at the chance and spent six weeks training and working with

Floyd and with Monique, Jani and several guest artists and traditional singers and dancers. Edna Manitowabi was sharing and teaching us songs in the Ojibwa language, Jani was building soundscapes with our voices, and Monique's movement work always started our afternoons with yoga. I conducted several clown and *bouffon* workshops—Edna's son, Vincent Manitowabi, was particularly adept at the *bouffon* work. It was remarkable to see some of our shyest student members opening up and reaching out for some hidden dream and hope.

In the final week and a half we toured the show to Moosonee, Fort Albany, Attawapiskat, Manitoulin Island, and to the men's and women's prisons in Kingston, Ontario. It was during the tour of our show on Manitoulin Island that I met the charming Drew Hayden Taylor. It was also when I witnessed the amazing presentation of Debajehmu-jig Storytellers' *Lupi the Great White Wolf*—entirely in the Anishnaabe language, Odawa dialect. Adults and children who had never spoken the language before were onstage igniting their language through verse and song—and I believe the ancestors were rejoicing. These performers—Ojibwa men, women and children from the Manitoulin area—were triumphant in finding their way back to a voice and sound of their ancestral Odawa identity.

After NTS, Jani Lauzon inspired and encouraged me to continue to sing hand-drum songs with other women. So Gloria Eshkibok, Merlin Homer, Sandra Laronde, Luanna Harper and I joined together a group of Native women once a week at the Native Canadian Centre of Toronto to sing: we shared songs and created songs. The act of singing was joy-ful; the songs seemed to touch each singer's core—igniting

a sense of pride and identity. Singing became an act of empowerment, for the singers and the listeners ... a simple creative act that empowered many women to reclaim their sense of identity. After six months, we began to be invited to open conferences and also asked to visit the women's prison in Kingston. We became known as the Anishnaw-beqwek Singers (a year later another women's drum group chose the same name, so we changed our name to Sweet-grass City Singers).

Indigenous arts were growing across Canada at a rapid pace. Artists were reclaiming their stories and the right to tell their truths through song, film, poetry, perfor-mance art and plays. One of the most remarkable theatre pieces I have ever witnessed was a solo piece called *Moon-lodge*, written and performed by Cree–Saulteaux artist Margo Kane. I believe it came to the Native Earth stage in the summer of 1991—it was very soon after Native Theatre School ended. It was a remarkable telling of what hap-pened to one Native girl after the "scoop-up": a story that had rarely been told and certainly had never been told so truthfully and so triumphantly.

The synopsis of the play is described on the Full Cir-cle: First Nations Performance website as follows:

Agnes is a girl snatched from her home and family by Child Welfare government services. She grows up in a series of foster homes, apart from the warmth and support of her family and her cultural commu-nity. Popular media depicting Aboriginal people both entice and repel Agnes. Later, in the 1960s she joins many others hitchhiking across America and

in that journey she begins to discover the authentic voice inside her that had been silenced but never lost. (http://fullcircle.ca/past-productions, accessed in April 2014)

The play was physically driven—with song, dance and athletic physical histrionics at every turn. I could see that her theatre training was extensive, and she was using every single bit of it in this show. Margo told the semi-biographical story of her life, portraying several characters with such aplomb and seduction that I was exhausted and exhilarated when the play ended ninety minutes later. I was extremely excited about what was happening in Native theatre and *Moonlodge* was a beacon of light for its future.

In 1993 Drew Hayden Taylor's *Someday* took the subject of the "scoop-up" on a different journey—he showed us the possible scenario of one family and child devastated by it—and the audiences were amazed and touched. Native audiences who have experienced this injustice were being validated. Non-Native audiences were being educated. The canon of Native plays was growing, and Native artists and actors had roles that demanded skill and technique to carry them through the complexities of the material.

Indigenous artists were also entering the campaign to protect the environment and save the Earth. Early in 1999 I joined a community arts group called the Buffalo Jump Collective. It was a group that Gary Farmer had gathered together with the intention to spread the Lakota story and teachings of the White Buffalo Calf Woman—teachings with an important message as we moved into a new millennium. Gary brought Sioux spiritual leader Arvol Looking Horse to Toronto to tell us his story, the story of the White

Buffalo Calf Woman, and the significance of World Peace Day. Born on the Cheyenne River Reservation, Arvol Looking Horse is the nineteenth-generation Keeper of the Sacred White Buffalo Calf Pipe—a spiritual responsibility to the Lakota, Dakota and North Dakota/Nakota Nations that he inherited when he was twelve years old.

Through Gary's vision, Buffalo Jump was preparing for the first World Peace Day event in Toronto, to be held as a part of National Aboriginal Day and Aboriginal Awareness Month. At that event he envisioned "a herd of buffalo people" would peace-march from Nathan Phillips Square, down Bay Street then on to Harbourfront Centre—where they would "buffalo jump" through a gigantic and beautiful peace hoop.

Herd of buffalo? Yes ... Gary wanted a herd of buffalo ... and he had figured out how to get the herd—he just needed the collective to do the legwork. To prepare for this event, Gary asked members of our group to go to schools and do workshops with the students. We would tell the students the story of the White Buffalo Calf Woman, and talk about the significance of the message, and build buffalo puppets and masks that all the recruited young people would carry in our peace march. The members who visited the schools were actors Ron "Loon Hawk" Cook and actor Tim Hill, poet Michael Paul Martin, actor Lorraine Pelletier, costume designer Angela Thomas and—yours truly.

For me, the side effect of our storytelling in the schools was that the story became animated in my imagination, especially when listening to Loon Hawk tell the story; and so the seeds of my play *White Buffalo Calf Woman—A Clown Dance Show* were planted.

On June 21, 1999, Gary Farmer's dream of a herd of buffalo marching down Bay Street came true. There

were about 2,000 "buffalo"—large, small and tiny—who marched and then "buffalo jumped" through the peace hoop at Harbourfront Centre. It was a magnificent sight.

As if that wasn't enough, Gary had been also hosting the very first Aboriginal Voices Festival at Harbourfornt—a week-long festival celebrating First Nations culture and arts, traditional and contemporary.

So ... Leanne Simpson's statement that "the first step to make something happen is often a dream or a vision" was awesomely cryptic.

By 2002, an early draft of my play *White Buffalo Calf Woman—A Clown & Dance Show* (*WBCW*) was ready to be submitted to organizations that help new playwrights workshop their plays. I struggled with the idea of putting this story on the stage, especially as a clown show, but Alanis King kept encouraging me: "Rose, the White Buffalo Calf Woman really wants to wear a red nose." (FYI: only the hunters wear the noses, but Alanis's words rang in my ears until I had to write the play.)

The teachings in the story are everlasting, and the prophecy is daunting—especially since the Earth is struggling to live and breathe free of pollutants and greed-driven destruction at every turn. Since the '90s, white buffalo calves have been born—not albinos, but genetically pure white calves.

"Regarding her prophecy—her return would be in a time of big crisis and great upheaval, shortly before the ... great cleaning of the earth is about to start. She will be there to support nature ..." ("The Prophecy of the White Buffalo-Calf-Woman," accessed at www.white-buffalo-calf-woman.com/legend_e.htm on Nov. 11, 2014).

The story is a warning, but storytelling need not be aggressive. In spite of the message of the prophecies, I wanted my characters to have a way of being *beautiful and surprising.* The play mixes different dance disciplines, clown and storytelling with an authentic purpose. I was very fortunate that Native Earth chose my play. They gave me the director and actors that I requested and it was presented in January 2003, at their Annual Weesageechak Festival.

At the Weesageechak Festival, WBCW caught the attention of producers at Harbourfront and they asked for it to be presented as part of their World's Fare Festival in July. Through the assistance of Toronto Arts Council and Canada Council, I was able to present the play there. But I was now artistic director of the Centre for Indigenous Theatre, so I was now learning a new kind of juggling act, as our summer program at Trent University was underway while I was presenting at Harbourfront.

In September 2003, CIT was hosting a five-day Iroquois Song and Dance Workshop. Wendy Hill—a Cayuga healer from Six Nations Reserve—was part of the group who came to teach. One day after dinner, she was sharing stories with me and some students who had stayed to listen to her. One of the stories was about the White Buffalo coming to her in a dream, insisting that she share her stories and dreams ... and she looked at me and asked me if I could help her by writing a play. I was quite surprised, but I shyly said I would try to help her and that I would incorporate her dream stories into my play. Well, it took me ten years to get to it but, with Wendy's guidance and the excellent dramaturgy work of Marion de Vries and Jim Warren, I was able to give a workshop presentation of the

new play—based on Wendy's dreams and the White Buffalo prophecies—as a part of CIT's 2013 Year-End Show. The White Buffalo Calf Woman and the Heyoka spirit vibrated on the stage at the Helen Gardiner Phelan Playhouse—because the CIT faculty had trained the performers so well, and the students were prepared to present an ethical and mystical message.

The Centre for Indigenous Theatre started out as a six-week summer program and has gradually developed into a three-year program that we call "a multifaceted process, weaving disciplines together with a flow through of Indigenous perspectives or worldviews." Our change is a direct result of the demands of our professional playwrights and screenwriters. Our playwrights have made a name for themselves worldwide. Our screenwriters, filmmakers and documentaries are also being recognized and held up around the world. Indigenous artists, actors, singers and dancers are acknowledged as professional and vivacious players, not just quaint sideline interest groups that are there for the non-Native audiences' amusement.

CIT's three-year program is not the only valuable theatre training program for Native youth, but it is the only three-year conservatory model that investigates the training from an Indigenous perspective. As I said before, identity issues are fragile and complicated, so we must begin with a dialogue about identity—at the start of their training—so that we can have an understanding and find a common denominator of what identity means and is for each ensemble group.

Story sharing, story creation and story weaving are the cornerstone of our methodology. This involves ensemble teaching and ensemble performance. Everyone in the

Production shot from the Centre for Indigenous Theatre's 2013 performance of Rose Stella's *White Buffalo Calf Woman—A Clown & Dance Show*. Dancers, left to right: Donovan Tailfeathers, Alex Twin, Christopher Mejaki and Kitsuné Soleil. PHOTO BY VICTORIA VAUGHN

room is working together for the story ... for the "what, why and how" of the story. Muriel Miguel of Spiderwoman Theater is a master performer, director and teacher of story weaving and ensemble building, and she has had a significant influence on how our program has developed. Our summer program is designed around the ensemble teaching model; and most recently, CIT has redesigned the first semester of the first-year program to be based on the ensemble teaching model, as it is a model that is historically successful in achieving the greatest student engagement.

Of course, our first-year program offers basic theatre training, but unlike other professional training schools it

also offers several opportunities to perform. Part of the program delves deeply into the area of technical theatre and design (stage management; set design and set-building; lighting design; costume design and building, etc.). Our intent is to not only offer students another road into the arts that is not about acting but to build an interest in this area with the result of creating more Indigenous practitioners in these professions.

We ultimately want to create professional theatre practitioners. We offer physical theatre, scene study, acting for camera, Shakespeare studies, playwriting, grant writing, improvisation, contemporary dance, core strength and voice and singing classes. By the end of the second year, our students usually know if their niche is in dance, acting or writing, but we provide them with training in all areas because Indigenous theatre is almost always multidisciplined. Santee Smith's Kaha:wi Dance Theatre incorporates actors into her dance stories and so many contemporary theatre pieces demand that the actors be strong dancers or movers.

One area we focus on in our third year is the solo performance piece. Some call it simply one-man shows; Margo Kane called it solo-voice theatre. But the value or import is that it is self-created and rooted in our oral and storytelling traditions. Darrell Dennis's semi-autobiographical one-man play *Tales of an Urban Indian* had Darrell touring after its Native Earth premier in 2003—all the way to New York City's Public Theatre in 2009, and its productions continue with and without Darrell as the performer. The career of Anishinaabe playwright and actor Waawaate Fobister took flight when his debut solo play *Agokwe* premiered at the Buddies in Bad Times

Theatre in Toronto in 2008. *Agokwe* won six Dora Mavor Moore Awards, including for outstanding new play, in 2009. Waawaate is still touring *Agokwe* as it is in demand across Canada.

Our hope is that our students can find their voice in such a play—and possibly hone their acting and producing skills by self-producing their solo plays at Summerworks and the Fringe, or even developing it through Native Earth's Animikiig Training Program or its Weesageechak New Play Festival.

Training is necessary to be prepared for opportunities and also to be able to recognize them—and, importantly, to be able to create them.

As with most theatre programs, not every graduate walks away and becomes an actor, writer or producer. Some continue in the arts as administrators or set carpenters. Some are community-driven and go back to their communities to conduct theatre workshops for youth. Some are inspired to go back to school and get university degrees. What they will do with their training is never definitive. What we are certain of is that all of CIT graduates will leave our school changed. They leave with a renewed self-awareness and self-confidence that some did not even think they were worthy of. Feeling unworthy has been the devastating sentiment that has prevented many of them from finding ways to improve their life. It is the throughway that feeds both apathy and anger. Imagine the change that can happen in communities when their young people are no longer feeling broken and hopeless. For communities plagued with teenage suicide, some of our students acknowledge the power they have to inspire positive change when they return home.

Our students are no longer satisfied to be cast as the "drunken Indian" or to be cast in some play or TV show because the producers assumed that they would arrive in powwow regalia.

I'm Not the Indian You Had in Mind—the title of a 2007 Thomas King film—is the new catch phrase, and our private smile.

Our students now go out into the world confident that they will instill an authentic and newly authoritative modern "Indian" image that will break through the old and tired images created by "dead white writers."

I never knew James Buller. I never even met him. But he is one of my greatest heroes. He had a dream that he acted on with impressive vivacity and the spark of his actions caught fire across Canada. His students became artists, role models and teachers. The cycle of positive change is apparent when a young man from Grassy Narrows wins six prestigious Dora Awards, or when we witness the enormous popularity of the imagineNATIVE film and media arts festival that is held annually in Toronto.

We are becoming the "Indian" that we want to be—and the "arts" are reflecting that.

I am very happy that the Centre for Indigenous Theatre can be a part of that good change.

Once upon a Medium

·······················

THE EVOLUTION OF THEATRICAL STORYTELLING

DREW HAYDEN TAYLOR
playwright & writer

*I*T WAS THE COLD WINTER OF EARLY 1995. THE WIND
was whipping up off the frozen lake, striking the
last blunt blows of frigid anger as it struggled valiantly
against the gradual turning of the earth's axis. Sitting
on two large La-Z-Boy chairs, in a small bungalow on an
insignificant First Nations community deep in the heart
of Central Ontario, sat a man. Beside him, sat an older
woman ... his mother. In their hands were the contents of
an opened manila envelope, detailing the modest success
of a play written by the young man. Both were reading
the material, which consisted of press releases, programs
and newspaper reviews concerning a distant production,
far away in another province. The package was called a
publicity kit, it had been put together by a theatre compa-
ny's publicist, and its contents contained some welcome
praise for the young playwright. Also, the man had been
appointed artistic director of Canada's premiere Aborigi-
nal theatre company, Native Earth Performing Arts, just a
few months before.

The older woman looked up from the printed matter, towards the man sitting just to her left, a combined look of pride and puzzlement etched across her face. She uttered the words that were, at the same moment, bouncing around the young playwright's head, regarding his sudden success in the fickle world of theatre.

"Where did all this come from?" Her Ojibway accent was noticeable. She was referring to the man's unexpected success in the theatre world.

The man answered as honestly as he could. "I have no idea."

That, essentially, explains most of my career as both a Canadian and First Nations playwright. Most dramatists I have come to know spent years in university honing their craft, and were anxious to change the world and passionately explore the pros and cons of Canadian life with their dramas. Even though it has been said that all you need for theatre is two planks to stand on and a passion for theatre, most playwrights I have met entered the field armed with a substantial background in theatrical studies, a practical knowledge of Canadian theatre and a desire to tackle some of the burning issues in our society. Very few people I know wake up one morning to suddenly discover ... "I am a playwright."

I, on the other hand, am both ashamed and proud to say that's exactly what happened to me. I have no idea what I do, how I do it, or why people pay me to do it. At its core, I just try and tell a good story. I have been involved in the capricious and amazing world of Native theatre since 1988, and am grateful to say that I've had a pretty successful time of it—with more than eighty productions of approximately seventeen of my plays, including the genres of

comedy, drama, musical and theatre for young audiences. There have been a smattering of awards here and there. I have lectured on the wonders of Native theatre in at least fourteen countries around the world, and have even found myself to be the answer in a popular Toronto newspaper crossword puzzle. All in all, a good career.

That being said, I have managed all this without having ever taken a theatre or writing course in my life. I have never been to university, other than to lecture and paint the residences at Trent University as a high school summer student. I do not speak in iambic pentameter. Aristotelian versus Brechtian ... I always thought it was a famous boxing match. I am an emperor with no clothes—or to be more culturally accurate, a chief with no headdress.

If anybody is to blame, blame Tomson Highway. Right now, if not for him, I would quite probably be working at the band office on my reserve embezzling money from the Department of Indian Affairs ... I mean Aboriginal Affairs and Northern Development Canada. Instead I am tap dancing across the theatrical stage, weaving tales of mirth and sorrow. When Tomson Highway offered me the life-changing opportunity to become a writer-in-residence for Native Earth, I had seen maybe a dozen plays in my life. Most of them in high school or because I had been given a free ticket. And I discovered that most of these plays were written by dead men. Or white men. Or, more usually, dead white men. Bottom line: I did not know theatre and theatre did not know me. Occasionally we'd bump into each other on the streets, but for the most part we ignored each other.

I do not mention these humble beginnings out of pride or hubris, or even an overinflated sense of divine purpose. This notable lack of preparation in my early life

has been nothing if not annoying, even downright embarrassing, when I find myself in serious theatre history discussions. There is an entire dramaturgical and pedagogical universe beyond my means. My mother's comment was actually quite right.

"Where did this come from?"

I guess it came from Curve Lake. I was born and raised in that small Ojibway community about half an hour north of Peterborough, Ontario. Two years of school on the reserve. Ten in nearby Lakefield. I had an interest in reading but no great love or even understanding of theatre. Every year we'd study a play in high school ... something Shakespearean, or occasionally a play like *The Crucible* by Arthur Miller. Most of these offerings were not exactly relevant to a kid growing up on a Native reserve. Yes, I know most theatre theorists and practitioners would and do argue that in good theatre, the themes are universal. I understand that and to a certain extent believe it, but there's universal ... and then there's universal. My universe at the time was much smaller.

Using a quantum physics metaphor, my universe consisted of a different but similar set of laws. My universe consisted of stories and storytellers. And was enveloped by an oral culture. Growing up, we had television ... usually two or three stations that, in bad weather, could get quite snowy and difficult to watch. But I was fortunate enough to grow up right across from my grandparents' house, which was the centre of much activity in our family for obvious reasons. You have to understand that at the same time, I come from both a big and a small family. My mother was the eldest of fourteen, which can happen when you don't

have the internet. Yet I am an only child, which my mother blames on the fact that I was 11 pounds 13 ounces at birth.

So I was surrounded by an extended family. At least two dozen first cousins that I can name off the top of my head. So family meals were huge. But more pertinent to my story is the fact that in front of my grandparents' place was a big fire pit. During the more temperate times of the year, any odd number of people from our family (and friends of our family) would gather in big wooden chairs near that fire and talk. They would tell stories. They would tell jokes. They would gossip. That was my ground zero for learning about storytelling and later, making the leap to theatre. You want to talk about mastering dialogue ... I couldn't think of a better classroom.

To be honest, I wasn't exactly raised in a world of traditional storytelling. I wouldn't actually be introduced to the world of Nanabush and other old-fashioned tales till I began visiting other Native communities. But there in Curve Lake, I would describe the storytelling as more a case of who could tell the most interesting story about the community, the funniest story about a family member, the story most relevant to what was happening in Curve Lake or the world that day or week. I remember much laughter. And these stories would go on into the night. As a child I would fall asleep and those stories and the ensuing laughter would be my lullaby, wafting in through the open window. To me, that was storytelling at its most pure and simple.

It was from those humble beginnings that I learned the power of storytelling. It was as basic as you could get. Merely, the ability to take your listeners on a journey using your voice, your imagination and your body (gestures, eye

contact, facial expressions). After all, I reasoned years later, theatre was and still is the next logical extension of oral storytelling. All theatre artists are storytellers and all storytellers are theatre artists. Don't let people tell you otherwise.

The journey from that bonfire to the proscenium stage at the Centaur Theatre in Montreal—where the press package had come from—or to any of Canada's other mainstream theatres for that matter, isn't as long a journey as you may think. It's like the difference in hunting with a bow and hunting with a gun. The technology has changed but the hunter and the final product are still the same. I know, it all sounds so deceptively simple. In theory.

During what I consider the Golden Renaissance of contemporary Native theatre, post-*The Rez Sisters* by Tomson Highway, a flood of plays were being written by Native people. It's difficult not to emphasize the revolutionary effect that play, and its follow-up *Dry Lips Oughta Move to Kapuskasing*, had on pushing open the doors for other Native playwrights in the larger Canadian theatrical community. Not only did it pave the way for an entire generation of those wanting to tell Native stories in a Native way, but it demonstrated that mainstream Canada was also quite interested in seeing life from our dramatic perspective. I don't know who were more shocked, Native writers or the Canadian public. Needless to say, the floodgates had been opened, and the barbarians were streaming through.

One of the great stories about that first production of *The Rez Sisters* is that at the beginning of the run—which took place in the auditorium of the Native Canadian Centre in Toronto—the company had to give theatre tickets away

to people on the street, because nobody was really inter-
ested in seeing a play about seven Native women wanting
to go to the world's largest bingo game. Especially in such
an environment. Ticket sales had been severely lacking. By
the end of the run, it was standing room only. A legend had
been born.

For a period of time, theatre quickly became one
of the primary methods of literary expression for First
Nations people. It's not that difficult to reason why. Due
to the highly questionable education many Native people
received in reserve schools, or in residential schools, com-
pounded by the fact that English was a second language,
their grasp and execution of English was often open to crit-
icism by its native speakers (meaning of course non-Native
speakers whose first language was English ... it gets
complicated). Attempting to write or express themselves
in that written language was frequently problematic for
many and often led to discouragement. I myself was too
timid to tackle a novel until about fifteen years and almost
twenty books into my professional writing career. Even
after twenty-six published books, I don't know what a split
infinitive or dangling participle is. I hire white people for
that kind of information.

But part of the beauty of theatre was the simple fact
that the mastery of written English, with all its linguistic
mysteries and hidden rules, was secondary. What Native
people like me knew and were very comfortable express-
ing was their knowledge of oral storytelling. And as was
mentioned before, that is what theatre was and is. Cultur-
ally, Native people knew how to generate and tell a story
through dialogue. What is theatre but that?

Most dramaturges and artistic directors will tell you that developing a unique and specific voice for each of your characters is often one of the hardest tasks to master. No two or three or a dozen characters say the same thing the same way or for the same reason. They all have different ways of articulating themselves. Most first-time playwrights have characters that sound the same and express themselves similarly. If it weren't for the names above each of the lines, it would be difficult to identify who was saying what.

Stories ... I had lots to tell. Most Native people do. Western civilization—if it can be called that—had been writing down stories for more than three thousand years. Native Aboriginal First Nation Indigenous People (NAF-NIPS) had been at it for maybe two or three dozen years. A few notable successful books prior to the renaissance came from such innovators as Maria Campbell, with *Halfbreed,* and Harold Cardinal, with *The Unjust Society*. Up to then, most of our stories had been written by academics or those with a glancing knowledge of Native people and our cultures. Ironically enough, there were a few odd bits of accuracy.

I'll give you some surprising examples: *How* is actually a word in Ojibway, but it doesn't translate as "hello." We've all seen the cliché Indian raising his hand and uttering "How" in greeting. More accurately, it sort of means "okay." For instance, somebody tells you something like "I'll see you tomorrow"; you would respond with "How" to indicate you had heard and understood. I guess *Roger that* would be a good comparison. *Kemosaabe* also has its origins in the Ojbway language, but don't ask me how it

made its way to a fictional southwestern American Indian named Tonto (which by the way means "stupid" in Spanish). And it does not mean friend or trusted companion. Loosely translated, it means to look or peek through or around something. Like maybe through a mask perhaps... As I said, oddly accurate when you think about it.

But theatre, essentially, did not exist as a substantial form of expression in the Native community. Definitely not in my life on the reserve. There had been hints—the occasional appearance of a Native play, rumours of a company here or there—but if Canadian theatre was a forest, Native theatre was a bush or possibly a sapling. It was the Sasquatch of Canadian performance arts, coming from legend but rarely seen.

Canada's premiere Native theatre company, Native Earth Performing Arts (NEPA), had been operating as a community theatre venture since the early 1980s. More or less, it had started out as a collaboration of friends exploring and explaining the urban Native experience, operating out of the Toronto Friendship Centre. Up on Manitoulin Island was another theatre company, De Ba Jeh Mu Jig Theatre Group, its title meaning storytellers or tattler of tales in Ojibway/Cree. At that time, the company was mostly geared towards dramatizing legends and occasionally made a few attempts at developing and producing new work for summer theatre. Ground tremors before the big quake.

Both companies were planting seeds that would harvest writers like Tomson Highway, Daniel David Moses and myself. But theatre needs more than just writers—it needs performers. Luckily, in Toronto there was an organization called the Native Theatre School (an offshoot of the

Association for Native Development in the Performing and Visual Arts). It later became its own entity, the Centre for Indigenous Theatre.

On the other side of the country was an organization also dedicated to training theatre artists of NAFNIP ancestry, titled Spirit Song Native Theatre School. Located in Vancouver, it too produced a generation of First Nations performers.

While all this was going on, I had just graduated from community college and was kicking around Toronto, trying to figure out why I had been put on this earth. Ever since I could remember, I had always wanted to be a writer. One of my first, primary memories, dating back to when I was five years old, was sitting on steps in the house I grew up in. On my lap was a pile of comic books. I actually remember thinking to myself "Wow, next year I get to go to school and I will actually be able to read these!"

My mother, may the Great Spirit bless her, always found some way of buying me books on her working-class salary. I read voraciously. A little half-breed kid, product of a single mother, spending hours reading about far-off exotic places that I thought for sure I would never get the chance to visit. And the more I read, the more I entertained the idea of becoming a writer. But alas, both my Grade 11 English teacher and mother told me there wasn't much future in creative writing. After all, like I said, there weren't many Native writers kicking around the Canadian establishment acting as potential role models. So I abandoned any thought of becoming a writer. Of becoming anything, really.

Like a lot of youth, I lacked focus in my early twenties. Basically I lurched from job to job, contract to contract,

doing what I could to feed my very hungry landlords. Very little of it involved writing, but ironically I always worked on the fringes of the arts. I was a trainee producer for CBC Radio. I was an office boy for the Canadian Aboriginal Arts Foundation. I even ended up working for a film company shooting a children's series taking place on a fictional Native community in northwestern Ontario, as a production assistant and casting assistant—the only Native on staff ironically. It was the typical starving artist scenario, minus my being a legitimate artist.

After coming off of that television series, desperate to keep those nasty and hungry landlords at bay, I looked for any way of generating some income. I even toyed with the idea of ... *gasp* ... writing. That's how serious things had become. Through some contacts, I got an offer to write a thousand-word article about my experiences on that TV show, and the process they went through adapting Native stories into a television and film format. From the research interviews I did, I somehow got invited to write an episode for the TV show *The Beachcombers*.

It was about this time that Tomson and I began our theatrical dance. During this period, he was artistic director of Native Earth. The company had received a grant for a playwright-in-residency program from the Ontario government. At the time there were two working playwrights in Ontario: one was Tomson, the other was the outgoing Native Earth resident playwright, Daniel David Moses. So Tomson had this tasty grant and nobody to offer it to. There was some desperation involved, because if he didn't spend that grant money he would have to return it, and that went against the nature of most theatre artists. As a result, Tomson did what a lot of people find themselves

doing occasionally in that situation: he went to the bottom of the barrel and there I was, passed out. One young kid from the wilds of Curve Lake, with a single half-hour television show on his resumé. I mean, I was so green I was camouflaged. I was still trying to work out how to spell the word ... was it *theatre* or *theater*?

I had met the man a few times here and there in Toronto. After all, the Native arts scene in Toronto was fairly small—one good-sized living room could have held everybody—and while I was not yet an artist, I could have been classified as a hanger-on. The long and short of it all, if I remember correctly and he might argue I don't, is that I turned down Tomson's original offer. I was suspicious of this strange world of theatre. It seemed pretentious to me, and this whole concept of the suspension of disbelief thing... I had a better understanding of television, from the perspective of both a viewer and the little work experience I had managed to obtain. But fate would have none of that. If truth be told, I needed the money and something to do with my life.

Being the charmer he is, Tomson wheeled and dealed. He told me that as a playwright-in-residence I had to maybe sit through the rehearsals of two plays, and maybe write a play at the end of it. It was twenty weeks' work, and more importantly, it was $400 a week. In 1988, this was a lot of money. I was sold. Ironically, I am one of the few people you will meet who got into theatre for the money. Thus, innocuously, began my career in Canadian and Aboriginal theatre. As the ancient proverb goes, mighty oaks from tiny acorns grow.

Eager not to embarrass myself in this unexpected position, I began to do my research. I started to read

scripts that were lying around the Native Earth office, and see what shows I could when they appeared in the Toronto area. It was a fascinating experience. The world and possibilities of theatre ... and more importantly, the Aboriginal approach to theatre began to open up for me, and reveal itself, with all its pros and cons.

As I pored over all this new material, I was looking for the key to theatre. A formula or structure that would allow me to understand and hopefully prosper in this alien world. Television is nothing but structure, from the opening teaser right down to the placement of commercials. Almost immediately, I noticed two themes in those plays, and they were connected.

First of all, I noticed almost all the plays I read by Native authors were dark, depressing, bleak, sad and angry. All the characters onstage were oppressed, depressed or suppressed. They all tended to highlight or explore the dysfunctional aspect of the Native community. This puzzled me at first, because over the years I had been lucky enough to have travelled to more than 140 Native communities across Canada and the United States, and practically everywhere I went, from the Far North to the far south, I was usually met with a smile, a joke and a laugh. Yet almost everything I was reading about the Native community, in play form, made me wonder if these authors and I had been travelling to different communities. It was still early in my education, but I had always thought that any form of art should represent all the different facets of a culture ... evidently this did not include Native theatre.

Second (though related), one of the dominant themes that came across was rape or some form of sexual oppression. Almost all the early work in contemporary

Native theatre included a rape as one of its major metaphors. Objectively, that made perfect sense. The Native theatre renaissance, like many others, was a reaction and response to an earlier, less progressive, repressed period of time. It was born as a reaction, a way of expressing and confronting many of the issues that had kept the Aboriginal voice down—like colonization, the reserve system and residential schools. So rape became the perfect metaphor (and reality for what had and was happening to Canada's Indigenous people). You had the European (or Canadian—depending on how you want to identify it) government and religion, largely patriarchal, forcing their way into Native society, which had many strong matriarchal elements or feminist perspectives. Ironically, in the end this resulted in several hundred years of trauma and provided the perfect fodder for the explosion of Native theatre in Canada.

Though confused at first, I realized all this doom-and-gloom theatre evolved organically from those years of repression. When an oppressed people get their voice back, one of the first things they will write about is their oppression, the reasons for it and the continuing effects of it. So rape, in addition to alcoholism, adoption, cultural confusion and so on, became fact-based story ideas. Tomson even uses the quote "before the healing can take place, the poison must first be exposed" in the introduction to the play *The Rez Sisters*. And that was the genesis for this flood of dark, accusatory theatre.

So for better or worse, this was my primer for a career in Native theatre. But I had a problem. I was not really interested in writing more plays about the dysfunctional aspect of the Native community. I distinctly remember, early in my career, making myself a promise

that I would never write a play about rape or any form of sexual abuse against women. So many others were already doing it, and quite probably much better than I could do. Instead, I wanted to do something more positive. Perhaps show something a little more uplifting.

Every time I read or saw yet another play with a suicide or rape in it, I couldn't help myself from wondering "Where is the humour?" that is so well known in our various cultures. Based on decades of research, it has always been my belief that it's been our sense of humour that's allowed us to survive all those centuries of attempted Canada-fication. Often, it was our way of dealing with the world, and all the difficulties it brought us. I saw it in our stories, in how we interacted, in how we reacted to the world.

An idea began formulating in the back of my mind. One that had its original inspiration years before, as we sat around that big bonfire at my grandfather's. I remembered the stories, and the laughter. More importantly, I remembered the positive energy I always came away with. I wanted to see if I could recapture any of that. Of course there was one little problem. Wanting to write a funny story and actually writing a funny story are two different things. Let alone if this story is your first attempt at writing a play.

My first effort was a three-act monstrosity about three Native women, childhood friends, existing in various positions in Canadian society. One was a lawyer, one was an activist and one was a stay-at-home mom. It was called *Up the Road*, then *The Island*, then *Children of the Moon*. Not really understanding theatre, I had created an unwieldy three-act thing that had monologues for no reasonable purpose, special effects that would have been difficult,

and clunky story progression. But, I was told, it was funny. I remember sitting in the audience at the Tarragon Extra Space, during the first reading of the play in a workshop at NEPA's Weesageechak Begins to Dance Festival ... actually it was my first reading ever. I was leaning against a painted brick wall, picking at the peeling paint, shrinking inside, but puzzled at all the laughter. And it wasn't cruel laughter—they were laughing at my jokes. I was so new to playwriting that I don't think I consciously put jokes in. I just wrote the dialogue as I envisioned so many people I knew and had met.

Regardless, I went home after the workshop, metaphorically dug a hole in the backyard, put a bullet through the title page, and buried it deep down into Mother Earth. Hopefully it will never be seen by human eyes again. I still occasionally shudder at what I wrote. It would be like building a boat when you have very little experience. You had better learn how to swim. After this, I swore off theatre. Though I had learned an incredible amount about theatre and dramatic storytelling, and had a lot of fun, it was obvious I had no idea what to do or how to do it. I returned to Canadian television, and began work on an episode of *Street Legal*. But theatre was not yet done with me.

Several months after the workshop, I received a call from another man who has been extremely influential in my life as a playwright: Larry Lewis. He had been dramaturge and director of all of Tomson's early work. Because of this experience, Tomson had tagged him to workshop my ill-fated play at Weesageechak; he tried valiantly to save it. Soon afterwards, Larry returned to Manitoulin Island, where he had just become the new artistic director of De-Ba-Jeh-Mu-Jig Theatre.

Larry, in my opinion, was just as responsible as Tomson for the development and success of Native theatre during that coming-of-age period. He midwifed an entire theatrical industry. I like to say that Tomson gave me the opportunity to stick my big toe in the sea of theatre but it was Larry Lewis who taught me how to swim.

Larry was a non-Native dude who discovered he had an affinity for Natives and Native storytelling. Armed with academic credentials and mainstream experience, he helped create the altar of Native theatre that we all currently worship at. When the true history of this industry is written, his name should be capitalized. But back to the story. When he became AD of De-Ba-Jeh-Mu-Jig, it was a small touring company. During the summer we worked together, he had produced a production of *The Rez Sisters* that toured to many Native communities. And by doing that one show, he had basically exhausted the number of Native plays available to be produced and toured. So, taking Tomson's lead, he went to the bottom of the barrel—where I was still passed out—and told me he needed a play for that fall and winter.

Not interested and still licking my wounds, I said no. No more theatre for me. Then sneakily he said he'd pay me something like $700 or $800 for a play. Suddenly, I found myself responding, "When do you want it?" Once again, greed forced me back into the evil embraces of the cruel and harsh theatre mistress. Only this time, a little more nervous and definitely with a chip on my shoulder, I decided to do this play my way. Harking back to those stories I had heard around the campfire, I thought maybe this time I would write something that as the writer I could relate to, and would find fun and interesting. So I

began working on this one-act play about a teenager going up to a sacred site. On his journey he runs into two other young men, one from four hundred years ago and one from a hundred years in the future. During the next fifty minutes, these three boys argue, laugh, talk about girls, fight and finally come away with their own definition of what being Native means to each of them. It was this thing called *Toronto at Dreamer's Rock*.

Having blue eyes and fair hair, growing up in a First Nations community and later living off the reserve, and with no connection to my white half, I had always faced identity issues. Both Native and non-Native people had seeming difficulty believing or even acknowledging the fact I was Native. Also, I was a big fan of fantasy and sci-fi stories, and their possibilities. It was a way to explore everyday issues in a new and interesting manner. So why not combine the two, I thought. If I was being paid to do something I had no experience or little talent with, I would at least have some fun failing it before leaving it behind, like the one time I tried skiing...

The problem with that theory is that the play became a huge success. It was remounted half a dozen times in the following two or three years. Published that following year. Compounding the issue, I won a prestigious writing award for it, which consisted of a plaque and a cheque for $10,000 that I almost lost in a bar that night, but that's another story. The worst aftershock came from a close friend, who over the years had seen me work as a soundman in documentary films, had read those occasional articles I had managed to scratch out, had seen my *Beachcombers*. She came to the opening of this new play when it toured to Toronto. Afterwards she

walked up to me, hugged me, and said, "Oh Drew, you finally found your medium. Good for you!"

That was when I realized, despite my best efforts and those of my mother and Grade 11 English teacher, I was a Native playwright. It was a shock. Let it be known, the Creator does indeed have a sense of humour.

Since those days, I have written about a dozen and a half plays that have been translated into Arabic, Czech, German and Italian. I was artistic director of NEPA for three years. I have travelled the world spreading the gospel of Native theatre as I went. And now, as I notice more grey in my hair, the second and possibly even third generation of First Nations playwrights have been staking out their claim. New ideas and new themes are emerging. What was once new and avant-garde is now mainstream.

Many of this new generation of storytellers are properly trained, having waded through the swamps of academia and skinned the moose of knowledge. In other words, they actually know what they are doing. I envy them. And oddly enough, more of them than not have sprung from an urban environment. To these jaded eyes, there is a different pulse or feel to their work. Not better or worse, just different.

It's been a long time since I have had the opportunity to tell a story around a campfire. I still do it across the kitchen table occasionally. And after having visited so many different countries, the stories I have to tell at that kitchen table sometimes take on a more ... international flavour. More tapas than tea. More biryani than bannock. More kimchi than corn soup.

Being a storyteller is like being God, but in a non-sacrilegious manner. It's the ability to create universes

and people, make them fall in love or fall out of love, fight, argue, create problems and possibly find their solutions. You can motivate and celebrate. You can make people laugh, cry or shake with anger. Bonfires can do more than keep your toes warm and toast your marshmallows.

Thomas King has written that stories are "all that we are" (*The Truth about Stories*, 2003, p. 2).

A contemporary storyteller, that's all I wanna be— but hopefully that doesn't make me a "wannabe."

Drumming 101

STEVE TEEKENS
traditional drummer

*A*S A PERSON WHO NEVER GREW UP ON MY FIRST Nation, I can say that I had a very limited exposure to my culture and traditions in my early days. The first time I ever heard and felt the sound of the big drum or powwow drum was a very moving experience for me. I must have been about thirteen or fourteen years old, and my parents took my siblings as well as me to that first powwow, which I believe was at Six Nations. I remember that I could hear the drumming before we even reached the powwow grounds. The sound was a deep pulsing rhythm that seemed to draw me in. As I got closer to the drumming I could hear the singing, which was like nothing I had ever heard before. I do not recall if I thought it was beautiful, but I was very curious about the drumming and singing.

I often describe that the drumming and singing drew me in like a magnet. As I got close to the drum, not only could I hear it and singing but I could actually feel the sound sort of hitting me. This experience intrigued me even more. I knew that I wanted to be a drummer

even back then, but there was only one problem: I was extremely shy. So I was happy asking my parents to take us to powwows and quite content being a spectator and taking the whole experience in, listening to the drumming and the songs. I could tell the difference in the singing melodies and drumbeats of different songs. I remember someone once asked me, "Why do you like that music? Don't all the songs sound the same?" To me the songs were not the same—the chanting or singing was different for each song and the drumbeats varied from song to song.

I remember that by my last years of high school I had evolved from being a spectator to being a volunteer at powwows and helping out wherever I could. I did the volunteering for years and learned about powwow organizing. When I went to college later, I found myself organizing the college's annual powwow. I was still a shy person, but had grown slightly less shy. It was just before that first college event that I had decided to ask these drummer guys I know if I could sit at their drum and drum with them. Day one of the powwow came and went and my shyness had got the better of me—I hadn't asked the drummer guys. Day two came along and I knew I had better ask them or I likely would not have a chance like this again. So shortly before the powwow was over I finally asked if I could drum with them. To my surprise the guys said yes. They gave me a chair to sit on and handed me a drumstick and asked, "Can you sing?" I said "No, but I want to learn." They then asked if I had drummed before. Again I said no but I wanted to learn, so I was told to only drum on the edge of the drum when they did their next song. I agreed, and when their song came up I drummed on the edge or rim of the drum. Then I noticed I was the only one who was drumming like

this—the other drummers were drumming closer to the middle of our drum, and the sound of their drumming could be heard more than mine. I decided I would drum just like them. As soon as I drummed off the edge the drumbeat sounded like horses trotting and the drumbeat was off. I looked quickly around and it seemed like all the drummers were looking at me. Then I looked at my drumstick and saw these other drumsticks knocking my stick off the drum, with the guys motioning to me to drum on the edge of the drum. After the song was over, I quietly walked away and didn't drum again for about four years.

In the summer of 1995 I moved to Toronto and took up a job working with Native youth. I decided to give the drumming another try. Things worked out very well for me because when I started my job working with youth, I was asked if I would be willing to supervise the drumming after regular hours. I was more than happy to stay late. To boot, I was also told that it would be good if I sat at the drum and encouraged the youth to drum. I was more than happy to do that. Taking my place there, I felt an instant connection to the drum: it changed something inside me and it was very moving for me, although this is sort of difficult to explain. I also felt no pressure to be a good singer and drummer because the youth were also learning and it was a safe place to learn and make mistakes drumming. There was no shame in drumming offbeat, which we did frequently.

I would say that after a couple of years of being the staff representative for drum practice, I started to get good at drumming and singing. I could sing a song all the way through, I could drum on beat and sing at the same time and was able to sing in harmony with the other singers. It

was around this time that I was getting asked to drum and sing at powwows and started attending other drum practices in the city at other Native organizations. It was also around this time that I became curious about the drum origins and teachings. Curiously, despite the problems going on in my life, I would feel better after drumming. Why did I feel good when I was around the drum? So I started asking about the teachings of the drum, and because I was genuinely curious, I kept asking. It wasn't too long before I received some instruction, and over time I learned quite a few different teachings about the drum and its origins.

What I was taught made so much sense to me and helped me to understand why I felt the way I did when I was around the drum. Basically, the drum has a spirit inside it and should be treated well. It came to the Anishnabe people during a difficult time, to help remind the people of the heartbeat of Mother Earth and to get more in tune with themselves and treat each other with respect. After learning these things about the drum, the bond I had developed with it was more concrete.

When I first started drumming, the type of drum we used to use was an old kick bass drum from a contemporary drum-kit set that was placed on its side. This was the type of drum a lot of drum groups used back then. I recall when the guys from the practices were given a more traditional powwow drum with rawhide on each side. We were so proud and happy to use it. I felt like a little kid in a candy store, I was so happy! The only problem with that drum was that the hide strings on the side were tearing apart, but we kept using the drum until it really started to fall apart. We had tried to find someone who knew how to fix the drum, but couldn't find anyone.

So I had acquired a buffalo rawhide and, without knowing exactly what I was doing, I took the hide off the broken drum's frame and put the new hide on, which repaired the drum. This was my introduction to working with rawhide and making drums.

MAKING DRUMS

I REALLY ENJOYED repairing that first big drum we'd been presented with. Working with hides really made me curious about making drums. Over time I learned how to make the drum frames or hoops and started making hand drums and powwow drums. Additionally, I eventually started doing drum-making workshops at different First Nations and at Native organizations all over Ontario, showing people how to make drums and giving the teachings that go with the drum. As I write this essay, I have been presenting drum-making workshops for almost two decades.

When I make drums, it's not like mass production. I have to be in the mood to make them. It is a process for me. It usually starts with making the wooden frames, which involves a considerable amount of woodworking. Usually I cut the wood with precise angles, then glue the pieces together to form the frames. Then I rough-sand them to take the edges off, to make them circular. After rough-sanding the frames, I fine-sand them so they are nice and smooth. This is a time-consuming process and good thoughts and energy are put into the creation of the frames. Once the frames are complete, I prepare the hides.

There are two types of rawhide I use: one comes from a tannery and is prepared with chemicals and

Steve Teekens prepares pieces of hide to be made into rawhide for drum-making. PHOTOS COURTESY OF STEVE TEEKENS

machinery, while the other type I prepare myself once in a while—this is a very long process, and it can take days to turn the hide of a deer of moose, complete with fur and fat, into rawhide. The process of turning a hide with fur into rawhide starts with soaking it in water for a period of days. Once the hide starts to smell bad, it's usually ready to start working with. The hide needs to soak water so the pores can open up. This allows the fur to be taken off easily, by scraping it or pulling it by hand. On the other side of the hide, I scrape off the fat and membrane, a process called fleshing. The fleshing is a labour-intensive process that takes time. Usually, if I do an entire moose hide, it can take me a whole day, sunup to sundown, for only one side. It takes me about the same amount of time to prepare the other side, if I am working by myself. Once both sides of the hide are fleshed and the fur stripped, the rawhide is stretched and dried and ready to be part of a drum.

The next process in making a drum is soaking the dry rawhide, once again in water, for about a day or less, so the rawhide is workable and not hard and stiff. The next step is cutting the hide a little larger than the drum frame. Small holes are then poked or punched into the edges of the hide to allow rawhide string or lace to go though to help fasten the hide to the wooden frame. Rawhide string is cut from the excess wet hide left over from covering the drum frame. When cutting the rawhide string, I am careful to "read" the hide and assess its thickness, and watch for weak spots. Where the rawhide is thin, I cut the string width slightly thicker to compensate for the hide potentially being weaker. Once the string cutting is complete, I go back and stretch the string, then trim it to ensure its width is uniform. Usually around this time my hands are

sore, because this is not easy work. To me this is a labour of love, and I enjoy this work. Once the string and hides are cut and the holes are made, the wet hides are ready to be placed on the frame and strung in such a way that they stretch and fasten the hide to the wooden frame. When I stretch hide over the frame, I carefully go back and tighten the string uniformly with the proper tension so that the hide or hides are tight enough to make a nice resonating sound when the stretched hide dries on the wooden frame. The drying process can vary, but usually I wait from two to four days to allow the hide to dry properly.

Hand drums and powwow drums can be made from a variety of animal rawhide. For small hand drums I prefer to use deer, moose or elk rawhide. For the big powwow drums I prefer to use moose or buffalo hide, because it tends to be thicker and more durable.

Many factors can affect the sound and tone of a drum, including the thickness of the rawhide, the humidity or dryness of the air, how tight the hide is stretched on the drum, the thickness and width of the wooden drum frame, and even the type of wood used on the drum. If a drum is flat or has no resonating tone, usually it could use the gentle application of heat to tighten up the hide to help it sound better. If the drum has a high pitch or pingy sound, that might indicate that the hide is too tight. This often happens if the drum is stored in a place where the air is too dry. The way to fix this is to apply water on the hide to allow it to loosen up a little. I usually tune a tight drum by dipping my hand in water and rubbing my wet hand over the rawhide to allow the hide to absorb the water. I also would rub my wet hand across the rawhide strings.

A completed handmade rawhide drum made by Steve Teekens.

THE FOUR CIRCLES AROUND THE DRUM

IN ANISHNABE COMMUNITIES you can often find the pow-wow drum or drums in the centre of the powwow. Usually they are under a shady shelter called an arbour. When the powwow is set up in this fashion, you will find that there are four circles around the drum or the drums.

The first circle is made up of the men, who are the singers and drummers. When the men form this first circle they sing and drum. When the men sing, they sing with one voice, meaning that they sing in harmony with each other. To be able to sing in harmony with other

singers like that takes practice and the ability to use your voice like an instrument.

While the men sing they also drum, each singer using his own drumstick, and sound the drum at the same time to create the drumbeat. Being able to sound the drum as one takes practice and usually does not happen overnight. The ability for several singers to sound the drum at exactly the same time is very important, as the drum also creates the tempo and the beat for the dancers to dance.

The second circle around the powwow drum is made up of the women. They usually stand behind the men and sing in harmony with the men. The women sing in a slightly different way from the men: they start their singing slightly after the men and also sing much higher than the men. In musical talk they sing an octave higher, but this must still be in harmony. The women are not always found singing behind the men: when I first started drumming, it was a rare occurrence to see the women singing behind the men, but nowadays it happens more frequently—and it's very beautiful to hear.

The third circle around the drum is made up of the dancers. It is said the dancers dance to celebrate life. As they dance, they may be praying for someone who is not doing so well or is sick. Sometimes the dancers are given tobacco to pray for people in need of prayer.

The regalia the dancers wear is often said to be a reflection of the individual dancers' spirit. The items they wear may give an indication of their spiritual colours, or the clan they belong to or the animals that have special significance to them. The beadwork a dancer wears may also give an indication of the tribal group the dancer belongs to. So, the individual dancers' regalia are almost

always unique and reflect each dancer's spirit—that is, if the regalia are not hand-me-downs. It is almost unheard of for two dancers to be wearing identical regalia. It's not as though powwow dancers can go to Walmart, take regalia off the rack in their size and start wearing them. A great deal of the time, thought and creativity go into making an individual's regalia. Additionally there are different styles of dancing in both the men's and women's categories of powwow dancing.

The fourth circle around the drum—a circle that only some people can see—is said to be made up of the spirits: the spirits of our relatives and ancestors who have gone on to the spirit world. They say the spirits are happy because we still have our cultural and spiritual ways, including our ceremonies, songs and dances, despite the organized efforts to end our cultural and spiritual practices. Our cultural and spiritual practices will carry on for future generations because our young people are learning our ways, and they will remain with us as time goes on.

THE SEVEN GRANDFATHER TEACHINGS

WHEN THE MEN gather around the drum that I carry, I try to be conscious of the Seven Grandfather Teachings. These are qualities or teaching that we should each strive to have in our life in order to live a good life. In no particular order they are: Love, Respect, Humility, Wisdom, Bravery/Courage, Honesty and Truth. I used to wonder how these beautiful teachings fit in around the drum. I came to understand that there is a place for all seven of these teachings around the drum, and I will briefly explain.

Love: It's so obvious how this fits in. I love to sit around the drum with my good friends, I love them like brothers! Some of the guys in my group I have known for years and we have seen our kids grow up and now some of their kids drum in our group. Not only do I love the guys in my group like brothers, but I love drumming and singing and seeing people dance to our songs. When I sing, I try to put my heart and feelings into the singing. It makes my heart happy when I see people having fun dancing to the songs we are singing.

Respect: I have a lot of respect for the drum and believe there is a spirit inside it. Some of the teachings on the powwow drum say the drum should be treated like a grandparent and respected. As the person in our group who is the drum keeper or caretaker of the drum, I have a feast for the drum regularly to feed the spirit in the drum. I carry a great deal of respect for the drum.

Humility: I always try to be humble when I come around the drum. I fully appreciate the gift I have in my singing and drumming; I appreciate that I am able to sit at the drum. I have had my voice go on me at powwows and at ceremonies in the past. The drum is a gift and it can be taken away if it is not cared for properly or the drumsticks could disappear or get lost. I know of drummers who have had the hide on their drum rip, or once one of the guys in my group lost our drumsticks and we were without drumsticks for a while and had to humble ourselves and ask to borrow sticks from another drum group. I have learned to appreciate these things while I have them and to be thankful for these gifts by being humble and not grow a swollen head because of the opportunities the drumming

has brought to my group and myself, because they could be taken away easily.

Wisdom: From being around the drum and being able to travel to powwows and ceremonies all over the place for a period of many years, I have learned to be a good listener to other people carrying traditional knowledge and spiritual teachings. Through this process I have been able to acquire wisdom. It is not just from simply sitting around the drum and travelling that wisdom can be acquired. It comes from talking to others and hearing their stories. If you listen well or learn from different experiences while travelling the powwow trail, you may be able to acquire wisdom.

Bravery/Courage: I often used to wonder how bravery or courage fit in around the drum. All I have to do is think about the first time I built up enough courage to ask to sit at the drum—which meant a great deal of courage for me. I am glad I was courageous enough to ask to sit at the drum for the first time and overcame my often overwhelming shyness. I imagine that for other people wanting to learn to drum it must also have taken a little bravery or courage to sit at the drum for the first time. I am glad I took a healthy risk and was able to get out of my comfort zone to be courageous enough to ask to sit at the drum for my first time. Who knows, if I had not been courageous enough, I may not have had the relationship I now have with drumming.

Honesty: When I am around the drum I try to be honest with myself and the feelings I carry. If I am carrying hard feelings about someone at the drum, I try to put those ill feelings aside, because there is no place for ill feelings

towards others around the drum. If I feel ill feelings for someone, I may remove myself from the drum so that negative energy is not present around the drum. When I used to teach drumming with youth, youth being youth, sometimes they would experiment with drugs or alcohol. I would sometimes ask that if anyone had been drinking or drugging, they could wait at least four days before sitting at the drum—out of respect for the drum, themselves and the others around the drum. I would ask them to be honest with themselves before they joined the drum. They did not have to disclose what they had been doing, just simply say they couldn't be around the drum at the moment.

Truth: Finally, there is a place for truth around the drum. The walk with the Seven Grandfather Teachings and the drum is to live a truly good life. To know and live by these teaching is to know yourself and to know the truth.

THE FOUR PARTS TO A SONG

FOR MANY OF our songs—whether they are ceremonial songs or powwow songs or even round dance songs—the song structure contains four parts that are sung repeatedly. The songs are often a call and response. Usually, one singer starts singing solo—this is called the lead. The second part of the song is sung by all the singers, who repeat the lead, which is often sung slightly longer than the first lead. The third part of the song—the main body of the work—is longer and all the singers sing this part. The fourth part is a repeat of the main body of the song, and again all the singers sing. Then the four parts of the song are repeated again and again. Often at a powwow, the

announcer or master of ceremonies will call on a drum to sing and might ask the singers to perform the song four times through, also called doing four "pushups."

MY DRUM GROUP AND OUR TRAVELS

I OFTEN SAY that the drum has been really good to me and my family. In my definition of family, I like to include my friends in my drum group, the Red Spirit Singers. I consider some of these guys to be part of my extended family. Some of these guys I have drummed with for a long time—we have been able to see our children grow up from being around the drum.

The drum has taken us to many places and interesting events, one of the most interesting of which was when we were invited to drum in 2002 at Downsview Park in Toronto for World Youth Day. This was a spectacular event because Pope John Paul II was visiting and our drum group was asked to sing. There were about a million people at Downsview Park. We were up on a stage that had to be about one hundred feet up above the ground, and from there we could see a sea of people stretching as far as the eye could see. It was an amazing experience! We were asked to arrive a day prior to the Pope's huge Mass. Security was extremely tight that night, and that was when we made a new song that we planned to sing for the Pope and his audience. We practised it all night and had it ingrained in our memories.

We were eventually summoned to the stage, and warned not to bring any cameras. Being the slight rebel that I can be, I shoved my camera in my pocket and

carried the drum up onstage with our singers and some dancers who were with us. When we arrived onstage, seeing all those people gave us amazing energy. It was an indescribable experience. When the time was right, I grabbed my camera and took pictures of our group and the dancers, with the sea of people behind us. Looking at the pictures reminded me of what it might have been like in Woodstock in the late 1960s, except this was an entirely different audience.

When it came time for us to perform our new song for the Pope, we began drumming and singing. The dancers started dancing too. For some reason we messed up the singing part of our new song in front of the biggest audience we had ever sung in front of. When the song was done, we were disappointed that we'd messed up our new song in front of such a huge crowd. However, to our complete surprise we received a huge cheer from the audience. I guess the audience were not big listeners to powwow songs and never even knew we had messed up our song. It seemed the only ones who knew we had messed up was us drummers and the dancers. That was quite the experience.

Our drum group, the Red Spirit Singers, has been around since 1998. We have been fortunate to be able to travel to many powwows and ceremonies. I have had a lot of guys come to the drum and go from the drum for various reasons. Today we are still going on strong and some of the guys in the group have been singing with me for a decade or more. I have to say the drum has been extremely good to me and my family. It has taken me almost around the world. In my travels I have learned that almost every culture in the world has a drum and many still have their teaching on the drum and its origins. I believe the drum

makes the Creator's favourite music—why would almost every culture in the world have a drum if it didn't? In Anishnabe culture you pretty much do not have a powwow or any other ceremony if the drum is not present; without the drum there would be no powwow.

Uncle Richard Van Camp's Storytelling Tips

......................................

RICHARD VAN CAMP
storyteller & writer

*H*I, EVERYONE.

I hope you're having a great day. At forty-two years of age, I am the luckiest man I know: our family is healthy and growing, I'm working on telling the stories of my dreams and I'm sharing the stories I worry about that the world may be forgetting.

I was so lucky to grow up in Fort Smith, NWT, where storytelling is revered. Sure, there's juicy gossip, but there's nothing like a room that is hushed as a storyteller begins weaving his or her medicine and the medicine of the story in a room that becomes family because of sharing.

I love storytelling. I actually love hearing great stories just as much as I enjoy losing myself in a great story when the channelling begins. It's the most wonderful feeling: knowing that you're sharing something important. In our traditional ways, we are told to tell stories every day and share them in the best way we can.

So that's what I do now. I am lucky to tour and I find now that when I'm marketed as a writer visiting a

community, we can sometimes pack the room, but when I'm marketed as a storyteller, it's standing room only. I think this is because we are all lonesome for stories; we are all lonesome for connection and community. It's stories that unite us and remind us of our place in the world as brothers and sisters, and it's an honour to be known as a great storyteller.

I wanted to sit down and share a few tips on how anyone can become a great storyteller. For those who are nervous as a public speaker, there's an old Indian trick where you bring a lot of props, so this way you can hide behind them for a bit before the spirit of the stories you wish to share gets everyone in the room sharing.

There's also another great technique where you get everyone in the room to introduce themselves; ask them why they've come and, chances are, your visitors will get going on their own stories and that'll spark the room.

Everyone loves a great ghost story and a sweet love story. Everyone loves hearing about how someone beat the unbeatable. What's your story? I bet you can amaze anyone if you share it.

I love stories and I think it's safe to say that everyone else does too. They remind us all just how precious life is.

Mahsi cho. I hope these help.

Happy sharing!

With respect,

RICHARD VAN CAMP

STORYTELLING TIP #1: LOCATE YOURSELF AND HONOUR YOUR AUDIENCE

HERE'S THE GOOD news: All great storytelling sessions are really just a great opportunity to visit.

A great storyteller leaves his or her audience better than he or she found them, so if you go into a room with a closed mind about what stories you are going to tell, you may be missing out on a chance to really connect with your listeners.

It is very important that when you do go before an audience, you locate yourself. Please tell people who you are and where you are from. It is always respectful to acknowledge the traditional people of the land on whose territory you are standing. For example, a great way to say this is, "I would like to acknowledge the Musqueam people on whose traditional territory we are gathered here today." If you do not know whose land you are on, you can say, "I would like to acknowledge the traditional keepers of this territory on whose land we gather today." This way you acknowledge the traditional people of the land and the ancestors and the land itself.

Without these introductions of who you are and where you are from, the bond will not have begun properly for a good visit. Many times I have seen a storyteller who launches into stories that are fantastic but ruined because the audience does not know who this person is or where they are from or why this storyteller should be trusted.

Everyone likes to learn and when you introduce yourself you are extending the hand of friendship and that is storytelling in a good way.

What I like to do is go into a room, thank my hosts, acknowledge whose traditional territory we are gathered on, tell people where I am from and share some stories about Fort Smith and my family and being raised in a time of storytelling and visiting. The whole time I am doing this I am reading the audience to see if there are any children or youth who may be nervous if I tell adult stories or stories that are about ghosts or bad medicine. Believe me: if you're going to make children nervous, you are going to have parents nervous and that shouldn't be the case. Your audience should be engaged and curious as to what you are going to say, not dreading another story that is offensive to the values of those who have travelled to see you.

So, read your audience, see who you are speaking to and, all the while, you should be sensing what is acceptable and what isn't with your audience. Also, if you are sensing that the audience is getting tired, it is always wise to cut your presentation short.

The key here is to connect to your audience through eye contact, voice level, body language and sincerity. Go on out there and have fun. Storytelling is like dancing or swimming, you just have to go for it!

STORYTELLING TIP #2: BE THERE

THERE IS NOTHING more important than being completely centred when you are about to share some good medicine with a group. Yes, we all have struggles. Everybody has problems. But you have to let all that go when you walk into a room.

A group will know if you are not completely there. Humans can sense worry and distraction in other humans. It's a survival thing. Can they trust you if you are looking over your shoulder and stammering your way through a half-hearted attempt at a story? Probably not.

Please know that when you stand up to share a story, people are automatically rooting for you. People want to visit. People *need* to visit! We are social animals, just like wolves!

So get on up there and enjoy yourself. As a storyteller, all you have to do is be there, enjoy yourself, share what it is you need to share, and you'll be surprised how easy it is to really celebrate being alive in front of your listeners.

Honour them!

STORYTELLING TIP #3: DON'T SCOLD OR LECTURE

THIS IS IMPORTANT. I've gone to many storytelling conferences and still wince when I think of the storytellers who have stood up and scolded their audience for not living a certain way, or lectured them on why their way of life is better than anyone else's. Yikes! This is not a good way, in my opinion, to honour anyone.

And it only shows that storytellers who do that are pushing an agenda and that is not honouring the audience because, as a storyteller, you are there to honour the people who have travelled to see you and learn something from you.

By walking into a room with an agenda you have already closed off that crucial human connection that we

are all wishing to feel with one another. People will sense it right away and this will only bring a room down fast.

No race has a monopoly on a better way of life. Every nation has something to offer us in the circle of life.

Those who have shown up to listen to you want to learn something, want to feel something, want to laugh and let go. They have made the time for you and do not need to be scolded or made to feel less than they are.

Honour your audience. Uplift their spirits. A great storyteller leaves every place and every person better than he or she found them.

A ho!

STORYTELLING TIP #4: LET GO

A GREAT STORYTELLING session is a dance of trust. Your audience is trusting you to take them to places of mystery and you have to trust your audience to guide you so that you can do exactly this.

This involves letting go.

Many times when I walk into a room or lecture hall I have no idea what stories I am going to share. It could be about the haunted woodstove in Fort Smith; it could be about the traditional medicine used in our town; it could be about how my three brothers are still trying to beat me up(!).

As I locate myself in front of an audience and share a bit about my background in terms of family, hometown and where I work, I am establishing that crucial bridge between myself and the audience. I am surveying the

audience and feeling my way through the energy in the room.

Many times I share a story and have no idea why I am sharing it. I am completely into it and am quietly thinking, "Oh Richard. Richard Richard Richard. Why are you sharing the hickey story?"

The truth is, I already know what I can and can't get away with here, with this audience, and "the hickey story," for example, may well be hilarious, but deep down I know that someone really needs to hear it.

Many times, after a great visit with an audience, I have people coming up to me thanking me so much for sharing a certain story. "I really needed to hear that story you told. It was good medicine for me." And that's that.

You see, I did not guide the audience. I located myself, got a sense of the energy in the room, opened my heart and mind and then let the audience guide me in what stories they wanted to hear.

So when you walk into a room and begin your visit, let go and begin the dance of trust. Your listeners will love you for it!

"Give'er!" as Northerners like to cheer!

STORYTELLING TIP #5: FIND A MENTOR OR MENTORS

ONE OF THE best things storytellers at any level can do is surround themselves with storytellers they admire. The more we listen and observe, the more tricks of the trade we can adopt. If, for example, you love how Ivan Coyote stands on her toes when she gets into the most emotional part of the story onstage, why not take that on yourself? If

you love how Ellen White takes her voice really high when she tells her mosquito creation story, do that too. Imitate those you admire. Eventually you will adopt some techniques from the living treasures around you and you will let other techniques go, to form your own style.

And this is the craft of storytelling. After a while, each storyteller's technique will evolve so that your name is known far and wide and you will have people who acknowledge you as a storyteller. This is easily the highest compliment I have ever received and this is my wish for you!

So run on out there and spend time with your mentors. If you know a storyteller who performs regularly in your community, ask if you can shuttle him or her around and help get the storytelling room set up. Ask if you can help take care of the paperwork involved and perhaps, if the storyteller is an Elder, write the thank-you letters for him or her after a performance. Let this person know that you want to become a storyteller just like them and wish to be an apprentice.

I know this can sound intimidating, but most storytellers would be honoured to know that someone wishes to learn as much as they can from them.

Don't be afraid to bring your mentor gifts: salmon, blueberries, tobacco and so on are always a great idea. Honour your mentors and they shall mentor you.

When I travel to the North I always stop at Irene Sanderson's house. She's an Elder I've known my whole life. I stop in and out comes the coffee and the smiles. We laugh, visit, gossip, catch up, but, after we have that out of the way, Irene will start telling me stories about her family, her life, the history of Fort Smith—and I listen. I listen with

everything inside of me. I'm recording, in my own way, the stories she is gifting me with because one day someone may ask me to share a story about Irene when she's not here and I shall be able to.

Another thing about visiting mentors is you can keep asking them questions about certain stories until you get the story right. I still go back and ask Irene questions to make certain I'm not messing up one of her stories. And I always walk away wiser, humbler and armed with new insight into one of the living treasures of our town: Irene Sanderson.

I have been learning from her for over a decade and we both treasure our relationship as mentor and student.

STORYTELLING TIP #6: FIND AN APPRENTICE

MORE AND MORE I notice that my brother Jamie is asking me to tell him stories. We'll be cruising around Fort Smith or Yellowknife and he'll just say, "Tell me a story." So I'll ask him what kind of story he wants to hear. Sometimes it's a love story, a ghost story or a medicine story. What he wants he gets. He is, after all, my baby brother. It's funny how life works: I am the oldest of four boys and yet I am the shortest. Good thing I fight dirty, hey? That's probably the only reason I'm still around. There is always one swipe left in the old lion, hey!

But, in our own quiet way, it has been decided that Jamie is my apprentice. I tell him the stories I haven't told anyone else and sometimes he'll ask me to retell some of my classics or ones I've shared with him years ago. Ones I am starting to forget.

Thank goodness my brother is collecting my stories!

As a storyteller, it is your duty to share your stories wherever you go. It is also your responsibility to find an apprentice and really train them in a good way to remember your stories. This way, you know that your stories will live on in the way you want them to.

Mahsi!

STORYTELLING TIP #7: BECOME THE STORY

NOW THAT YOU'VE introduced yourself, told your audience where you are from, what you do, a bit about your family—and established that crucial link with your listeners—you are ready to share some stories that want to be told.

But here's something very important that I want to share with you: make sure you dress up as a storyteller. Even stand-up comics dress up, eh! Get spruced up for every occasion. It's important. You'll find, as you are getting ready to share your stories and you're putting your fancy clothes on, that you are in a ritual of preparing yourself to honour your audience. Often, I will pray and ask for guidance so I leave each person and place better than I found them. I will also pray that I do not offend anyone and that I leave each person with a lighter spirit and a full heart. That is my wish every time.

A good storyteller stands and faces the audience. I have seen time and time again that a storyteller who sits will nine times out of ten not establish the crucial link that a good visit entails. I will always stand because this opens up the body for sound and movement. It also welcomes energy, so you can move fast with the story or slow down. If you are showing how tired someone is it is very hard to

do while sitting. Also, people do not want to be craning their necks to see you.

Get that podium and mic out of the way. Those block the link between you and your audience. Trust me on this: if you don't need a mic, get it out of the way. If you are speaking to two thousand people then by all means employ the mic, but try and make it a wireless mic or one of those doodads that goes around your ear.

Remember: what is important is that you stand and deliver your story in a good way. Your voice and body movements and facial expressions are your tools to become the story.

If you need to move stage left because you feel there's a bit too much chitter-chatter going on over there and you want those kids to know you are aware of their energy, then head on over there. If you want to start hopping around the stage to show what it feels like to have your tail on fire as in a coyote story, by all means start hopping! The point here is that a great story will get you moving around making a clown out of yourself or just dominating the space with action. The key here is for you to enjoy yourself. You're a storyteller. This gives you a passport to get on up onstage and really have fun. Do your best imitations, hang your head and limp when you speak of the wounded, stagger around the stage if you are talking about your crazy uncles—do whatever you have to to deliver that story in the best way.

People really want to see you enjoy yourself. If they know you've given 100 percent they will really enjoy their time with you.

And this is how you become the story: you act it out, give 100 percent of yourself and you will never lose. Uncle promises!

STORYTELLING TIP #8: READ YOUR AUDIENCE

IT IS IMPORTANT that, as you are locating yourself for your listeners with who you are and where you are, you read your audience. Who are you dealing with?

Recently I spoke at the University of Washington by invitation of the Centre for Canadian Studies. I was asked to speak about aboriginal literature in Canada. As I walked in I was very surprised to see at least twenty gigantic football players in the back row. Most of them had their laptops open and they were obviously a close team with their own code of conduct.

I was not expecting this at all. But, you see, the professor was a wrestling and boxing legend on campus and these students studied both sports with him when they weren't dominating the USA with their skill as football players.

Everything I wanted to do went out the window as soon as I saw that the majority of the students in the room were tough men who were used to training and dishing out some punishment.

I was a bit worried about the laptops. I understand that at a university some students like to take notes during a lecture, but I could tell the students were downloading music, updating their Myspace sites and reading emails.

As I introduced myself, I started to make eye contact with each of the football players there and I started to talk about how when we were growing up in the Northwest Territories my grandparents were powerful medicine people and how people would travel for miles to see them to be prayed for. I talked about how my grandfather cured a boy who stuttered. I spoke about how my grandmother was trained as someone who brought peace to those who were getting ready to pass on. I spoke about how frustrated I was that I could not speak directly to my grandparents as they were very traditional Dogrib Indians and how I had to learn French from kindergarten through Grade 12. As I spoke, I spoke softly. The students who had been whispering to each other in the beginning were now no longer talking. Many of the guys at the back started to close their laptops.

I spoke sincerely and quietly and from the heart. I spoke to them as a man with something to say and they could all relate in their own way to what I was saying. Some of us were the same age and yet I came from a different place with a different background. I am very fair and yet they were surprised when I greeted them in Dogrib. They were touched when I told them about how Irene Sanderson cured her brother's gangrene using beaver castors. I asked if anyone in the room had asthma and the biggest guy there raised his hand (shyly) and I told them that there is an Elder in our hometown, Maria Brown, who has cured many people with asthma by using goose grease.

My lecture went out the window because what I felt as soon as I walked into the room was that the class wanted to learn something magical from someone. They wanted a visit, and visiting is becoming a lost art in so many ways.

I only had fifty minutes with them, but I used the time in a good way to honour them and speak to them gently and respectfully, and they were appreciative when I was done.

What a joy that visit was!

Had I stuck to my lecture, I'm sure the laptops would have stayed up, the whispering in the back row would have continued and we all would have lost out on something I'm sure we will all remember. I hope so anyway!

By reading your audience you are getting a sense of what the audience is expecting and what they want. If your talk has been set up as a lecture, this is fine. But if your audience in that lecture have been sitting through lecture after lecture and are getting a bit long in the face, why not spruce it up with some great storytelling? It's good medicine for everyone.

STORYTELLING TIP #9: ASK FOR FEEDBACK

WHEN YOU ARE finished sharing your stories, ask the audience if they have any questions. This is important. It is very easy to lose yourself in the stories that want to be told. Perhaps you've missed following up on a family you spoke about or perhaps someone in the audience is curious as to how someone you spoke about is doing today.

This is a good way to invite participation from your audience and can often lead to great discussion and, hopefully, even more storytelling.

Often, when I am done sharing stories, I save ten to fifteen minutes at the end for exactly this. It is a great way to hear comments and to invite others to share their

thoughts with the group. It is also a great way to close the bond you've created in a good way.

At the same time, you are inviting feedback from your audience as to how you did. I think it is always wise to remain a student of any craft and sometimes, if you keep hearing that people do not understand something you have said, it is best to revisit that story and change it so that your message is clear.

Mahsi.

STORYTELLING TIP #10: GET INVOLVED WITH YOUR LOCAL STORYTELLING COMMUNITY

STORYTELLING IS A lot like dancing or swimming. I keep saying that and it's true: you just have to get on out there and do it or you'll end up sitting on the sidelines missing out on something incredible.

If you are nervous about finding a community for your storytelling, why not have a full moon ceremony in which you have a feast and put on some candles and get everyone to share a story? This is a gentle ceremony in which everyone is honoured and it's very informal and a lot of fun.

If you want, why not start up a storytelling group where you get together at a local coffee shop and share stories? Many coffee houses now have an open mic evening and would be happy for the business.

There are usually storytelling festivals in larger cities. This is a great chance to listen to storytellers from all over the world. There are usually open mic events for

people to get on up there and share a story or two with an audience.

The key is to get up there and share a story. Once you've done it, you'll be so happy you did and the feedback is immediate. If people see that you are up there in a good way wishing to share something that is magic to you—you can't lose.

The more involved you are in your storytelling community, I promise it will only grow. Soon, there will be invitations to speak at schools, conferences, festivals and tons of other places.

If you keep getting your name out there as someone who is professional, does great work, has a lot of fun and gets the audience laughing and feeling great—what's not to love?

Aboriginal CON-Fusion

DAVID WOLFMAN
chef

*W*HEN I WAS LITTLE, NOTHING SEEMED LIKE A greater future for me than to become an astronaut. I guess seeing Neil Armstrong walk on the moon was a life-changing moment for just about everyone who watched it happen on television—especially little boys like me—but it stuck with me for years. I was excited about my potential to do something that had never been done before, to be the first at something big.

Starting at age nine, I sold the *Toronto Star* on the corner of Yonge and Queen Streets every day after school in the downtown core of Toronto, working for a guy named Jim who taught me the ropes and took me under his wing. I learned to make money the hard way, counting penny after penny and quickly calculating what I could do with my savings. I was robbed more than once by drug-crazed street people but more often than not was awestruck by those customers who were generous enough to give me a ten-cent tip. And I was made fun of at school by not only the other kids but my teachers as well, who didn't like my

blackened fingers, dyed from the newsprint. Luckily for me there was a man like Jim who was willing to give me the chance at such a young age to make some money, which I used to help out my family. I realize now that I learned more about people, power, influence and the value of customer service by the age of ten than a lot of people ever do. Who knew this little job would have such lasting impact on me in life.

When I pestered my mother in the kitchen of our Regent Park apartment, hungry for something to eat one time, she put me to work helping her make supper. This, I found, gave me quicker access to what I wanted than if I waited for it and it helped her out, which meant I would be let off dishwashing duties and my sisters would have to do that. A fair deal, I thought, so I kept helping her. When it was just the two of us in the kitchen, she'd share stories about her childhood on her reserve in the B.C. Interior and I came to enjoy both handling food and this special time with her.

Fran's Restaurant was an institution in Toronto way back when, and I was just fifteen and got a job there at the takeout counter. This was my first exposure to the business and I loved it—the crazy pace, the business-lunch rush and the goings-on in the kitchen. The little window into the kitchen that I sent the takeout orders through was the window to my future. So at age sixteen I followed this interest right into a four-year cook apprenticeship training program at George Brown College. I had left high school earlier than I should have but was no stranger to hard work, so I was able to keep up with all the older students.

They piled mountains of onions, carrots and celery before at me in the kitchen of the restaurant where I did

my apprenticeship, and I did my best to keep washing and peeling, hour after hour, only to be given more piles to wash and peel and a mop to clean the floors. I left home at 4:30 in the morning to take the hour-long bus ride to be there on time each day, and then I watched what everyone did in the kitchen and learned by observing them, but was anxiously waiting for my chance to do something a little more interesting and challenging than prepping stocks and cleaning. These periods at the restaurant were interrupted by rotations of class instruction back at college.

Day after day I watched the other restaurant kitchen staff work with oysters, lobsters, sweetbreads, galantines and terrines, while I mopped the floor. Those were long years of what seemed like endless and thankless work, working in relative isolation and supervised by a chef who was never happy with anyone or anything, it seemed.

This is not the beginning of a bad joke: the team really consisted of a Hungarian baker, a German executive chef, an Italian butcher/entremetier (vegetable cook), two Chinese sous chefs, a Jamaican garde manger (seasoning expert), a German garde manger, an Irish dessert lady, a Portuguese tea-service lady, a Spanish maître d' and an English general manager. In a metaphoric totem pole, I was at the bottom, as everyone was above me in importance.

The odd thing was that here I was still on the other side of the fence, able to see where I wanted to be but unable to get there. I learned how the fancy dishes were made but had never tried them myself let alone had the chance to even handle the food. The closest I had ever come to eating in a nice restaurant was when I was about ten and my family was treated to dinner in a five-star hotel restaurant in Detroit. We never had a car so we took the

train to get there and some cousins took us out for what I now know was a seven-course meal—with a parfait served at the halfway point. At the time we didn't know to expect so many courses, so naturally we filled up on the appetizers, finishing our plates clean as we did at home, with me in particular overdoing it by smearing the funny-tasting margarine on everything and eating basket after basket of the bread. Nobody got any sleep that night; I burped garlic all night long, in agony with a bad case of heartburn.

My life as a cook apprentice definitely wasn't the typical life of most sixteen-year-olds and I couldn't really share my day with people my own age because they didn't understand, had so much free time and were out having fun late at night while I had to go to bed early. And I was living on my own by this time, so had rent to pay and did extra work—any time I had a chance—as an '80s electro-dance-music DJ on weekends at local dance clubs to help make ends meet. There was no real pressure from anyone to keep going with the apprenticeship, but I did, totally committed to succeeding. And one day it happened. The guy who was supposed to work in the garde manger section that day called in sick and I was put in his place to make show plates.

The restaurant where I served my apprenticeship during my college days was at the private National Club on Bay Street, Toronto (I was there from January 23, 1977, until the end of April 1981). On any given day, between six hundred and seven hundred bankers and lawyers ate lunch at the club, carrying out meetings in the formal dining room, beyond the halls I had access to. The restaurant specialized in classical French cuisine with exquisite sauces and garnishes, with plate after plate prepared to be visually

appealing, yet totally identical. The day flew by as I systematically garnished the plates while the executive chef breathed down my neck, and I never looked back. It was three years from when I had started here before I finally reached the journeyman stage, which meant I could spend one month working in each department of the kitchen: salads, meat, bakery and so on.

BAKERS WERE ALWAYS considered to be the most artistic, yet in reality I found that their creations were the most scientifically prepared based on exact measurements and precise sequences that, if not followed perfectly, could result in dismal failure. Baking struck me as the least forgiving art of all the departments, and it attracted a lot less of my interest than preparing mains that require combinations of starches, proteins, fruits and vegetables.

I took my mom to a fancy restaurant some years ago as a treat for her birthday, and when her plate of food arrived it had meat on top of potatoes and veggies on top of meat, and garnish on top of the veggies, in a multi-tiered structure. She picked at it and turned the plate around a few times, hesitating as to where to begin. She waited and turned her head sideways and asked me what was wrong with the potatoes. She figured they must be hiding them underneath because there was something wrong with them.

Once on a tour of the Savoy Hotel in England, where master chefs Auguste Escoffier and César Ritz had worked in the 1890s, I saw true artists at work and was humbled. I was there for a brief internship and saw whole teams at work spending the entire day to create glazed appetizers that were utter masterpieces and picture perfect, made out of lobster farce (purée) put back into lobster shells and

garnished with tiny flower petals. They were truly gifted artists who were very disciplined to meet incredible standards, I thought, while I had high tea with the head chef in the grand, one-hundred-year-old institution I had previously only read about in school.

As head chef at the Kraft General Foods Account, while employed by Marriott Management Services (from May 1985 until September 1993), I was required to follow Marriott company recipes exactly. I was told there was no room for creative departure whatsoever, and this frustrated me a lot of the time when I saw opportunities to enhance the main menu with specials made from, um, leftovers. My upbringing was modest—in what I jokingly refer to as one of Canada's largest reserves (downtown Toronto) —and my mother had taught me to make good use of food and not waste anything, which had been reinforced at the National Club, where all parts of the vegetables were used to make stock; bones had purpose; and everything was planned with conservation in mind. My new employer challenged these values, demanding conformity and uniformity more than anything. And it appeared the customers wanted this too, as these were employees of the company who ate their lunch in our dining room daily and had been accustomed to the predictability of the rotating menu on a three-week cycle.

Not feeling like an artist at all, I toed the line, repeating the same recipes every three weeks, but in time I quietly made some "additions" to the menu. They raved about my lasagna and breakfast specials and I changed the steam table from army-camp-style service to pre-plated individual dishes, completely garnished, which as it turned out increased sales. Yet my supervisors were suspicious

and still unconvinced this was a good thing, knowing that from a management perspective, having one person creating new things is risky, as the question of sustainability arises. What will we do if and when he leaves the company? Well, eventually I did leave. Funny enough, I recently ran into a former customer from those days, some twenty-eight years after I left the company. She remembers to this day how much she enjoyed my Eggs Benedict and Seafood Newburg. Apparently nobody made them like I did after I left.

I didn't really begin to think of myself as an artist, however, until I worked at the Century 66 restaurant on Yonge Street, where I had free rein to design the menu, develop and test the recipes, plan the garnishes and train the kitchen crew, who were so impressed with my creations. It was their stunned reactions to the taste and appearance of my dishes that made me conscious of my artistry. I still thought of myself as a chef, but they disagreed and called me an artist.

I had already been a regular volunteer cook for some time at functions several times a week in the aboriginal community of Toronto when one event took an unusual turn. A private potluck reception was being held in honour of Tomson Highway's play *Dry Lips Oughta Move to Kapuskasing*. As the only volunteer to show up in chef whites, tall white hat and so on, I was immediately assumed to be in charge, so all the other cook volunteers came to me for direction and instruction, handing over their pots and pans of homemade corn soup, bannock, moose stew... Even though I was still young, only twenty-four, they treated me like a leader, so I took charge and created order out of the chaos, assigning everyone a job while assembling platters

of their food, making garnishes out of anything I could find in the fridge—like apples and oranges, parsley and tomatoes—as they smiled and nodded, amazed at how I was able to completely alter the presentation of their contributions to make them look so professional and appealing.

The kitchen where this meal was being prepared was under partial renovation, so we had to be really resourceful to pull it all off despite the awkwardness, and as a special treat for this reception I thought I should make a cake to match the poster from the play—as a surprise. I made a large cake and set about making a huge pair of lips to go on top, made out of cream cheese icing. I moved to the coffee lounge to make the lips because the fan was not working in the kitchen and the cream cheese was getting too warm. Within seconds of hauling the cake to the lounge, I had attracted the attention of a number of people who I imagine were homeless and who happened to be around, and who agreed to help hold the bowls while others rearranged the furniture to make room for the procedure. I quickly mixed the ingredients together and, as a group, we conspired over the food-colouring situation, not sure just how dark to go to make the lips look really Native—comparing our own to the odd mixture in the bowl.

Laughing the whole time, I shaped the icing into lips and stuck the cake in the freezer portion of the fridge that sat in the lounge, because I discovered much to my disappointment there was no room in the fridge in the kitchen. Upon removing the cake to deliver it to the building where the party was taking place, I was horrified to see that the freezing had cracked the lips open. It was too cold, too soon. Not knowing what to do, I stood over the cake in shock, only to find the guys who had helped me with it excited

about how realistic the lips were. "Hey, dry lips! They're perfect!" they cheered. Off I went with cake in hand and served it at the reception with a tiny card beside it with my name and phone number. Apparently it was the press who took an interest in the cake and circulated so many photos of it that my phone started ringing with orders for not only cakes, but dishes featuring aboriginal foods and traditional ingredients. That's when I decided to start my catering business, Lillooet Catering, named after my mom's home community in British Columbia but located in Toronto.

"Aboriginal Fusion" is the term I coined to describe my menu to catering customers, but it was really a lot of aboriginal CON-fusion at first. I struggled to come up with descriptive yet enticing names for my dishes. There was no internet, Facebook, YouTube or websites in those days, so I really had to express myself in writing that was based almost entirely just on the names of my dishes, in order to sell them. It wasn't easy to make musk ox, deer or buffalo sound appealing to people who had never had it before but wanted something different. I researched traditional foods, sought out experts, and set to work to figure out how to present wild game at cocktail parties. My background in classical French cuisine naturally came through in my cooking, which is where the "fusion" came in as I interwove white sauces, mushroom veloutés and beef-bone broths into just about everything I made, finding I had reached the point where I was truly free to choose my way with absolutely nobody to restrict me.

Some time later I had the opportunity to experiment with hors d'oeuvres for a cocktail party for seven hundred. Being free to concoct appetizers of my own and garnish them any way I wanted was unbelievably exciting, and the

lights went on for me that I was actually creative. Was I truly an artist now?

It was 1992 and I was busy. At six foot two and under 130 pounds, I was gangly in my chef whites, but I was a workhorse, hiring staff soon afterward and setting up to operate through a lease arrangement with the Native Canadian Centre of Toronto. That's where I also prepared the "soup kitchen" style lunch for local Elders, centre staff and several hundred homeless people, day after day. It wasn't the Savoy Hotel, but it was my kitchen and I took ownership to keep it spotless and produce quality meals.

It was a successful business because I had systematic command of the brigade and maintained order, systematically producing large volumes of food as I had been taught. The challenge was keeping up with the demand on such limited resources. A lot of aboriginal cooks worked for me along the way and I had a lot of hungry, unemployed volunteers who were eager to lend a hand to get a free meal as payment. There were always floors to wash and bags of garbage to take out, so I never turned them away. What was surprising was that, for the first time, I had found a place where I could express myself completely—using my knives as paintbrushes, the pots and pans as canvas—and have so much fun at the same time working with people who always laughed at whatever was going on. Everyone who worked in the kitchen had a story to tell about what they ate as a kid and how their mothers cooked for them, and so on. This was definitely not the case in any of the kitchens I had ever worked in before, so it made me feel like I was home again. When I apprenticed we were not allowed to whistle, sing, listen to music or talk any more than necessary to communicate with each other to get the

job done. What a change this was, running my own business at the Toronto Friendship Centre.

As a caterer I had every kind of request and never knew what to expect. People would call me and ask what kind of lunch I could make with a budget of only $2 per person! Another time a woman came in to the kitchen and asked if I would roast some geese for a naming ceremony and I agreed, expecting to be supplied with cleaned and frozen geese. Instead, as an urban Native I was in shock after opening a box and finding three whole geese, fully feathered, just staring up at me, and buckshot to boot. But the woman returned and taught me how to clean the geese—gleefully pulling them apart and turning parts inside out, and saving other bits in different piles for traditional uses such as earrings, wing fans and so on—as I watched, totally grossed out from the butchery, blood and guts all over.

What a change to then compete on the aboriginal team at the World Culinary Olympics in Germany later that same year, where we prepared the finest of showpieces on the most extravagant platters we could assemble. We won seven gold medals, attracting international attention.

In 1993 I was invited to return to the National Club to design a menu and take charge of a special event in honour of Ovide Mercredi, national chief of the Assembly of First Nations at the time. It was humbling to return to the scene of the crime where I had apprenticed and take charge and be respected as an equal in the austere institution that has not changed much (even to this day). And I was honoured to cook for the national chief. It was almost like being an artist, commissioned to do a piece for someone who simply trusts you will provide them what they want and like.

Around this same time, I was asked to lead an event for a government function in Ottawa, so I assembled my aboriginal staff and off we went to the capital. We arranged ourselves in the huge industrial kitchen and set to work. By this time I had developed a freer, more relaxed approach to my work so we thoroughly enjoyed cooking and talking, laughing and joking with one another while the regular staff looked on in disbelief at our informality. They told us afterward, when it was a smashing success, that they couldn't believe we were actually able to produce so well, because they thought we were playing more than working.

My mom would help me from time to time when I needed an extra set of hands with the catering and she'd cut up mounds of chicken livers for me while telling me stories about growing up among bears and cougars in the mountains, as I stirred the industrial-sized pots and prepared brandied pâté and smoked salmon puff pastry for business cocktail clients downtown.

Those years of working as an independent caterer are a bit of a blur now, as I catered so many events for every kind of organization and community you can think of—hundreds of events over the years, taking care of all the thankless jobs that caterers do, labouring in the kitchen while everyone else partied on outside the kitchen. But I was energized by the passion I have always had for culinary arts and was happy to make others happy with my food. But I wasn't the only one who wondered what people really meant when they called me an artist. One of our catering clients called my cook Brian an artist one time, based on the beautiful food display he had made for a function, and he was actually offended. He snapped back,

"You know, the food tastes good too!" as he went back to the kitchen muttering to himself.

Chefs can be a touchy bunch when guests respond to our food in ways that we don't anticipate. But that's the thing about this kind of creation: it's judged basically on appearances alone and it's so personal. When you think of paintings or sculpture, art is considered to be the same thing as beauty, which is really only skin deep. In the case of culinary arts, though, we in the business aim to produce food that tastes as good as it looks, if not more so. As much as we strive to make perfect presentations, we aim to bring out fragrances in the food that gently add to the appeal as people are eating. And we are most concerned about texture, attentive to making soups with just the right pouring consistency, sauces with just the right viscosity, breads with perfect textures, pies with perfect flakiness in the crusts, and so on. We actually seek to engage all the senses at once in a multidimensional experience that, unlike other art forms, disappears immediately upon consumption. So, judging food as art before eating it is not what chefs want to hear. We want to hear that *after* everyone has eaten and has appreciated the combinations of flavours and textures, the aromas and lingering tastes, had a lot of good conversation, some laughs, and is content.

Aboriginal cuisine is a term that is now generally accepted as the name for the foods and flavours of foods indigenous to North America, or Turtle Island as we say. Or some call it Canadian cuisine. Either way, it's an education for those in the industry who know all about classic European cuisines, Asian cuisine and so on but have no knowledge about what foods were here before the lost explorers arrived. But there is a fine line to cross

in aboriginal cuisine, because food is considered to be traditional to many in the aboriginal community who are protective of how certain dishes are prepared and fearful of exploitation.

Others, however, recognize that for several generations many aboriginal youth have come to lose interest in traditions and traditional foods. In fact, a lot of aboriginal youth will simply not even touch it, preferring fast food, convenience foods and the like. One Elder told me after attending one of my Aboriginal Fusion cooking demonstrations featuring traditional food at a First Nation, that what I had done was bring the tradition back home by making wild game front and centre again—by preparing it in ways that are more palatable to people and young people especially. I know they shy away from anything that even remotely resembles a vegetable and take wild game for granted at times when what they really want is a Big Mac and fries. My demos at First Nations schools have opened their eyes to see that food can be prepared in so many different ways and that it can be cool even if it is good for you.

One time, when I was in New Brunswick assisting a major hotel that was catering a large Assembly of First Nations gala dinner for their annual general meeting, I was summoned by staff to speak to a big, burly chief who brought his plate of food in one hand and appetizer in the other back to the kitchen, wanting to speak to me. He barrelled towards me with nostrils flaring. He proceeded to point to his salmon mousse. It was perfectly shaped, about one inch tall and about two and a half inches wide and had a little lemon zest on top. The small bowl contained a creamy fresh lobster bisque. He said to me, "First of all, they told me this is salmon," pointing at the mousse, "but

my thumb is bigger!" He added, "And this is my appetizer?" pointing at what suddenly appeared to me to be a tiny bowl of bisque, compared to his hands. "Where's the lobster?"

I soon realized that expectation was everything and he certainly had a different expectation of what he'd be getting for dinner that night. I did my best to explain what a mousse was and what a bisque was, sending him away scratching his head, but no longer mad at me personally, laughing in fact. It's a funny thing how some people have this kind of reaction—so extremely different from the ones who are blown away by the presentation. These people see virtually no value in food presentation and are confused by artistry, wondering why anyone would go to such trouble to make food look so good when it's just going to be eaten. What they really want is volume. They miss the point entirely.

I am glad that First Nations communities value their recipes and traditions the way they do, but I do have to laugh at times at how irate some will get about what is authentic and what isn't, like the hotly contested subject of what belongs in a corn soup. That's a topic sure to liven up any group of Native women in southern Ontario, I learned. I was "corrected" on several occasions myself for making the tragic series of errors of putting red and green peppers and potatoes into it and then garnishing it with a dollop of sour cream and a sprinkle of chives followed by the even more shameful act of selling it at a powwow. With a smile, I made it and seasoned it and sold it anyway. I knew that wasn't the way everyone else made it, but that's how I made it and I knew those same ladies would come back to tell me how good it was and ask if they could have the recipe. And they did (privately, of course).

The design of a tepee inspired me one time for a kitschy dessert I was making for a large conference, so I made one out of a buckskin-coloured tuile—a French pastry—with caramelized brown sugar as tepee poles and melted chocolate as the aboriginal motif on the sides, finished with maple-flavoured ice cream in the centre. The hotel was to use this model to make seven hundred of them for the day of the event. But when I returned, things were not as I expected. Once again, the kitchen was too hot, so the chocolate had melted down the sides of the tepees, and the ice cream had melted and created a soupy effect, with some bubbling over the tops of the little upside-down cones, clearly indicating we had seven hundred brown erupting mini-volcanoes on our hands—not tepees. Thinking fast, I told the maître d' to turn down the lights in the ballroom as dessert was being served. He asked if this was a traditional aboriginal custom. I told him it wasn't unless your dessert looked like it might explode. Later I was asked to show the audience photos of the model tepee to demonstrate what their desserts were supposed to have looked like. They all laughed at my expense.

AS MUCH AS I respect tradition, I am aware that culture grows and changes over time. Nothing goes on and on without change. Even trying to get access to the ingredients that once were plentiful and freely available takes a lot of effort at times. Not only do I not have instant access to fresh kill or fresh catch out my back door, but I can't sell any meat that hasn't been federally inspected. There are those who do it anyway, but I don't take the risk. And another thing is that farm-raised animals are fed corn products and a lot of times they all start to taste the same

way—beef, buffalo, deer, etc.—because they are all essen-tially eating the same feed. That's not like how it used to be, but times have changed, so we've got to change with them.

When I want game I have to shop at butcher shops. Occasionally I receive uninspected meats as donations from aboriginal hunters to prepare for community func-tions when they hire me to design a menu and train their caterers to put on a meal, as I don't cater myself anymore. This is okay so long as the meat is not being sold. The taste is better but the cuts are not what I'd call uniform, making it virtually impossible to serve any kind of large function with hundreds of identical plates. I have to laugh when I open a mysterious package and have to ask what cut it is because I can't tell due to the frost on it. There are quite a few self-taught butchers on First Nations who just hack their kill apart and wrap it up any which way in nearly unrecognizable shapes and sizes. And they will often cook all parts of the animal essentially the same way: fried in bacon fat with salt and pepper. They don't realize the importance of using different kinds of techniques to cook different parts, or marinating the tough cuts or altering seasoning beyond salt and pepper. They are surprised to learn these things from me and are pleased to discover how to maximize flavour by capitalizing on the various proteins and enzymes of different types of meat as well as the properties unique to each cut. In fact I have had people line up after having my food at large functions to tell me how surprised they were with how good it tasted because they'd had this kind of food since childhood but had never tasted it the way I prepared it.

More than twenty years after I shut down my cater-ing company I still get calls from people who want me to

cater a function with Aboriginal Fusion, so I must have really made an impression as an aboriginal caterer in the '90s. A CBC interviewer once suggested I was something of a pioneer in creating a cuisine that apparently didn't exist before I started working on it, and I guess this is true, but only because of my chef training and my time spent with aboriginal cooks who exchanged their knowledge for mine. They introduced me to wild game and community foods, and I showed them how to mass produce, how to properly store and freeze food, how to make everything from scratch, how to garnish, and how to adapt meals for people with special dietary restrictions and allergies—without frying! For every bit of technical wisdom I was able to share, they shared stories and personal experience. But it was this public recognition that led to my being invited to host my own cooking show, *Cooking with the Wolfman*, on the Aboriginal Peoples Television Network, and also to become a chef professor at the world-famous cooking school at George Brown College, where I was asked to design the first culinary program in aboriginal cuisine in a college in Canada.

Ironically, as a culinary professor at George Brown, I am now obliged to teach my culinary students the critical procedures to follow for successful employment in the industry, and this requires respectful attention to producing quality products with consistency. Again and again they waver off course to express their individuality on their plates as I did when I was younger, and I have to correct them by explaining that there is a hierarchy of knowledge and skills to be learned first, as well as what we refer to as industry standards that they must acquire and be able to demonstrate to their professors in order to graduate, first, and second, become employable.

David Wolfman carefully plates a dish. PHOTO BY MARLENE FINN

An internationally recognized expert in traditional aboriginal cuisine, David Wolfman gives time-honoured ingredients and recipes a contemporary twist with his signature "Aboriginal Fusion" style.

Some of my colleagues are outraged when students ignore their directions and make elaborate garnishes on their plates before they even know how to cook, but I try to gently guide my students back on course, reminding them that at this point they are here to learn how to function effectively as part of a bridgade. This is what Escoffier became famous for—establishing the culinary team in which each person in a kitchen has a specific role to fulfill in order that production is successful each and every time—so essential for volume production.

If you think about it, I suppose fine art students must go through the same thing—being impatient to create their own works. I know quite a few aboriginal artists who went to art school but left soon afterward because they felt too restricted by how the courses were taught and did not see the importance of studying art history or what "those French and Italian guys painted a few hundred years ago." That makes me laugh, but I don't think they realize that if you are in a school to study an art and receive certification of some kind, you need to be committed to becoming knowledgeable and skilled in the art form such as it is, not expect to use the school's equipment, supplies and space to do your own thing. I believe that long ago this is how aboriginal youth were taught as well, by observation, and patient instruction, gradually and through experience working under the supervision of a master.

I tell my students it's the same with doctors, lawyers and pilots—but especially in trades. Nobody wants people graduating from these schools if all they did was experiment and try to do things their own way. Can you imagine? And it's the same in culinary arts, but I also tell my students that they will have plenty of opportunity to be creative and,

if they want, operate totally independently if they choose to become an entrepreneur instead of an employee.

As I write this essay, I am in my nineteenth year as a professor at George Brown, my TV show has been airing in Canada since 1999 and now it's in the United States, and I realize I've been in the business for more than thirty-five years. I obviously never became an astronaut, but at times I felt like I was walking on the moon when I received the respect and admiration of those I respected and had always wanted to emulate in my profession. And I have been honoured to receive respect from Elders who thanked me for taking enough interest in traditional foods to study them and learn to make them popular. Walking into just about any aboriginal community across the country, I get the standard greeting, "Hey Wolfman, you got any food?" Usually from a passing pickup truck! So in a lot of ways I was the first in my community to do what I did, but if I hadn't been driven by my passion for culinary art it probably wouldn't have lasted this long. I don't see my job as work because I love what I do. And that's how artists think. We will continue to create because that's what we do.

Haida Manga

MICHAEL NICOLL YAHGULANAAS
manga artist

*F*EW ARTISTS EXEMPLIFY THE COMBINATION OF TRADI-
*tional Aboriginal storytelling with contemporary art
forms like Michael Nicoll Yahgulanaas. His use of the Japa-
nese form of manga illustration to highlight stories inspired
by his Haida heritage make him one of the most unique First
Nations artists working today. As with all the other contribu-
tors in this book, he was asked to discuss and explore in essay
form that which best demonstrates the connection between
his chosen art and his ancestral background. Welcome to
M.N.Y.'s world.*
— Drew Hayden Taylor

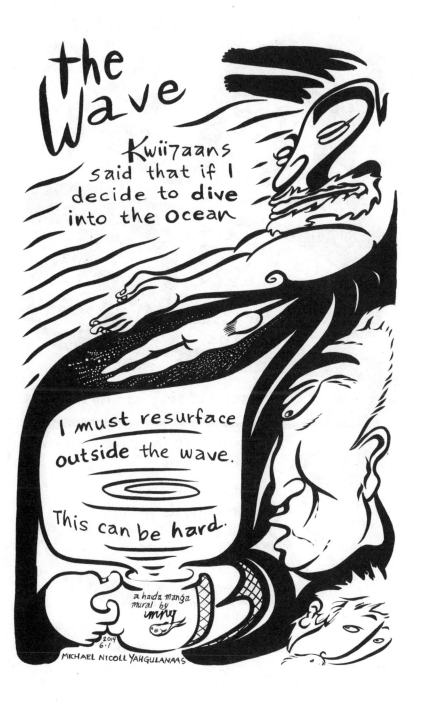

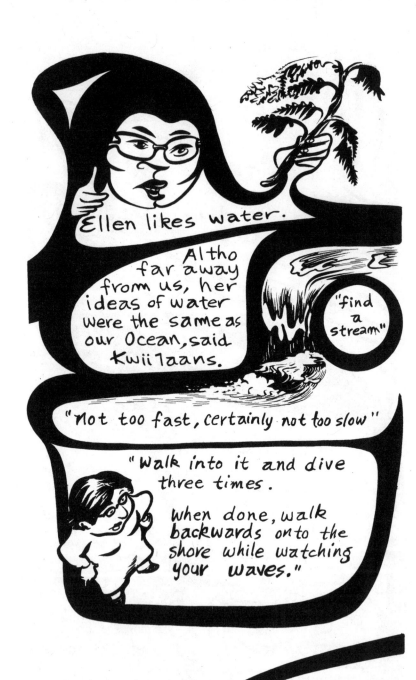

Ellen likes water.

Altho far away from us, her ideas of water were the same as our Ocean, said Kwiilaans.

"find a stream"

"not too fast, certainly not too slow"

"Walk into it and dive three times.

When done, walk backwards onto the shore while watching your waves."

Kwiiḻaans is gone.
In a few weeks an older, opposite gender relative with a common female ancestress, "aunty" is directing his headstone placement and **washing**.

know the depth before diving.

too late to ask?

Kwiiḻaans
Born
April 12,
1919

pg 6/10 2014.6.1

did I listen poorly?

what if I do it WRONG?

can I make a MISTAKE?

Ellen saw one. A woman had turned away from her splash. There was a SHRIEK and a strange creature leapt out of the water and reattached to her.

The splash **washes** off my weaknesses and if I face it with

open eyes

the wave will

carry them away.

Pg 8/10 2014·6·1

Images
are
revealed

I
ride the front
bristles, the
outer edge of
this realized
possibility.

I am a brush.

pj 10/10 2014·6·1

ℓ
About the Contributors

Inuk producer and director ZACHARIAS KUNUK, OC is most notable for his film *Atanarjuat: The Fast Runner*, the first Canadian dramatic feature film produced entirely in Inuktitut. He was president and co-founder—with Paul Qulitalik, Paul Apak Angirlirq and Norman Cohn—of Igloolik Isuma Productions, Canada's first independent Inuit production company. English is his second language.

Actor/playwright MONIQUE MOJICA (Guna and Rappahannock) is passionately dedicated to a theatrical practice as acts of healing, resistance and reclaiming historical/cultural memory. She founded Chocolate Woman Collective in 2007 to develop the play *Chocolate Woman Dreams the Milky Way*, which relies on a dramatic perspective tied to Indigenous Guna cultural aesthetics, story narrative and literary structure. Other projects include *Side Show Freaks and Circus Injuns*, co-written with Choctaw novelist/playwright LeAnne Howe.

Artist MARIANNE NICOLSON ('Tayagila'ogwa) traces her ancestry to both Scotland and the Dzawada'enux̱w First Nations, a member tribe of the Kwakwa̱ ka̱'wakw Nations of the Pacific Northwest Coast. Her training encompasses both traditional Kwakwa̱ ka̱'wakw forms and culture and Western European–based art practice. She has exhibited her artwork locally, nationally and internationally as a painter, photographer and installation artist, has written and published a number of essays and articles, and has participated in multiple speaking engagements. Her practice engages with issues of Aboriginal histories and politics arising from a passionate involvement in cultural revitalization and sustainability. She has a BFA, an MFA, and both a master's and PhD in Linguistics and Anthropology.

Artist MAXINE NOEL is Santee Oglala Sioux, born on the Birdtail reserve in southwestern Manitoba. She has been an artist and mentor for more than thirty years and says: "I believe that there is a common bond that links all cultures of the world and I am committed in my work to bridging the gaps between all communities through conversations which explore the places where history and spirit can come together." She signs her work with her Sioux name— ioyan mani—which means "To Walk Beyond." She would like to thank her friend Douglass St. Christian for his help in telling her story.

Fashion designer KIM PICARD, who shares her Native culture with others through her creations, is from the Pessamit First Nations community. She was born to a Montagnais (Innu) mother and an Algonquin/Mohawk father. She received a fashion design degree from LaSalle College

in Montreal in 1997, then worked for various companies in the Montreal fashion industry. But she has always felt great concern for Native youth and the struggles they face, and after winning several provincial and international awards she took a five-year break from fashion to work for different Native organizations. She has participated in many fashion shows in Canada and the United States, and in 2010 was chosen with six other aboriginal designers to represent Canada at the "Aboriginal Fashion Showcase" during the Olympic Games in Vancouver. English is her third language (after Innu and French).

Bluesman MURRAY PORTER has an instantly recognizable sound. The Mohawk singer, songwriter and piano player from Six Nations of the Grand River Territory in southern Ontario brings his culture and history to the masses through his music. With a mix of blues, country and humour, Porter turns his gravelly, soulful voice to songs not only about the history and contemporary stories of the aboriginal peoples of Canada, but also about universal themes of love, lost and found. He has spent more than three decades playing his self-taught unique style of foot-stomping, hand-clapping blues piano around the world.

Cultural theorist KARYN RECOLLET (urban Cree, Sturgeon Lake First Nation and Southern Ontario) is a faculty member in the Women and Gender Studies Institute at the University of Toronto. Her work includes exploring Indigenous new media, Indigenous studies, gender and race analysis, popular culture, Indigenous performance and hip-hop culture.

Choreographer, dancer and producer SANTEE SMITH—who is also a mother—is a member of the Kenien'kehá:ka Nation, Turtle clan, from Six Nations of the Grand River, Ontario. She is the founder of Kaha:wi Dance Theatre, a vehicle for her award-winning artistic work, and performs internationally. Her dance journey began early and included attending Canada's National Ballet School. She holds kinesiology and psychology degrees from McMaster University and a master's in dance from York University.

Actor, director, dancer and singer ROSE STELLA has been artistic director of the Centre for Indigenous Theatre (CIT) in Toronto since mid-2003. Originally from Arizona, she is Tarahumara First Nation and Italian. In 2003 her play *White Buffalo Calf Woman—A Clown Show* was invited to the World's Fare Festival at Harbourfront Centre in Toronto. In May 2013, CIT students presented a new draft called *White Buffalo Calf Woman—A Clown & Dance Show* (which animated the prophetic dreams of healer Wendy Hill) for their year-end show. Requests for a tour to several reserves in southern Ontario followed. On the music front, Rose made her debut at the Toronto Jazz Festival as a featured singer in June 2013.

DREW HAYDEN TAYLOR is an award-winning playwright, novelist, scriptwriter and journalist who was born and raised on the Curve Lake First Nation in Central Ontario. *Me Artsy* is his twenty-sixth published book, and he looks forward to seeing what other stories the Creator sees fit to bless him with. His earlier books include *Me Funny* and *Me Sexy*.

Drummer STEVE TEEKENS is an Anishnabe of Nipissing First Nation who has been teaching drumming and singing to youth and men at various Native organizations inside and outside Toronto since 1995. (In this part of the country only men sit at the big drum; women use hand drums.) The drum has been good to him and has helped to promote healing and a sense of pride in his culture. He has worked with the marginalized and homeless sector in Toronto since 1995, and since 2009 has been executive director of Na-Me-Res (Native Men's Residence), which provides temporary and transitional housing to aboriginal men.

Internationally celebrated author RICHARD VAN CAMP is a proud member of the Dogrib (Tlicho) Nation from Fort Smith, Northwest Territories. He is the bestselling author of more than a dozen books, with a whole lot more on the way. You can visit him on Facebook, Twitter or at his website: www.richardvancamp.com

Chef DAVID WOLFMAN, a member of the Xaxli'p First Nation of British Columbia, is an internationally recognized expert in wild game and traditional aboriginal cuisine. He is a classically trained chef, and an enthusiastic educator and entertainer. He has been a culinary arts professor at George Brown College in Toronto since 1995 and is also executive producer and host of a popular TV program, *Cooking with the Wolfman*. The show features his signature "Aboriginal Fusion: Traditional Foods with a Modern Twist" and is broadcast on APTN (the Aboriginal Peoples Television Network) in Canada and FNX (First Nations Experience) in the United States.

Visual artist MICHAEL NICOLL YAHGULANAAS was raised in Haida Gwaii and planted his artistic flag only after a decades-long public service career on that group of islands far outside Canada's western territorial seas. He started creating Haida manga (manga being Japanese-style comics) after being exposed to Asian art forms, has now published numerous works and lives on the West Coast of Canada. In keeping with a tradition of innovation and in celebration of hybridity, he re-imagines the icons and symbols that we use to describe our personal and collective identities. In doing so he reminds us that we are the liberators and heroes we once longed to become.

Acknowledgments

···························

*T*HIS BOOK IS A COLLECTION OF DREAMS AND STORIES from both the people in the book, and those who helped in its development and publication. It is truly an honour to have worked with all these people. To all the people within these pages who shared their perspectives, I send you all out a group hug. I give an aboriginal high five to the people at Douglas & McIntyre who originated the Me series (*Me Funny* and *Me Sexy*) with me and believed there was, and is, so much more out there to explore in Native culture. And of course two thumbs up to my meticulous and brilliant editor, Cheryl Cohen, who can now be classified as an expert on the aboriginal artistic journey. I would also like to send out a special fist pump to my agent, Aurora Artists, and the lovely Janine Willie who provided me with a lot of help, love and support during this project.